-THE

ENCYCLOPEDIA

OF

PASTEL TECHNIQUES

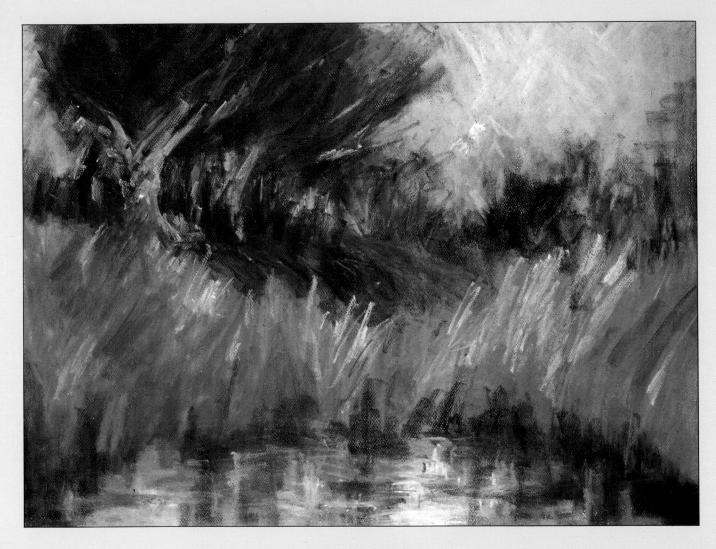

DEBRA MANIFOLD "Evening Glow"

THE

ENCYCLOPEDIA

OF

PASTEL TECHNIQUES

JUDY MARTIN

Library of Congress Cataloguing-in-Publication Data is available upon request

1098765432

Published in 2003 by Sterling Publishing Co., Inc 387 Park Avenue South New York NY 10016-8810 USA

Copyright © 1992, 2004 Quarto Publishing plc

All rights reserved. No part of this publication may be reproduced, stored in a retrieval system, or transmitted, in any form or by any means without the prior permission in writing of the publisher, nor be otherwise circulated in any form of binding or cover other than that in which it is published and without a similar condition being imposed on the subsequent purchaser.

This book was designed and produced by Quarto Publishing The Old Brewery 6 Blundell Street London N7 9BH

ISBN 1-4027-0911-0

QUAR.EPP

Senior editor: Hazel Harrison Art editor: Philip Gilderdale Designer: Anne Fisher

Photographers: John Wyand, Chas Wilder

Picture manager: Sarah Risley
Picture researcher: Bridget Harney
Art director: Moira Clinch
Publishing director: Janet Slingsby

Distributed in Canada by Sterling Publishing c/o Canadian Manda Grøup 165 Dufferin Street Toronto, Ontario, Canada M6K 3H6

Typeset by En to En, Tunbridge Wells Manufactured in Hong Kong by Regent Publishing Services Ltd Printed by SNP Leefung Printers Ltd, China

CONTENTS

INTRODUCTION

PASTEL TYPES • 8

PART ONE

TECHNIQUES • 12

ACCENTING • ACRYLIC AND PASTEL • BLENDING • BLOCKING IN • BROKEN COLOR • BUILDING UP • CHARCOAL AND PASTEL • COLORED GROUNDS • DRY WASH • EDGE QUALITIES • ERASURES • FEATHERING • FIXING • FROTTAGE • GESTURAL DRAWING • GOUACHE AND PASTEL • GRADATIONS • HATCHING AND CROSSHATCHING • HIGHLIGHTING • LINEAR MARKS • MASKING • OIL PAINT AND PASTEL • OVERLAYING COLORS • PENCIL AND PASTEL • POUNCING • PROJECTING AN IMAGE • RESIST TECHNIQUES • SCRAPING OUT • SCRATCHBOARD WITH OIL PASTEL • SCUMBLING • SFUMATO • SGRAFFITO • SHADING • SIDE STROKES • SKETCHING • STIPPLING • TEXTURED GROUNDS • TINTING • WASHES • WATERCOLOR AND PASTEL • WET BRUSHING

PART TWO

THEMES • 70

LANDSCAPE • 72
THE ENVIRONMENT • 100
THE FIGURE • 120
PORTRAITS • 142
ANIMALS • 158
STILL LIFE • 170
INDEX • 188
CREDITS • 192

Many manuals on pastel painting take for granted the use of traditional soft pastels, a dry medium that provides the richness and variety of paint colors. Soft pastel is certainly the most versatile and widely used kind of pastel, but the modern choice of materials includes other pastel types that have their own specific characteristics as drawing and painting media, and also function as useful supplements to soft pastels. The techniques described in this book relate to the full pastel variety — soft and hard pastels, pastel pencils, oil pastels and water-soluble pastels.

The exact characteristics of all of these media vary slightly between different manufacturers' lines. You may find a particular brand that you prefer for its ease of handling or color qualities, but it is quite possible to mix and match from different

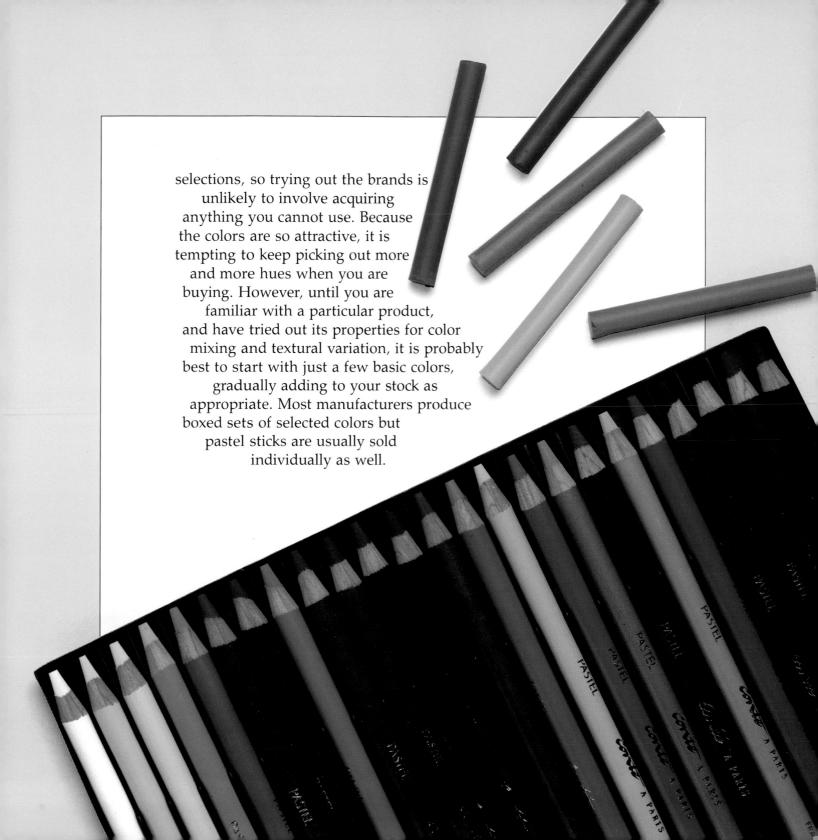

Soft pastels

The basic ingredients of pastels are ground pigments and a binder that holds the pigment particles together. They are mixed to form a stiff paste, which is then compressed into round- or square-sectioned sticks and allowed to dry. Soft pastels have a high proportion of pigment to binder, hence the ease with which they transfer color to the support and the brilliance and rich texture of the colors. Soft pastels may also include white chalk, or a similar filler, which gives luminosity to bright hues and pale tints.

The color choices vary with the manufacturer, and there is no standard identification of the pigments. Some of the high-quality pastel lines have literally hundreds of colors, including pure hues together with lighter and darker shades of each individual hue — these may be identified by numerical codes that signify related color values. This abundance of colors acknowledges the directness of pastel as a painting medium — deprived of the ability to mix colors infinitely, as you can with paint, you are offered a palette of pastels that would enable you to vary the color of every stroke. Other good brands provide slightly less color variation, but all are likely to meet your requirements more than adequately.

The loose, grainy texture of soft pastels provides great color clarity, but it is also the reason why many people find pastels difficult to use. The powdery color can seem to spread uncontrollably, and it is aggravating when a fragile pastel stick snaps or crumbles in the middle of a stroke. This can lead to a cautious approach, but the best results come from working freely and decisively.

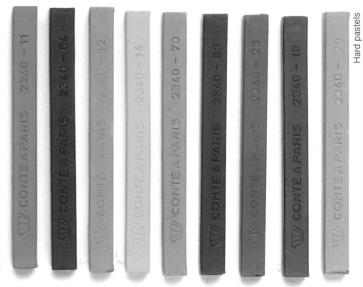

Hard pastels

These have a greater proportion of binder to pigment, so they are more stable in use than soft pastels, but do not have such wide potential for varied surface effects. Traditionally, they are used for preliminary sketching out of a composition, and for adding linear detail and "sharpening" touches to soft pastel work – in effect, hard pastels are the drawing medium that complements soft pastels as a painting medium. You can exploit the linear qualities by using the section edge of the stick, or even sharpening it to a point by shaving it with a fine blade, but there are also several techniques you can use to develop effects of massed color, such as shading, hatching and crosshatching. The color range is quite limited by comparison with soft pastels, with nothing like the degrees of variation in hue or shading.

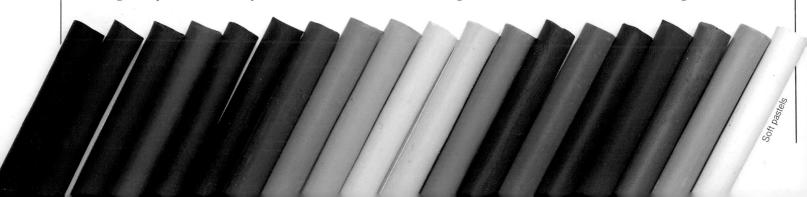

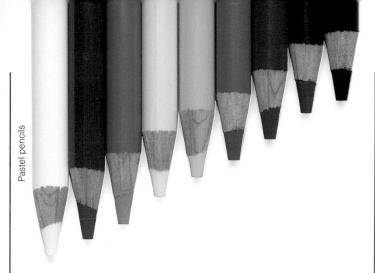

Pastel pencils

These are thin sticks of pastel encased in wood, and come in a relatively limited color range. The "leads" are typically harder than soft pastels, although they may also be somewhat softer than hard pastels. Their main advantage is that they are clean to use and easy to control. As with hard pastels, you can make use of their linear qualities to add crisp finishing touches to a rendering mainly worked in soft pastels.

Oil pastels

This medium is unique among the pastel types, containing an oil binder that makes the texture dense and greasy, and the colors slightly less opaque than soft pastels. Typically, the colors are quite strong, and the variation of color values is restricted. The moist texture of oil pastel can quickly fill the grain of the paper, so the capacity to work one color over another is somewhat limited, but for painting effects, oil pastel marks can be softened and spread by brushing them with turpentine.

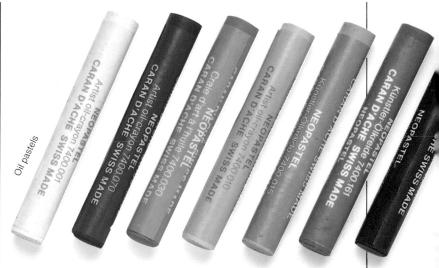

Water-soluble pastels

The wax content of these color sticks gives them a slightly moist texture, so that they handle rather like oil pastels when you use them for drawn strokes. But brush over the color with clean water, and it instantly dissolves into an even, semitransparent wash. The quality of the wet color is like a coarse watercolor wash. You can vary it considerably according to the amount of water that you add — for instance, with a barely wet brush, you can spread the color tint while retaining a strong impression of the linear marks.

The restricted color choice is composed of strong, unsubtle hues, but with the potential fluidity of the medium, you have more scope for mixing and blending colors on the working surface.

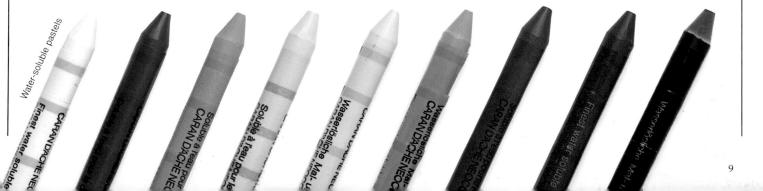

PART ONE TECHNIQUES

Pastels are unique in the way they bridge the gap between painting and drawing media. The stick form gives pastel strokes a linear character that enables you to exploit the calligraphic qualities of line and the controlled effects of linear shading, while the loose texture and brilliant color qualities allow for painterly effects of mass and surface texture. Pastel is the most direct of color media — it flows directly from your hand and, unlike a brush or pen nib, has no intermediary factor that contributes its own qualities to the marks you make.

You must juxtapose, mix and blend your colors on the support —

you cannot try out color mixes in a palette or paint out errors and begin again. To achieve the full potential of pastels, therefore, you need to be aware of the medium's technical range and

develop confidence in applying it.

Practicing the individual
techniques demonstrated in this
section of the book — with no initial
pressure to produce a successful or
even recognizable image — will enable
you to get the feel of the medium, gaining

practical experience which will contribute to your ability to interpret a particular subject.

If you have difficulty mastering any of the techniques, or the results are not as you hoped, remember that there are individual elements that can be subtly varied. You might need to try different colors, a slightly different quality of pastel stick, more or less pressure from your fingers and hand, or an alternative paper color or texture.

Fortunately, you can experiment with pastel work on a small scale and quite economically.

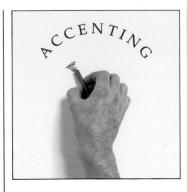

Color accents are the little touches of color you use to "lift" a work in pastel. They add emphasis and points of focus in a composition. The marks you make may be very brief and quite abstract in themselves, but they should derive from something that you see in your subject which, accurately translated onto the page, enhances the definition and detail of your drawing.

Accepting can be similar to HIGHLIGHTING — like the tiny points of pure white or very pale tints that give life to flesh tones and facial features in a portrait. But color accents apply more broadly to overall color effects, relating to local colors, lights and shadows. Because an accent is a small mark, you can be surprisingly bold with its color value and still find that it works effectively in relation to the surrounding color areas — a patch of strong violet can give richness to a dark cast shadow, for example, or a streak of brilliant pink can light the far horizon in a landscape.

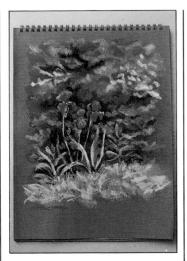

1 This small soft-pastel study of flowers and foliage is nearing completion. The natural variation in the flower colors provides bright color accents, but the foliage background lacks depth and detail.

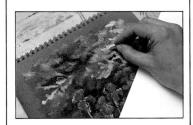

2 In the top right-hand corner of the image, touches of pale blue and yellow are put in to indicate glimpses of sky and sunlight reflecting on the leaves.

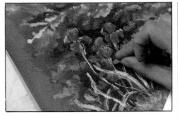

3 The shadow areas behind the flowers are strengthened, using warm brown over black to contrast with the greens and yellows.

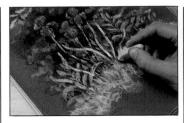

4 The lighter green grasses in the foreground area are retouched with a pale mauve pastel to give cool color contrast against the warm shadows.

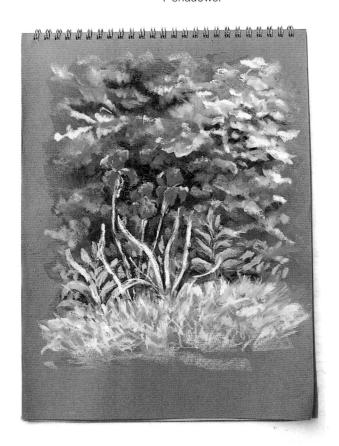

5 In the completed image, the color accents give more definition to the form and texture of the leaf masses and enhance the sense of depth

between foreground and background elements.

Acrylic paints are artists' colors which have the substantial textural quality of oil paints, but can be mixed and diluted with water. This means that they can either be handled like watercolors, heavily diluted to achieve thin, translucent washes; or they can be applied as solidly brushed, opaque color or thick impasto layers, like oils. Acrylics used in "watercolor mode" can be combined with soft pastels in the same way as watercolors (see WATERCOLOR AND PASTEL), or you can use oil pastels with washes of acrylic in resist techniques. With more thickly worked acrylics, you can use soft pastels or oil pastels to draw into the paint to develop linear qualities and impressed textures.

It can be more difficult to work pastel strokes over dried acrylic. The particular characteristic of acrylic paint is that it dries by a chemical bonding that produces a "plasticized" surface, impervious and irremovable when dry. Once the paint is thick enough to mask the surface of the paper or board, you will have lost the tooth that helps pastel strokes to grip, and you may find that the adherence is poor.

1 The head and face are sketched out in soft pastel, using a light, neutral color. Shadow areas and the basic colors of skin and hair are brushed in with very dilute washes of acrylic.

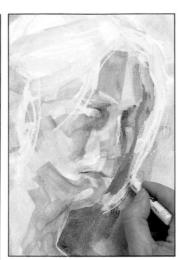

2 Further washes are overlaid to model the face and head roughly with broad brushstrokes. The paint is allowed to dry, and soft pastel is used to develop details of the face and hair.

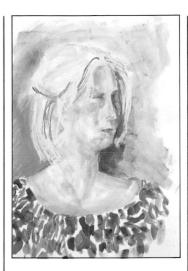

3 The flesh tints on face and neck are reworked with additional washes to strengthen the colors and integrate the tones. Pastels are used to draw in the lights and darks in the strands of hair, linked to shadows and highlights on the face.

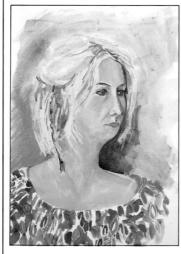

4, 5 In the final stages of the painting, the acrylic washes and pastel marks are freely combined, laid in one over another in different areas of the image to build up form and

texture. Definition of the facial features is drawn in pastel, while slightly more dense washes of acrylic enhance the tonal contrasts in the skin and hair. The detail (above) shows how translucent washes of paint overlaid on the pastel marks allow the linear detail of the drawing to show through.

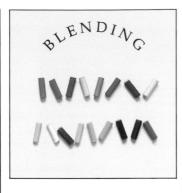

In traditional methods of pastel painting, particularly as applied to portraiture, colors

were smoothed and blended together to produce images with a high degree of surface finish comparable to the effects of contemporary oil painting techniques. To the modern eye, much of the medium's impact comes from the grainy, rough textures of pastel and loose networks of individual pastel strokes. But the subtleties of blended colors and smooth gradation of hues and tones are vital elements in rendering specific materials and surface qualities soft fabrics, for instance, or

uniform, reflective surfaces such as metal and glass — and atmospheric impressions. Blended colors also provide visual contrast when integrated with loose pastel strokes and BROKEN COLOR in a composition.

The special tool for blending soft pastels is a torchon — a tight roll of paper that is shaped like a pencil and used in the same way — you "shade" into the pastel strokes with the tip or side of the torchon to spread and blend the powdery color. You obtain

a clean point on the torchon by unwinding some of the paper from the tip. A torchon enables you to control the blending quite precisely, and is thus ideal for small areas. Alternatively, you can use your fingers, a cotton swab, tissues or a rag, or a brush (soft-textured fabrics and brushes will lift some of the color).

Blending with a torchon Lay down the pastel color, and gently rub the surface with the tip or side of the torchon to soften and blend the colors.

Blending with a brush
Use a short hog-hair or
synthetic bristle brush to break
down the grain of the pastel
particles and spread the color
evenly.

Blending with fingers
Rubbing with your finger
merges the colors and presses
the pastel dust into the paper
grain. It is an effective way of
blending linear or side strokes
in soft pastel.

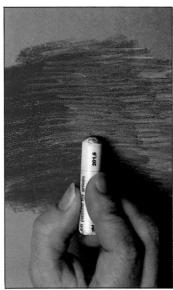

Blended strokes
With oil pastels and hard
pastels, which do not spread so
smoothly on the surface of the
paper, use short strokes to
overlay one color on another,
varying the pressure so that the
integrated marks produce an
impression of mixed hues and
shading.

This term refers to the process of rapidly laying in the main shapes and broad color areas of a composition before starting to develop the detail. The purpose is to provide yourself with a basic structure for the painting and a tonal or color key relating to the overall impression of the subject.

The quickest way to block in large color areas is using SIDE STROKES to apply broad patches of grainy color, but you can use any method of SHADING with the tip or edge of the pastel stick. However, this is a preliminary stage of your work, and it is important not to overwork the pastel, or you will encounter problems in keeping the colors clean and strokes distinct when you start to build up the detail. Whatever method you use to block in basic shapes, shades and colors, use minimal pressure so that these initial layers are lightweight and open-textured.

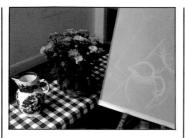

1 A quick outline sketch of the subject establishes the main shapes as a guideline for laying in the color areas.

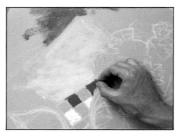

2 Working with one color at a time, the artist starts to fill each area with a loose, open layer of pastel. When blocking in, use the side or tip of the pastel to apply the color freely.

3 Complex forms like flowers and foliage can be blocked in initially as simple shapes with a suggestion of color and texture, bearing in mind that this sort of detail can be developed and reworked at a later stage.

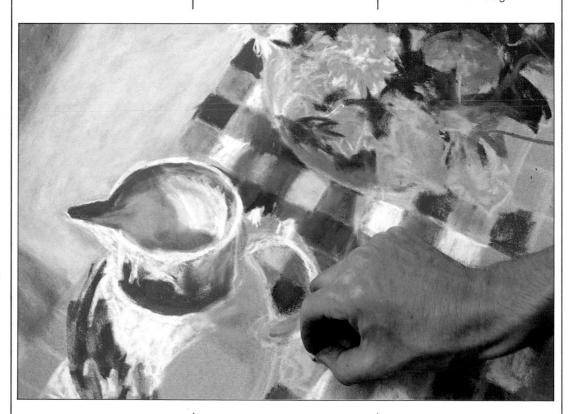

4 The artist gradually works his way around the whole image to achieve a broad impression of all elements of the subject. Notice how the still life has

clearly taken on a sense of solid form, although the shapes are as yet imprecise and the pastel marks still free and vigorous.

Pastel is an ideal medium for achieving broken-color effects — the shape and size of the pastel stick and the small-scale gestures your hand makes when manipulating it provide the basic elements of this technique.

As the term suggests, broken color is the complete opposite of flat or smoothly blended color. You build whole color areas using short strokes of the pastel, juxtaposing or interweaving two or more colors. This enables you to produce rough blends and color mixes, one hue or tone modifying another. From the appropriate viewing distance, broken color "reads" as a coherent surface effect, while closer up, you can appreciate the color interactions and lively textural qualities of the mingled strokes.

As with any color medium, overmixing devalues the contribution of all the component colors and results in a muddy effect, so you need to think carefully about the variety and number of individual colors that you use. You might use three kinds of blue, for example, to create the impression of a very vibrant, active, single color, or employ a range of shades that enables

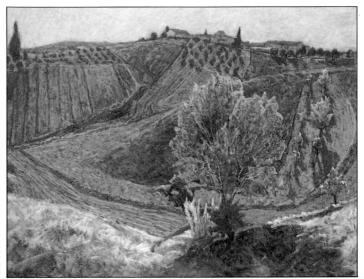

■ PATRICK CULLEN

"Purple Fields near Centaldo" In this landscape, each area is interpreted as a complex mass of broken color, consisting of interwoven and overlaid marks. Careful integration of the color values gives a coherent structure to the overall view and its individual elements.

you to suggest light and shadow. You may wish to combine harmonious colors for a gentle effect, or introduce contrasts to intensify strong passages — massed foliage in a landscape, for instance, could be represented with a serene combination of yellow, green and blue, or you could create depth and warmth by juxtaposing greens with red, orange, brown or purple.

One of the color elements may be supplied by the color of the support, which also gives an underlying unity to the mass of pastel strokes. A white or light-tinted ground contributes luminosity; a darktoned support enhances the brilliance of applied hues.

This technique works well with all types of pastels, the shape and texture of the particular medium governing the delicacy or coarseness of the broken color effect.

▶ DIANA ARMFIELD
"Teatime, Brown's Hotel"
In this interior view, the broken color effects create a shimmering, atmospheric impression. The color combinations describe form, texture and pattern, with grainy marks also allowing the tone of the paper to show through in places (see COLORED GROUNDS).

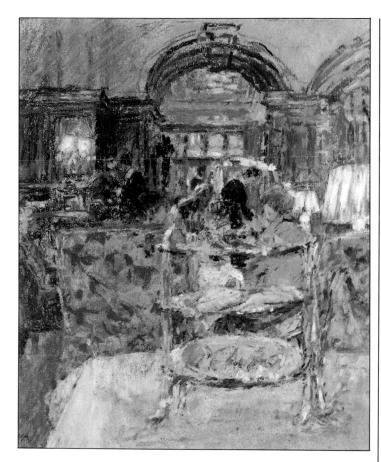

■ Detail of top left. The variety of closely related colors applied to the tree foliage implies both its mass and detail, the brighter hues drawing out the shape from the background of more muted color.

■ Detail of top left. The color variation in the grassy and plowed fields is naturally suggested by their individual forms and textures, but note how the open sky is also treated as a mass of overlaid, pale tones, not as a single flat color.

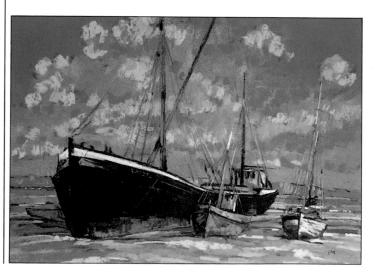

■ GEOFF MARSTERS
"Barge, the Raybel"
In this picture the pastel strokes are used more emphatically to construct the varied shapes and surface values. The vibrant color combinations are boldly stated, but carefully arranged to develop the impression of form and space.

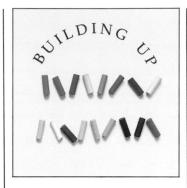

Unless you are using pastels only for quick sketches, or working in line alone, you will need to develop your own strategies for building up color effects and detail. Pastel is a medium that demands a gradual approach if you are to avoid overworking the surface too quickly, or losing the clarity of color and detail through too much mixing of marks and textures. Many people find it easiest to control the very loose texture of soft pastels by FIXING the surface at regular intervals as the work progresses, which suggests an approach that involves "staging" the color applications.

One common method of building up a pastel painting is to begin by BLOCKING IN broad color areas quickly, then applying a variety of techniques to develop form, detail and texture. If you are rapidly laying in an initial impression of tones and colors overall, keep the layers of color light and grainy so that you do not fill the tooth of the paper too quickly and arrive too soon at a "solid" surface quality that resists further color applications.

Most artists agree that the best approach to building up a

composition is to work all areas of the image to the same level of surface quality and visual detail at each stage before moving on to more complex or intricate elements. If you complete one particular area of a painting in full detail before applying yourself to the next, it is difficult to achieve an image that has balance and consistency. As pastel is such a direct medium, which forces you to make immediate decisions on shading and color values, you need to be constantly aware of the interaction of different elements of the image and how, for instance, introducing a new color may give an unexpected cast to the colors you have already applied.

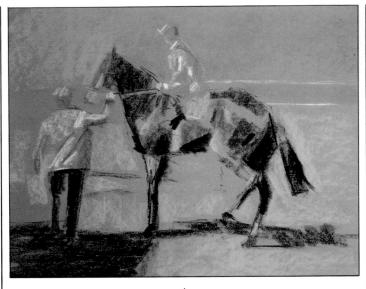

Soft pastel

1 The whole image is first blocked in rapidly (see BLOCKING IN), using side strokes and sketchy lines to lay out the main color areas and individual forms of horse, jockey and trainer.

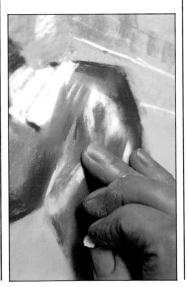

2 Each section of the image is built up with thicker layers of color, using a combination of hues and shading to develop the modeling of the forms. The specific texture of the horse's glossy coat is imitated by finger-blending the pastel marks.

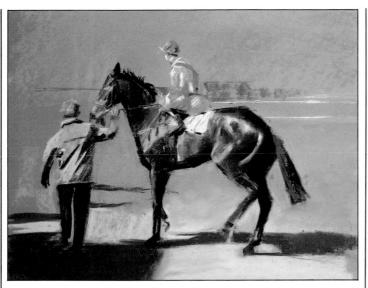

3 As this treatment is applied to increasing areas of the image, the picture gains form and structure. Strong lights and shadows in the foreground enhance the spatial qualities.

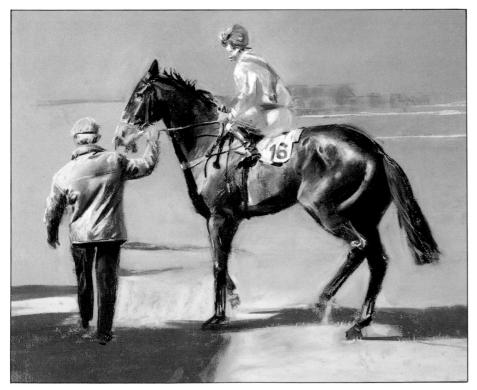

4,5 In the finished image, each form has been fully modeled with a subtly varied selection of tones and hues. Careful BLENDING has been used to describe the weight, solidity and surface textures of the horse and figures, but there is still enough evidence of the individual pastel marks to give the image a lively rhythm and suggestion of movement appropriate to the subject. The detail (above) shows how features such as the saddle and harness and the jockey's clothing are drawn with a more complex network of individual marks and small patches of color. Tonal contrasts, as in the folds of the boots and saddlecloth and the darkly cast shadows beneath them, are boldly emphasized.

Hard pastel

1 The composition is first blocked in as a monochrome sketch, using gray and white pastels to outline and loosely shade in the basic shapes.

2 The colors of the leaves and flowers are described with light and medium hues. Linear techniques such as shading and hatching are used to put in the blocks of color.

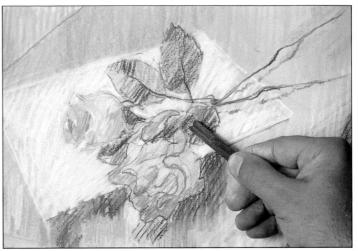

3 Color detail is gradually developed, introducing additional hues to describe the variation of the flower petals, and dark tones to model the shadow areas. In places, the linear marks are lightly rubbed with a finger to spread and soften the color.

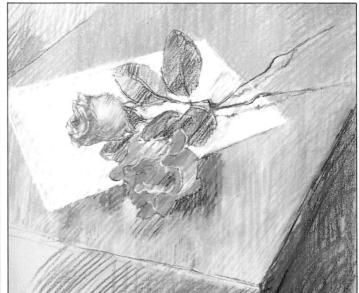

4 The same techniques are used to build up the image in layers, reworking different parts of the picture in stages. The

dense pastel marks merge into an increasingly detailed impression of form and surface texture.

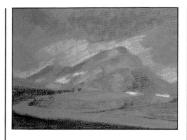

Oil pastel

1 In the BLOCKING IN stage, the main color areas of the landscape are established using SIDE STROKES and loose shading.

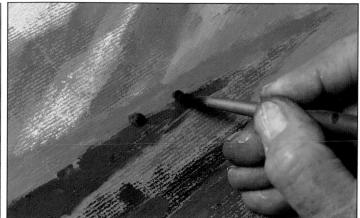

4 The silhouettes of trees in the foreground and middle distance are painted with a brush. This is done by picking up the color from the tip of a pastel stick on a brush moistened with turpentine, then transferring it to the working surface.

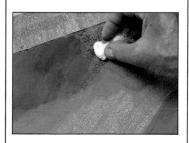

2 To blend the sky colors, a little turpentine is applied to a cotton ball and rubbed over the pastel to soften the color and texture.

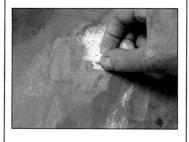

3 The variety of shading and color is built up by overlaying the oil pastel more thickly. This process of layering and blending the colors is applied to the image overall.

5 As the main forms and color areas emerge in more detail, pale tints are overlaid. The tip of the pastel stick is used to apply highlights on the road, grass and hillside, enhancing the impression of light and space. Note the variations in

the density of the pastel layers, so that in places the paper color shows through, giving textural contrast against the more solid pastel color.

Charcoal is the medium traditionally used for sketching the layout of a composition, providing the guidelines for application of color and tone. In this role it is a useful complement to pastel, particularly soft pastels and oil pastels which you might use to build dense IMPASTO effects over a compositional framework drawn with

charcoal. You can create a quite clearly defined charcoal sketch to begin with, then brush away the loose charcoal with a soft paintbrush before introducing the color work.

Alternatively, you can use charcoal as a more significant visual element to enhance the graphic qualities of a pastel drawing. The textures of charcoal and soft pastel go

well together, but charcoal is grittier and can contribute sharp line qualities and hard blacks. To avoid contaminating colors with black dust and charcoal fragments, confine this mixed-media approach to quick sketches and studies, and use frequent, very light sprays of fixative as necessary.

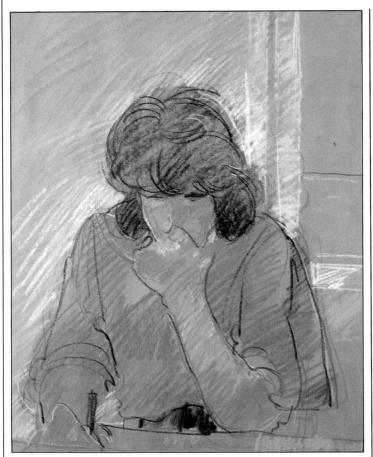

Charcoal over pastel

1 A linear technique is used for this portrait drawing, initially applying charcoal and hard pastel in quick, light strokes to establish the contours of the figure and the broad color areas.

2 The gradual buildup of color continues, with warm browns and pinks developing the richness of the flesh tones, contrasted with cool gray shadows and brilliant white highlights. Charcoal is used extensively to emphasize the dark tone of the hair and to delineate the eyes.

3 In this area of the portrait, the charcoal again signifies linear detail and shadow areas, as in the folds of the pink shirt. It is worked over the pastel color,

which has been applied as loose shading and hatching; then the final highlights and color accents are touched in with the pastels.

Pastel over charcoal

1 Here the approach is different, with charcoal used to create a detailed monochrome drawing of the subject, which then forms a base for the color rendering. In the initial drawing, sharp lines are contrasted with loosely worked shading and graded tones. When applying the charcoal, you can work up the dark tones quite heavily. Because it is a very dry medium, it does not clog the paper tooth.

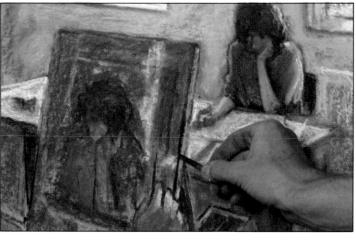

4 As the colors are built up more heavily, charcoal is again used where necessary to redefine the framework of the composition and give emphasis to the forms. It is possible to draw over the pastel and still obtain clean, heavy blacks. In

the final stages, the balance of shades is adjusted by applying thick color with the tip of the pastel stick to develop highlight areas and color accents.

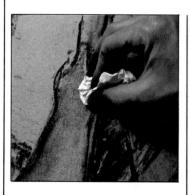

2 Light and medium shades can be smoothly graded by rubbing the charcoal with a tissue. Dust off the surface, and apply a light spray of fixative before starting to apply pastel color.

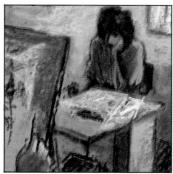

3 The first layers of color are blocked in quickly using the tip and edge of the pastel stick. At first, these show broad color variations across the whole image. Highlights are applied to counterbalance the dark charcoal tones.

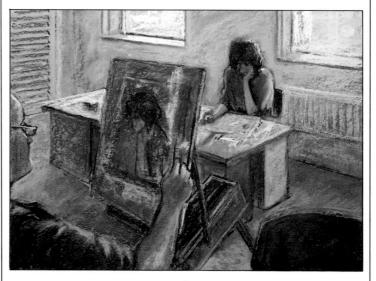

5 The finished composition has a strong pattern of light and shadow. Foreground shapes remain dark, with the pastel used just to tint the blacks,

while the light near the windows is conveyed by heavier overlays of color, the charcoal showing through as a linear framework.

Use of a colored ground is a traditional aspect of pastel painting, still employed in fresh and interesting ways by contemporary artists. Given that the grainy texture of pastel usually allows the color of the support to show through, it is not always appropriate that this color should be white. A colored ground can be used to set an overall tonal value for the work - dark, medium or light - or to give it a color bias in terms of warm (beige, buff, brown) or cool (gray, blue, green) color. It can stand in for a dominant color in the subject - blue or green for landscape, for example, buff or terracotta for a townscape. Subtle hues are typically selected, but there are occasions when you might choose a strong color to isolate the image and throw it into relief.

The wide choice of colored papers available, encompassing varied chromatic qualities and surface textures, provides a wealth of choice for ready-made colored grounds for pastel work. If you prefer, you can apply color to a white support using thin washes of watercolor, gouache or acrylic paint, or you can tint a paper subtly with a pastel DRY WASH. For oil pastel work, you can color primed paper or canvas board with a glaze of diluted oil paint. In this way, you can achieve the precise color value you want, and then grade, blend or texture it if you wish a colored ground does not have to be a single or uniform color.

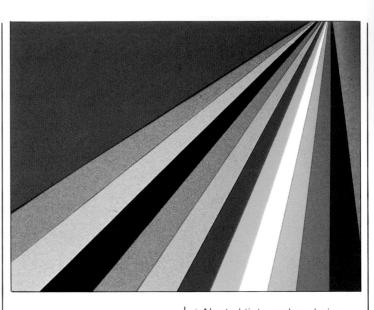

▲ Neutral tints such as beige, buff and gray provide a medium background that enables you to key your range of pastel shades and colors. These can give the pastel rendering a cool cast, for instance blue-gray, or a basic warm tone, as with an orangebuff paper.

Colors that are bright or very densely saturated make a strong impact on the overall image, intensifying the hue and texture of the pastel marks.

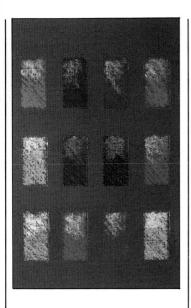

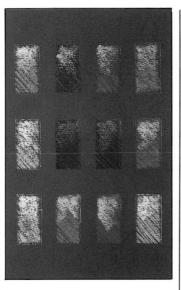

Tinting with watercolor

1 If you are applying a watercolor ground to your paper, it is necessary to stretch it first so it will dry flat after the wet color has been applied. Soak the paper thoroughly, and lay it on a drawing board. Apply a strip of gummed paper tape all along one edge.

2 Smooth down a second strip along the adjacent edge of the paper. Work around all four sides in the same way, making sure there are no wrinkles in the wet paper and pressing the tape down firmly so it adheres well to both paper and board.

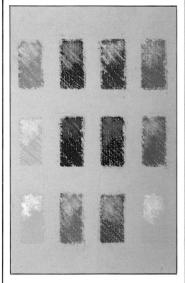

and the brown pastel comes up surprisingly light-toned on a dark gray or red ground. The red paper gives greater intensity to the greens, because the colors have complementary contrast.

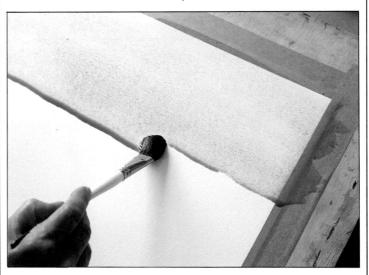

3 Mix a large quantity of dilute watercolor in the desired color. Using a large, soft brush, spread an even wash across the paper, working from side to side and gradually extending the wash downward. Allow the paint to dry completely before beginning work in pastel.

This technique strictly applies only to soft pastels, as the true effect of a dry wash depends upon the powdery quality of pastels made with a minimum of binding material. To begin with, you reduce the pastel stick to powder by scraping the long edge with a knife blade. Hold it over a palette, dish or piece of clean paper, to catch the powder as it falls, and try to graze, not chip, the edge of the pastel with the blade, so that the powdered color is quite fine.

When you have a reasonable quantity of powdered color, use a rag, small sponge or cotton ball to pick up the powder and spread it on the paper, working evenly across the support to lay down a flat color tint. To produce tonal or color gradations, you can strengthen the color in selected areas, or overlay additional colors.

This is one method of creating a COLORED GROUND for pastel work, using colors and textures that will be naturally sympathetic to the pastel strokes you overlay. It is also a good way of developing hazy or atmospheric effects in landscape rendering — representing large areas of sky, land or water, for example.

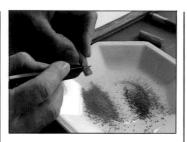

1 Use a craft-knife blade or similar tool to scrape the edge of the pastel stick evenly, collecting a heap of finetextured powder color.

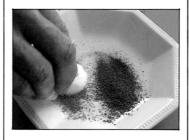

2 If you are using more than one color, they can be mixed and blended on the paper surface. Dab a cotton ball into the first color to pick up some of the powder.

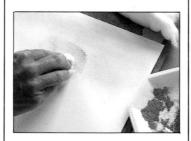

3 Rub the cotton ball across the paper surface, laying down a thin, even color tint. Work it well into the paper grain and increase the tonal depth gradually with successive applications.

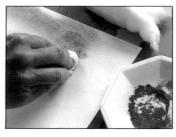

4 Apply the second color in the same way, working it into the required areas of the paper. Varying the pressure you apply to the cotton ball creates subtle differences of tone and texture.

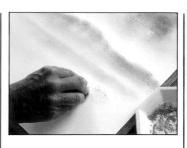

5 To apply a third or subsequent color, simply repeat the process as required. Keep the batches of powder separate to avoid devaluing the colors.

6 As with this example, you can use dry-wash technique to block in the basic color areas of a composition, or you can simply use it as a method of TINTING the paper to create an overall color key.

Different subjects require different treatments in terms of conveying solid shapes and forms and qualities of light, mood and atmosphere. To take a simple example, man-made environments and objects frequently incorporate hard edges, well-defined contours and sharply angled shadows, whereas natural subjects may have more complex and amorphous forms, or curved and fluid shapes, and subtle modulations of light and shadow. The ways in which you define the edges and contours of your color areas can help to give your rendering detail and precision.

Soft edge qualities are achieved by using opentextured side strokes, by letting massed linear strokes create a fuzzy or irregular contour, or by gently rubbing the edge of a color area with your fingers or a torchon to fade it away indistinctly (see BLENDING). Hard edges are obtained by highly controlled SHADING of dense color, by giving a definite outline to a shape – which could be in a slightly lighter or darker tone than the main color area, or by using MASKING techniques to isolate the desired shape.

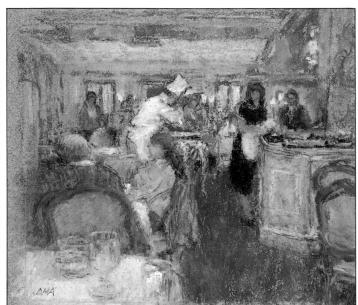

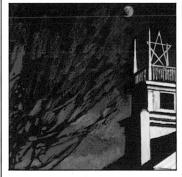

Norman Rockwell's Church"
The oil pastel has been applied in controlled areas of shading on a dark ground. The edge qualities in the building are crisp and hard, with the direction of the pastel strokes following the outlines of the forms. The organic quality of the tree branches is shown in ragged edges emerging from the looser treatment of the sky colors that form their background.

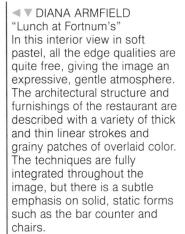

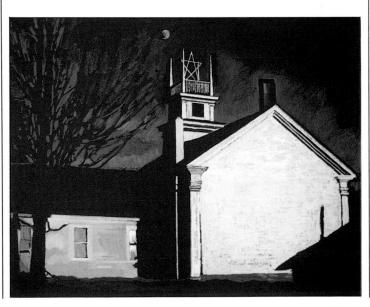

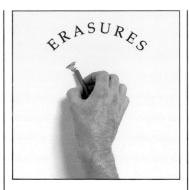

It becomes progressively more difficult to erase pastel as you build up the color layers. Any method that you use for erasure interferes with the natural texture of the pastel strokes and can also spoil the paper surface. In other words, do not count on making major changes in this way beyond the early stages of a pastel rendering. As long as the pastel has not completely filled the paper grain, you should in later stages still be able to make corrections by overworking the part you want to change.

While the pastel is still thinly applied and fairly loose on the surface, you can use a hog-hair or synthetic bristle brush to flick away the powdery color. The best type of commercially made eraser for pastels is a kneaded eraser - it has a slightly sticky consistency that picks up the loose pastel without the need to rub the surface heavily, which can smear the color or flatten the paper grain. A plastic eraser is useful for cleaning off the color dust that accumulates around individual shapes and at the edges of a composition; carefully manipulated, it can also be used to erase thinly applied

color and retrieve highlight areas. Heavy pigment particles can be scraped away with a single-edge razor blade or lightweight, sharp knife blade, and you can then follow up with a kneaded eraser.

Many pastellists recommend fresh white bread as the only medium for erasing soft pastel. A small piece gently rolled between the fingers can be used to lift out color delicately and precisely. It is similar in principle to a kneaded eraser, but has a lighter and cleaner touch.

These techniques work with dry pastel crayons, but the greasy texture of oil pastel is very difficult to erase, and you cannot make erasures to oil or water-soluble pastels that have been treated with a solvent. If you have made errors with these media that cannot be overworked, there is probably no solution but to start again.

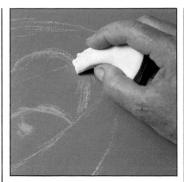

▲ Using a kneaded eraser
Shape the eraser to give a firm edge or point, depending on the quality of the mark you wish to erase and the area it covers.
Use gentle dabbing motions to lift the loose color. A faint trace of the marks may be left on the paper.

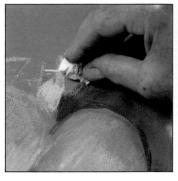

▲ Erasing with bread

Tear off a small piece of bread and shape it into a firm wad.

Press it lightly on the pastel surface to pick up loose color.

Once the surplus color has been removed, you can use a fresh piece of bread to rub the surface gently, further erasing the marks.

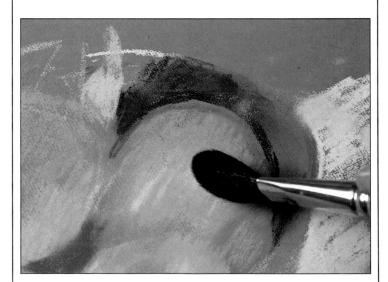

Where you have blocked in color too heavily, or you wish to open up the surface for overworking, use a brush with soft but firm bristles to flick away the pigment particles.

The term "feathering" accurately represents the technique — quick, light, linear strokes made with the tip of the pastel, keeping the direction of the strokes consistent. Feathering is a way of overlaying one color on another to modify the original hue or tone, or of integrating a

variety of hues to form a coherent but active surface effect of blended and mixed colors.

Because feathering is formed from a mass of individual strokes, it is a good way of adding richness to a color area that seems dull or flat, particularly where you have already applied solid or blended color that has filled the paper tooth and you need to revive the liveliness of your drawing's texture. As a modifier, feathering provides the opportunity to produce subtle changes of color character — to lighten or darken a medium shade that lacks contrast with surrounding colors, for instance; to "cool" a warm color, or vice versa; to enliven

hues that have deadened by introducing light touches of a contrasting color.

This is a particularly useful technique for developing mixed colors with hard pastels and pastel pencils, which do not blend as easily as soft pastels. Also, because you must use a light touch, you can achieve successful feathering with oil pastels without ending up with a smeary, unworkable surface.

▼ GEOFF MARSTERS
"IHI at Aldeburgh"
Feathering is used very
effectively here to enhance the
atmospheric qualities of the
image and create subtly vibrant
color mixes.

▲ This area of blended hues is built up on the white ground of the paper by overlaying light, quick strokes of pink, purple and pale blue.

▲ The same colors are used here on a flat ground of yellow pastel. Each successive color application modifies the effect of individual hues.

▲ Very fine, elongated strokes are used here to produce a shimmering effect of color and texture composed of light-toned hues.

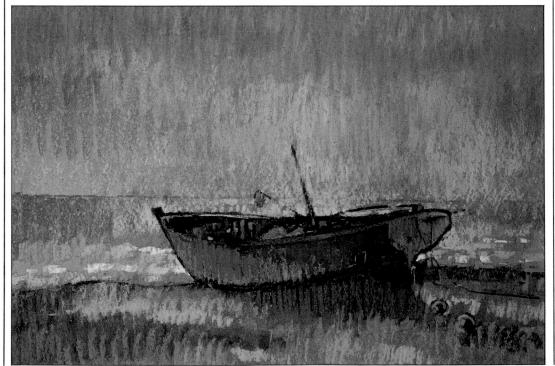

The question of whether or not to use fixatives, and when, creates controversy among pastellists. The brilliance and fragility of the pigment particles clinging to the working surface are regarded by some artists as essential characteristics of pastel work. Fixatives may be considered to degrade both the color and texture of soft pastels. However, careful fixing need not spoil the surface qualities, and you may feel that any disadvantages are offset by the protection that fixative gives to your work, both during its stages of development and when it is finished.

The key to successful fixing is to use the fixative sparingly. Overwetting the surface can cause the pigment particles to merge, muddying the texture; it can encourage strong colors to "bleed" through overlying tints; and it does tend to darken colors slightly. But if you apply a light layer of fixative at successive stages of the drawing, it enables you to overwork colors freely and keep the hues, tones and individual marks distinct and clean. Fixing again when the work is finished prevents accidental smudging, powdering or flaking.

If you are working on a light or medium-weight support, you can spray the fixative on the back of the paper. It will penetrate enough to dampen the pastel gently and make it more secure. If you definitely prefer to do without fixative. try "fixing" the surface of a finished work by laying a sheet of tissue over it and applying even pressure to push the pastel particles a little more firmly into the paper grain.

Aerosol cans of fixative are convenient and are usually now environment-friendly. Some artists still prefer using a mouth diffuser spray to apply fixative from a bottle, but you get a more reliably even spray from an aerosol.

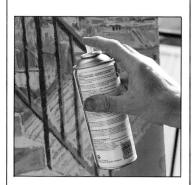

Spraying fixative

Make a quick test spray first to check the nozzle is clear and the spray quality even. Hold the can about 12in (30cm) from the paper and spray from side to side, covering the whole area. Avoid overspraying, as this wets the surface and may cause colors to run or mix.

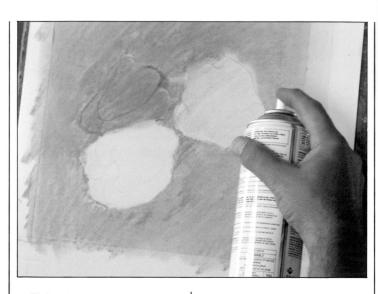

Fixing in stages

Some artists like to use a light fixative spray at intervals throughout the work, even in

the early stages, to seal the surface before application of further color layers.

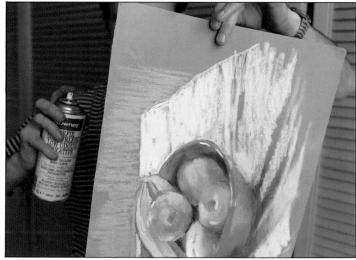

Spraying from the back Use this method only on light and medium-weight papers. Apply the spray evenly and sparingly as described above, covering the whole of the back of the paper.

This technique is a means of reproducing the effect of a specific texture by placing your paper over a textured surface and rubbing the pastel stick over the paper. The different features of the underlying texture show up as variations in the pastel color. According to whether the

surface is raised or recessed at a given point, the pressure of the pastel stick varies, and you automatically obtain corresponding changes of shade from dark to light.

Frottage ranges from subtle, evenly patterned impressions taken from a close-textured material such as burlap or fine screen mesh, to the irregular graphic effects thrown up by a coarse wood grain. You can take a lightly grainy texture from heavy sandpaper, or reproduce the man-made pattern of a sheet of molded plastic or glass. The character of your rubbing will also depend upon the type of pastel you use. Soft pastels and oil pastels will tend to form a cohesive surface effect, while with hard pastels and

pastel pencils, it may be difficult to eliminate the marks of the strokes you make on the paper, adding a faint linear bias to the texture picked up from the underlying material. The effects of overlaying pastel colors, using the same or different textures, is interesting to experiment with as a way of obtaining areas of BROKEN COLOR.

▶ The effects of frottage are unique to each surface, and sometimes unpredictable. The examples here were achieved by rubbing over (from top to bottom) architectural stonework, wood grain, rough textured concrete, and a slatted wood door.

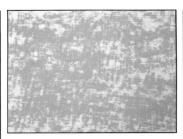

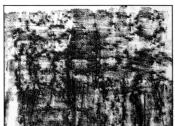

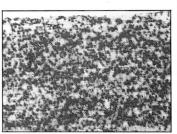

BROKEN COLOR effects and complex textures can be built up with successive layers of frottaging. This works particularly well with regular textures like a mesh weave or evenly embossed surface. The interwoven effect of this sample is achieved by moving the paper slightly between colors so that each application mixes with the one before.

The essence of this technique is using rapid and uninhibited movements of the pastel to capture the immediate impression of a subject. It relates particularly well to subjects that have movement -- individuals or groups of people, animals, a windswept landscape or pounding sea. It is important to develop a free connection between what you observe and the way you translate it to paper, letting the motion of your hand and arm echo the rhythms of shape, contour and direction. The spontaneity of the approach is lost if you become concerned with individual details.

Gestural drawing is especially successful with soft pastels or oil pastels, because they glide easily across the paper and provide a broad range of surface effects. Exploit your repertoire of LINEAR MARKS and use loose SIDE STROKES to convey massed color or shading. If you work with hard pastels or pastel pencils, the character of the medium suggests a more sketchy, linear style, using scribbled textures and roughly worked hatching or crosshatching (see HATCHING AND CROSSHATCHING) to represent volume and contour.

JUDY MARTIN "Over the Jump" An open, linear style has been used to draw the horse and rider, beginning with free outlines that are gradually reworked to refine the shapes. The color of the paper gives a coherent background to the rapidly laid marks. Broader sweeps of color are added with side strokes and loose hatching (see HATCHING AND CROSSHATCHING) to give the image a sense of depth and solid form.

▼ JUDY MARTIN "Golfer"

Here the figure is built up quite heavily as a network of overlaid marks, with the tip of the pastel used both to shade in color blocks and describe linear contours that contribute to the sense of movement. The suggestion of a background of blue sky is also worked with scribbled marks rather than laid as an area of flat color, complementing the dynamic impression of the pose.

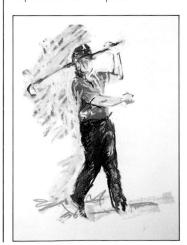

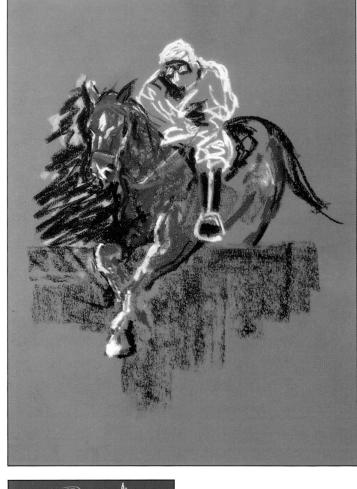

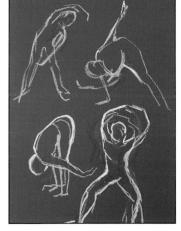

■ JUDY MARTIN

"Movement Studies"

Sequential movement can be studied in simple outline drawings, letting your hand follow freely the rhythms of the form. Each of these sketches was done in a matter of seconds, as a means of studying the motion rather than aiming for a definite image.

▲ GEORGE CAYFORD "T'ai Chi Exercise" Fluid contour lines capture the essence of the pose and also describe the roundness of the limbs and body, where the artist's hand lets the pastel tip flow easily around the forms. The movement sequence is described here using successive colors as elements of the pose slowly change.

▼ KAY GALLWEY "Ballet Dancer" Active treatment of every area of this image enhances the impression of space and form. Directional marks are used to indicate the structure and detail of the background location, to

describe the textures of the dancer's dress and hair, and to suggest her movements. Visual contrasts are created between some strokes that are fragile or harshly linear and others that are broad and richly grained.

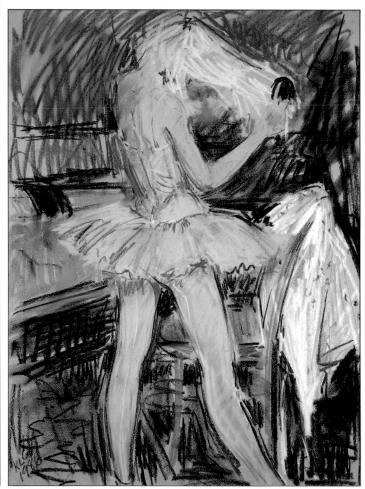

Gouache and soft pastel are ideal partners for mixed-media work, providing similar color

character and complementary textures. Both are opaque media in which the pure hues and tints are particularly brilliant — gouache lightens slightly as it dries, and its paler colors are highly reflective.

In combining these media, let the gouache do the painting and take advantage of pastel's qualities as a drawing medium to provide additional detail and textural contrast. Exploit LINEAR STROKES and massing techniques — for example crosshatching (see

1 The composition is lightly sketched in with a pale yellow soft pastel. Initially, washes of gouache color are laid into the background area, blocking in the main forms of the building.

This is an excellent combination of media for outdoor subjects — landscape and townscape. You can block in the general color areas with gouache and work over them with pastel to develop the textures and patterns of, for instance, grass, flowers and foliage, or building materials and architectural details. Another good use of pastel in

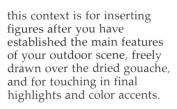

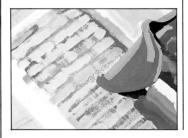

3 The ribbed pattern of the stonework on the left-hand wall is drawn over the dried gouache layer using brown and orange soft pastels. Thicker bands of gouache are overpainted on the same area.

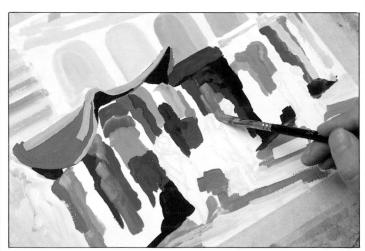

2 Basic shapes and colors in the market stands and road are similarly blocked in. In these early stages, the main purpose is to eliminate most of the white paper and create a colorful surface for working over in more detail.

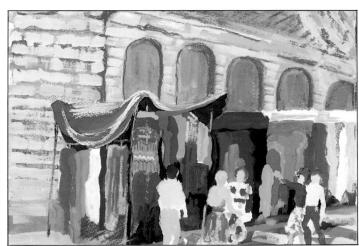

4 The combination of media is freely worked to develop texture and color overall. With the figures blocked in, all the white paper is now covered, and pastels are used to draw in finer detail on the figures and stands.

5 Pastel work on and around the figures is quite free and sketchy, but designed to model the forms more solidly and give an impression of greater detail. The grain of the paper is still visible, although the pastel is applied over opaque gouache.

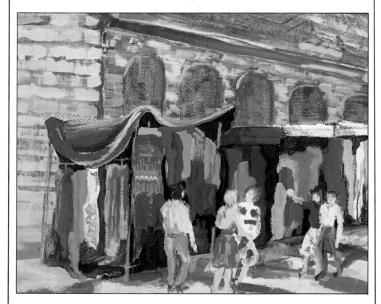

6 Pastel is used to enhance the lights and shadows on the road. In the background, the proportions of the wall of arches are adjusted using solid

gouache applications and broken dry-brushed textures, together with some pastel shading.

still damp. This has the effect of binding the pastel particles, giving the marks a heavy IMPASTO character. Pencil was also worked into the surface to create a finer contrast of linear detail (see PENCIL AND PASTEL).

This term refers to gradual transitions from one color or shade to another. This is a vital element in modeling form and volume, particularly of curved or rounded forms, and in recreating certain effects of space, distance and atmosphere. Gradations of shade and color may be very subtle and small-scale in figure work, portraiture and still life; while in landscape, color transitions over large expanses of land, sky or water may be the key to capturing the sense of openness and the climatic mood.

Methods of conveying gradation vary from smooth effects of BLENDING and SHADING to controlled textural variations formed by HATCHING AND CROSSHATCHING OF STIPPLING. The simplest tonal gradation consists of laying a patch of fairly solid pastel color and fading it gently outward with your fingers or a torchon. The same technique can be applied to merging two colors, fading them slightly where they overlap.

To create a smooth gradation when you are employing the basically linear character of a pastel stroke (as with shading and hatching) you need to consider whether

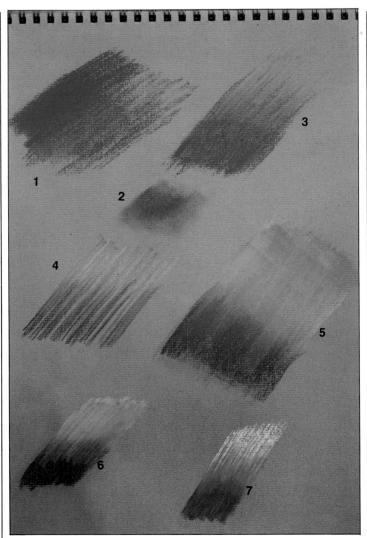

you should overlay or alternate the colors at the point of transition, or introduce a third color that links them together (yellow over red, for instance, or yellow-orange-red). You must avoid breaking the transition with a too-abrupt change, or overworking the transitional area excessively so that its texture stands out.

- 1 To obtain a tonal gradation of one color only, you can shade the pastel in close, even strokes, gradually lessening the pressure to lighten the tone.
- 2 An alternative way of producing graded tone is to use a torchon to spread the color so that it fades outward from the original marks.
- **3** Gradation from one color to another can also be achieved by shading, overlapping each color on the previous one to integrate the hues.
- 4 This example of red grading into yellow is worked with hatched lines in the two main colors, which merge into orange where they meet and overlap.
- **5** The same principle of color mixing is applied to yellow and red side strokes, blended with a torchon (see BLENDING) to produce the gradation through orange.
- **6** In this example, the red and yellow color bands are linked by a separate application of orange pastel in the center.
- 7 The moist texture of oil pastel creates a fusion of the graded colors. In this shaded gradation, the pink is an applied color, not a mixture of the white and red.

As the classic method of creating tonal values using a linear medium, hatching is particularly associated with monochrome drawing techniques, but it can also be usefully applied to color work. It provides a means of varying effects of tone, color and texture, and can enhance depth and form in a composition.

Hatching consists of a series of roughly parallel lines, drawn fairly close together. From a distance, the lines merge to give an impression of continuous tone or color; from a closer view, the individual marks can be deciphered. The linear texture contributes a lively surface quality that can be a good alternative to, or contrast with, flat or blended color.

Hatched lines need not be straight, nor uniform in thickness and density. They can be thick or thin, curved, tapered or broken, crisp or ragged (see also LINEAR MARKS). You can use consistent strokes that follow the form they are describing, or vary the directions of strokes in adjacent areas of a drawing to suggest differently angled planes and contours in an object or spatial arrangement.

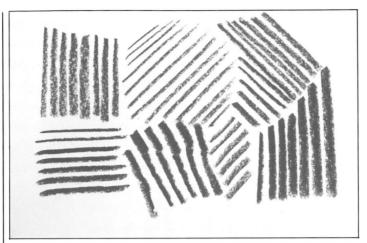

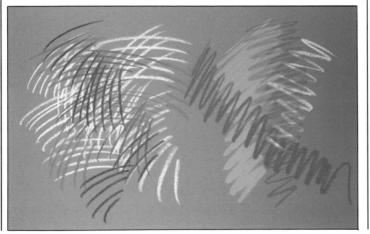

■ Variations of tone and texture can be obtained by varying the quality of the line between thick and thin, and the widths of the spaces between lines.

■ Color variations, either mixed hues or gradations of color, are developed by integrating two or more sets of lines made with different pastel sticks.

■ Hatched lines need not be straight or one-directional.

Overlaid curves (left) build up a loose, informal kind of crosshatching. Scribbled marks are also effective when applied to a free style of imagery.

Crosshatching

In crosshatching you overlay one set of hatched lines on another, angled to produce a woven, mesh-like texture. As with hatching, the effects vary according to the line qualities and spaces between the lines, but because the texture is more complex, you can have a greater range of variation — different angles between two or more sets of lines; different colors for each succeeding layer.

When layering colors, use light but clean and decisive strokes to avoid devaluing hues and shading. Sometimes a little color from an underlying layer is dragged into a fresh stroke, and this can have an enlivening effect that also helps to mesh the colors. Both hatching and crosshatching are useful techniques for keeping an active, open surface when you are working over previously laid pastel color or on a COLORED GROUND.

▼ Crosshatched texture consists of two sets of lines roughly at right angles to each other, which may be in the same or different colors.

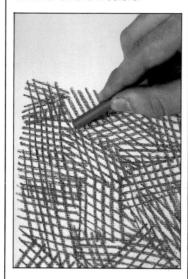

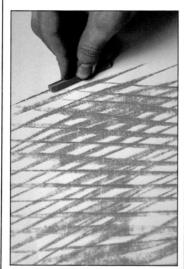

Vusing the long edge of a square pastel stick produces a variable linear texture ranging from thin, sharp lines to broader, grainy marks.

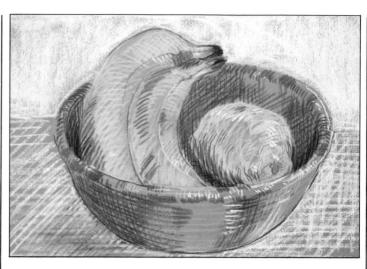

▲ Traditionally, hatched lines follow the contours of the object. In this simple still life, the lines describe the curved shapes of fruit and bowl, with straight lines emphasizing the flat plane of the tabletop. A limited group of colors is interwoven to create shaded variations giving depth and form.

▼ This detail shows how the extent and directions of the hatched lines are varied to indicate the different shapes of objects and the pattern of highlights and shadows.

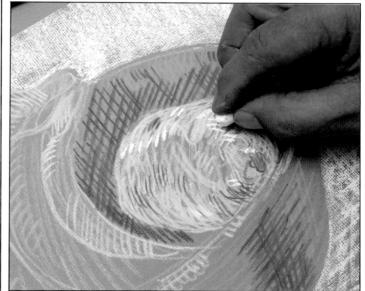

Highlights represent the points of light most intensely reflected from the surface of an object, and they add sparkle and a high finish to a pastel rendering. Highlighting is usually done in the final stages, as this enables you to judge the highest tones against the other colors and prevents dirtying the whites with subsequent color applications. Highlights can either be added with quick, decisive touches of the pastel stick, or you can use an eraser to reclaim the white of the paper. The latter method will only be successful if the quality of the pastel marks is such that you can lift the colour cleanly - you will not get an effective highlight if the pigment is firmly impressed into the paper grain.

Applied highlights are usually more effective, and you will quickly acquire the dexterity to overlay a crisp, white mark without smearing or picking up the underlying colour. If the color layers are thickly built up, you can scrape out gently with a razor or scalpel blade and apply a light spray of fixative before adding the lights.

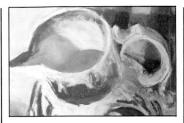

1 Smooth-textured materials such as ceramics, glass and metal throw off the most intense highlights. In this ceramic pitcher, lit from the left-hand side, the lip, rim and handle need to be strongly highlighted.

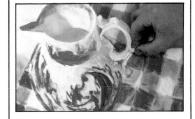

2 Additional highlighting follows the modeling of the form; pure white pastel is thickly applied to enhance the lit effect on the outer curve of the pitcher's handle.

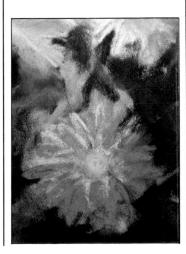

3 Soft-textured forms such as flower petals do not reflect light so strongly, but need gentle highlighting to emphasize the petal shapes. Notice that the artist has used lighter strokes for this effect to maintain textural contrast.

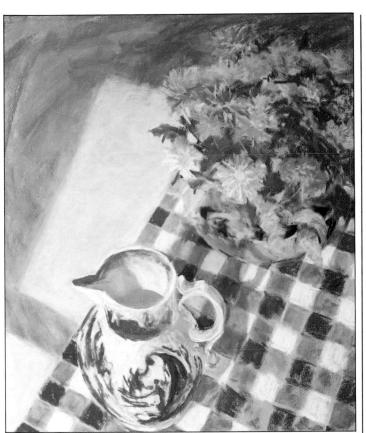

4 In the finished image, the overall pattern of light and shade is clearly described, and the highlighting gives extra definition to the individual forms of the pitcher and flowers.

In painting, this term refers to thick strokes of color, applied with a brush or knife, that stand out from the surface of the canvas or board. Applied to pastel, it means using heavy, thick strokes of a soft pastel or oil pastel that deposit the full strength of its color and texture on the working surface.

You can lay impasto strokes directly on the surface or build them up over thinner, grainy color. The facility for overworking is ultimately limited, because with this technique the tooth of the paper fills more quickly, and the surface soon becomes resistant to further applications.

Edgar Degas (1834-1917) achieved wonderfully rich, thick textural effects, often by unorthodox means. He would sometimes work dry color into a wet vehicle, experimenting with oils, varnishes and fixatives, so that the pastel color became a kind of workable paste — a true impasto medium.

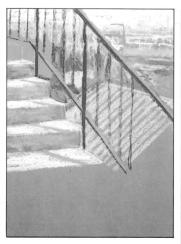

Soft pastel

1 The townscape view is blocked in quickly using heavy, free strokes to establish overall color values. In the areas where colors have been overlaid, you can see already the rich texture of the thickly worked strokes.

2 The increasing density of the pastel layers is evident with the gradual disappearance of the paper color, now virtually eliminated from the image except where faint traces have been left to stand as medium shades and light shadowing; for instance, on the risers of the steps and the façade of the building on the right.

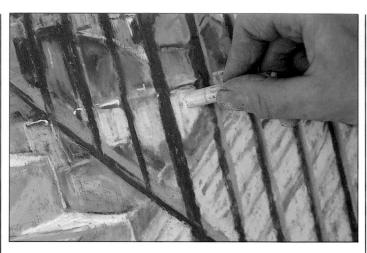

3 Thick impasto strokes in pale shades produce very intense HIGHLIGHTING. Surface texture becomes very rich, with BROKEN COLOR where strokes are overlaid and ragged, grainy edge qualities.

4 The finished image is similar to a brush painting in oil or gouache, with a cohesive, opaque surface. But working this way with pastels, you have very direct control of the individual marks and color mixes.

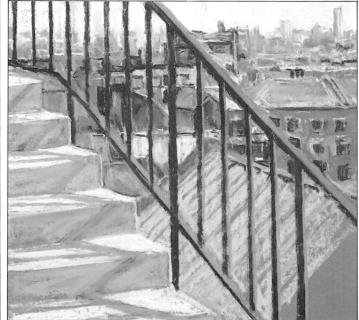

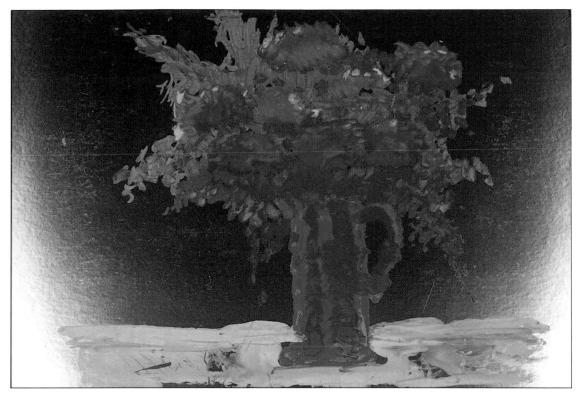

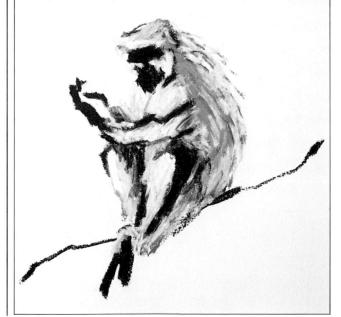

Wet color

▶ This impasto sketch was completed very quickly, working soft pastel into wet fixative so that the color remained pliable. The monkey was first loosely drawn in black and white using the dry pastel sticks, then fixative was sprayed on liberally and the image was rapidly reworked in black, white, gray and burnt sienna.

▲ JOHN ELLIOT "Red. White and Blue" This is an unusual technique for oil pastel work, producing a unique kind of "painted" effect. The support is laid over an electric hotplate, turned on at a low setting. The heat softens the oil pastel as it is applied and gives the individual strokes a fluid, paint-like texture. This technique can be used with most types of paper or board; this example was painted on a nonabsorbent, metallicsurfaced board, which makes the color spread very freely.

Any stroke that you apply using the tip or short edge of a pastel is basically linear in character, simply because the pastel's area of contact with the paper is confined. This does not mean your technique is limited, as you can use line work to build blends of shades and colors by systematic HATCHING AND CROSSHATCHING, Or by loose shading and scribbling. But there is also a wide variety of line qualities that you can exploit, in both structuring a drawing and

developing the overall color values. It is worth trying pastels of different shapes, sizes and textures to discover their full variety.

Pastel is often thought of as an imprecise medium best suited to loose, impressionistic effects, but square-sectioned soft or hard pastels, and particularly pastel pencils, enable you to produce quite precise, sharp lines. A free stroke with a soft pastel produces a lightweight but thick, soft line; heavier pressure both spreads the line and gives it more density. By pressure variation and by turning the pastel between your fingers, you can also produce fine lines that swell into grainy trails, or broad strokes tapering off narrowly. This variety can be exploited in describing space, distance, volume and contour. It also contributes textural variety to hatched and crosshatched color areas.

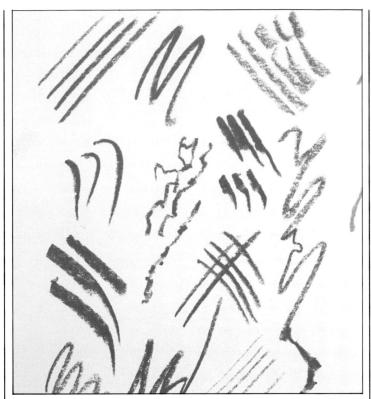

Soft pastel

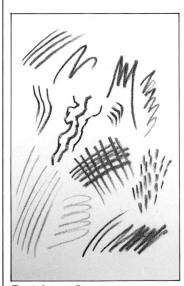

Pastel pencil

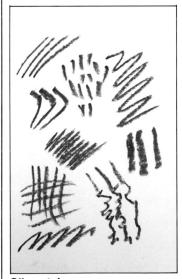

Oil pastel

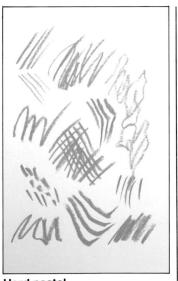

Hard pastel

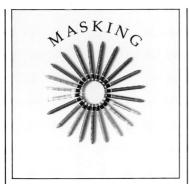

A mask is simply something that protects the surface of the paper in an area that you are not working on, but masks can be used in a positive way to give a clean edge to colored shapes or to a whole image. There are several types of masking material, but because of the fragility of pastel work, materials designed to adhere to the surface, such as masking film, tape or masking fluid, are not suitable.

Simple paper masks can be used to outline shapes that you are completely filling with color by techniques such as SHADING, SIDE STROKES OF DRY WASH. Just cut the shape out of tracing paper, layout paper or thin cartridge and hold it down on the working surface while you apply the color. Similarly, you can make a paper frame for the whole image area if you want to keep the borders clean. To create a hard edge when coloring, for instance, the corner of a building, simply hold the edge of a paper sheet down the line representing the junction of two planes and work up to it with the pastel strokes.

■ This abstract pattern shows the range of different textural effects you can obtain by working into and around masked shapes, varying the density of the pastel strokes and overlapping colors one on another.

▼ Simple shapes cut out of pieces of paper form stencil-type masks that can be "filled in" with different qualities of pastel color, creating relatively hard-edged shapes.

1 When applying color within a masked shape, keep the direction of the pastel strokes consistent and work over the edges of the mask to ensure that the whole area is colored.

2 The cutout from inside the stencil can be used as a mask to form a negative of the original shape.

3 To keep the shading around the masked shape consistent, hold the mask down firmly while angling your fingers to gain access to the complete outline.

Oil pastel can be combined with oil paint to contribute additional linear qualities subtly different from those that can be achieved by brush drawing. Marks drawn directly onto canvas with oil pastel have a grainy quality that can be retained when lightly overlaid with oil paint thinned to a semitransparent glaze. Alternatively, you can work into a thin layer of oil paint with the pastel tip to develop linear textures and shading the passage of the pastel stick actually grooves the surface of the paint and also leaves color traces.

When you are working into wet paint, the medium or diluting agent used to thin the paint may soften the pastel texture. If you want to achieve harder line qualities, allow the paint layer to begin drying before you add pastel work.

If you work on paper or cardboard very lightly primed with acrylic gesso (or even unprimed), the oil paint will dry quite quickly. Because the paper absorbs some of the oil, it will also have a matte surface, which blends well with the pastel.

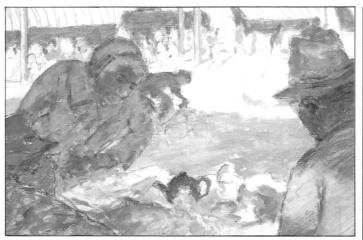

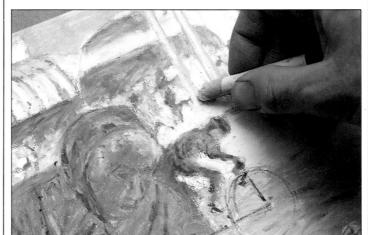

Painting with oil pastel

1 In this example, oil paint is used to block in the basic color areas; then all the detail is developed with overlaid oil pastel. This picture shows the initial application of paint.

2 Oil pastels are used to work into the color areas, modeling individual forms and developing the surface patterns and textures in the figures and background. The pastels are manipulated in different ways to create areas of broken color, as in the woman's hair and scarf, and linear detail such as the awnings and masts of the market stands.

3 The pastel is rubbed into the wet paint and areas reworked to intensify the contrasts of light and shade and draw in the detail in the foreground.

Compare this with the first stage to appreciate how the pastel colors are variously used to emphasize the forms and rhythms of the composition.

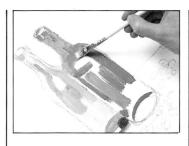

Drawing into oil paint

1 The basic shapes in the still life are drawn with oil pastel on a primed surface. The main color values are rapidly blocked in with oil paint applied quite thickly.

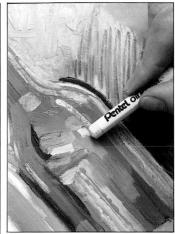

3 Black and gray pastels are used to hatch in the shadow area behind the right-hand bottle. Details of the reflected colors and highlights on the glass are drawn into the wet paint with yellow, green and yellow ocher oil pastels.

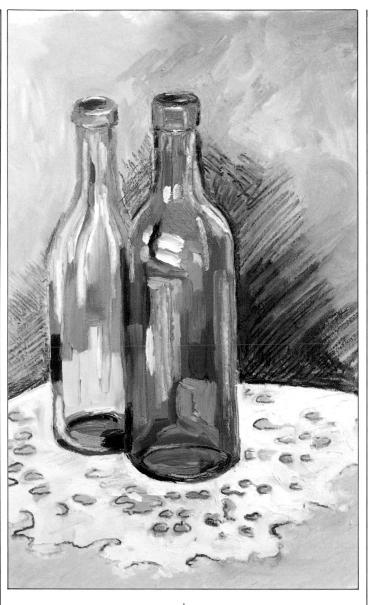

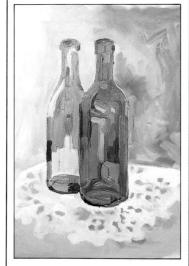

2 The whole image area is covered in the same way, using the paint only at this stage to create a solid rendering of the two bottles and a general impression of the vertical and horizontal planes.

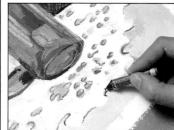

4 In the same way, linear details of the pattern on the lace doily are drawn with black and yellow ocher pastels. The pastel tips are sharpened by shaving them with a craft knife to produce a fine line.

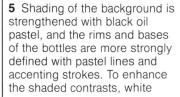

highlights and intense black shadows on the bottle glass are brushed in with bold dabs of solid, opaque paint.

The buildup of layer upon layer of colors is the great fascination of pastel work, from broad drifts of loose color laying out the basic shapes to the small accents and highlights that add the finishing touches.

The textures of the medium and support allow glints of color to show through in successive applications. When you overlay open-textured SIDE STROKES Or soft SCUMBLING, Or apply linear or broken color effects such as CROSSHATCHING, FEATHERING and STIPPLING over flat color, you can obtain subtle or brilliant color mixes and modifications that on close inspection show their interwoven marks as individual hues. Even a thick IMPASTO stroke dragged across an area of previously laid color may have ragged edges that reveal fragments of the underlying hue.

These effects are best seen in soft pastel rendering, where the wide color choice and textural versatility of the medium can be given free rein. So that the layering processes retain the richness of the contributing colors, it is advisable to apply a light spray of fixative at various stages of the work.

■ ROY SPARKES
"Frindsbury Garden,
Elizabeth H."
The slight translucency of oil
pastel is exploited here,
forming interesting textural
contrasts between areas of thin,
almost flat color and the layered
effect of successive
applications, using short
stabbing strokes and circular
motions to overlay and
interweave the varied hues.

▼ JOHN ELLIOT
"Monument Mountain"
Grainy side strokes of various colors freely overlaid describe the form and space of this atmospheric landscape. Fine linear strokes are added to emphasize shape and contour.

However dextrous you become in manipulating pastels as drawing tools, it is difficult to sustain a hard, sharp line in this medium. Some subjects suggest a style of rendering in which linear qualities should be combined with a softer technique - seaspray washing over jagged rocks, for instance, or a bird of prey with a sharp beak and glittering eyes mounted on a mass of rumpled feathers. In such cases, pencils can be a useful complement to pastel colors.

Choose relatively soft

1 The basic form of the animal is blocked in with soft pastel, using LINEAR MARKS and broad color areas rubbed in with the fingers.

pencils, those graded from B to 6B. In relation to pastels, of course, even these are fine, hard drawing points, yet they produce a subtle variability of line and appreciably grainy texture that complement pastel qualities. If you are using the pencil only for line work, you can work it into and over pastel color, and vice versa. If you build up dense pencil shading or hatching, the slightly greasy texture of the graphite will resist an overlay of dry pastel particles.

Use the pencil decisively, but delicately. If you allow the point to groove the paper and try to erase any lines, the impressions will show up through pastel worked on top the same area. Otherwise, you can combine the media very freely. You could explore the combination of line and color further by trying other point media, such as colored pencils, marker pens, even pen and ink.

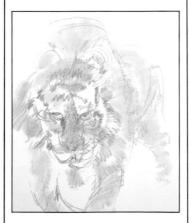

2 A furry texture is built up around the tiger's face with lightweight, feathered strokes of a 2B pencil.

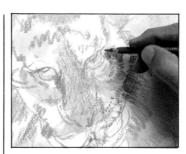

- **3** Pencil line is also used to sharpen the detail around the eyes and nose, working freely over the pastel color.
- **4** As the drawing develops, loose hatching and SHADING with the pencil builds up the stronger blacks of the tiger's stripes. Variations in the density of the pencil marks create texture and tonal variation.

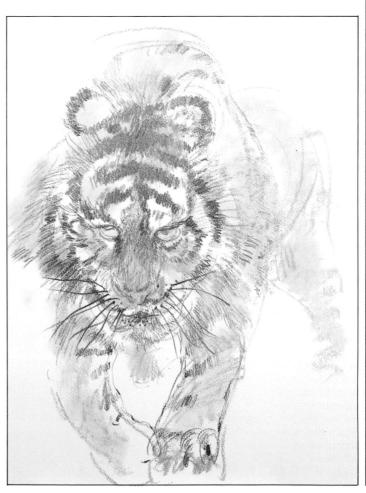

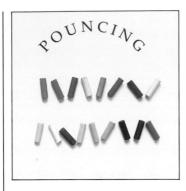

This technique for transferring a drawing from one surface to another is useful if you are going to create a finished rendering based on a sketch or working drawing. It is more suitable for pastel work than the conventional method of tracing down an image, since tracing often involves pressing quite hard with a pencil or ballpoint pen to transfer the image effectively. This creates a definite outline which may be hard to cover with the pastel, and possibly indents the surface of the paper as well, but with pouncing you use a powder medium to

obtain a faint, dotted guideline. This does not affect the quality of the working surface and is easily obliterated as you build up the pastel work.

In the first stage of pouncing, you prick holes at appropriately spaced intervals along all the lines in your original drawing. This does, of course, damage the drawing, so if it is one you want to keep, you may prefer to take a tracing of it for this purpose, rather than using the original sheet. For piercing, you can use a stylus or a darning needle — anything that makes distinct but not over-large holes.

You then lay the pricked drawing over the working surface and force a powder medium through the holes to leave faint marks on the surface below. You can use powdered pastel, chalk or graphite — wrap it in a piece of cheesecloth and twist the ends to form a little bag, which you dab over the drawing.

1 Lay a sheet of strong tracing paper over the original drawing, and trace the main outlines of the subject.

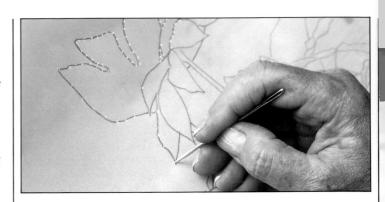

2 Use a large darning needle to prick holes through the tracing paper at regular

intervals along the outlines of the drawing.

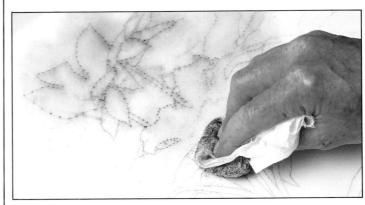

- **3** Scrape the edge of a soft pastel stick with a knife blade to produce a quantity of powdered color. Wrap the powder in a twist of cheesecloth. Lay the tracing over a clean sheet of paper and dab the bag of powder along the outlines, forcing color through the pricked holes.
- 4 The pounced image forms a soft, dotted guideline for overworking with pastel color. Blow away loose pastel dust from the pouncing before applying fresh color.

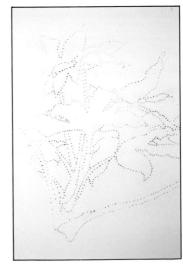

When sketching the guidelines for a pastel composition, ideally you need to keep the drawing to a minimum and avoid ERASURES that may spoil the paper surface. A useful method for making an accurate preliminary drawing when working from a previously made drawing or a photograph is to project the image directly onto the paper and trace it lightly in pastel. This also enables you to enlarge or reduce the image to suit a required scale.

If your original is a drawing, photographic print or reproduction, have it photographed on transparency film and mounted as a slide, then use a slide projector to throw the image onto paper pinned to the wall or a drawing board. Adjust the size by moving the projector closer to or further away from the paper surface.

If you are taking photographs yourself as reference, of animals or landscape subjects, for instance, you can alternatively take them as slides for projection, and have prints made from them to which you can refer as you develop the composition.

1 If you are working from a previously drawn or painted image, copy it onto slide film. Alternatively, use a slide of a live subject for projection.

2 Put the slide into the projector, and train the image onto the wall or a drawing board. Adjust the distance and focus to obtain a clear image of the correct size.

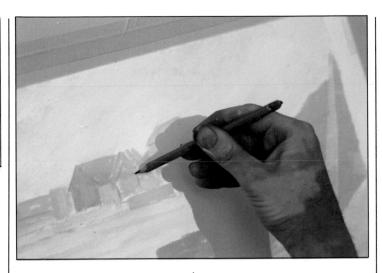

3 Tape your sheet of paper to the wall or board. Use a pencil, pastel or charcoal to trace around the main elements of the image.

4 Draw only as much detail as you need to provide a useful basis for your pastel rendering. A simple line sketch is usually adequate.

Resist methods are based on the incompatibility of oil- and water-based mediums. If you lay down lines or patches of color using an oil pastel and brush over it with a thin wash of ink, watercolor or acrylic paint, the greasy texture of the pastel repels the fluid color — the paint settles into the paper around the oil pastel marks, leaving their color and texture clearly visible. With repeated applications of both media, allowing the washes to dry in

between, you can build up a dense, complex image.

A lightweight pastel stroke leaves parts of the paper grain unfilled, so the paint will settle into irregularities within the pastel color, as well as around the edges. To get very distinctive, strong-colored marks, you need to apply the pastel quite heavily. If you want to layer the image, the best media for this technique are inks and liquid watercolors (those sold in bottles).

Some hard pastels have a wax content that makes them of limited use for resist technique. You need to experiment with the variety and density of hard pastel marks, as sometimes they do repel the wet color, but also intermittently they absorb it. Soft pastels are ineffective as resist media; the color will spread into an overlaid wash (see WET BRUSHING).

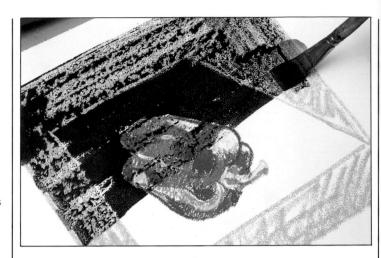

2 Apply a free wash of ink or liquid watercolor, using a large, soft brush to flood the color easily over the pastel drawing.

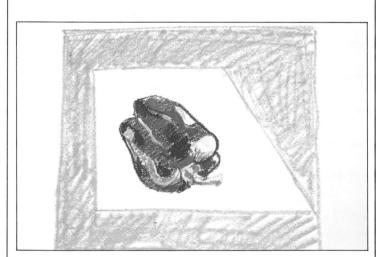

1 Draw the image in oil pastel, using heavy, boldly textured strokes. You can apply as many colors as you wish.

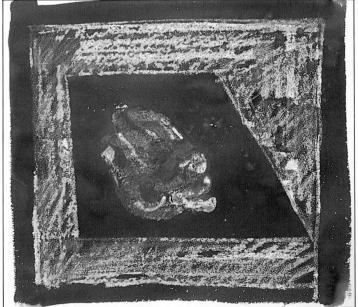

3 As you complete the wash, the liquid color will settle into the paper grain within and around the pastel marks. You

can use a single color for the overlay, or more than one.

Scratching out

▲ Some particularly dense drawing inks may flood the pastel marks rather than be repelled by them. If this occurs, you can use a knife blade to scratch back the ink when it is dry, retrieving the color of the underlying image.

Layering the image

This resist image was built up in several stages with liquid watercolor over oil pastel. The textured pattern of the leaves was first drawn with white, pink and gray pastels, then loose washes of brown and green watercolor were overlaid. When the paint dried, parts of the pastel drawing were reworked and further washes applied, adding blue and red to the color range. This process was repeated once again to build up the density of color and texture.

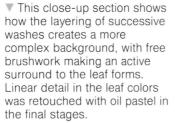

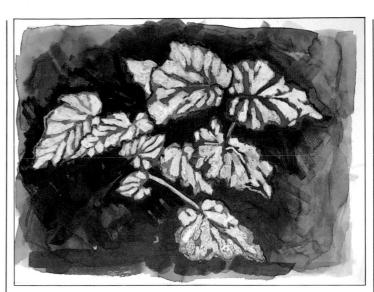

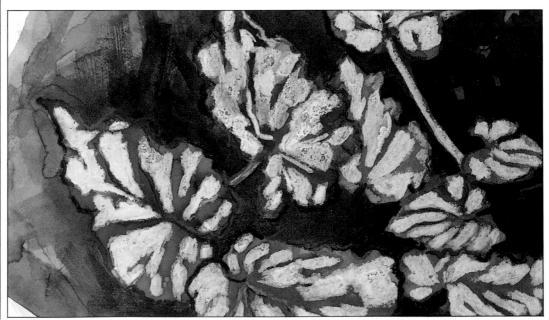

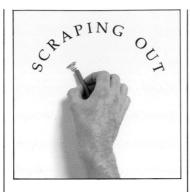

This is a technique that enables you to reestablish a workable surface when you have built up layers of soft pastel very thickly and find it difficult to apply further color. A heavy accumulation of pigment particles can be scraped back with the flat edge of a fine blade, such as a scalpel or craft-knife blade. You can then spray the area lightly with fixative and redraw when the fixative has dried.

Some artists use the technique very successfully as a positive drawing element. Scraping out pastel layers has the effect of fusing the colors in a rough, scratchy overall

texture; if a colored ground is used, its underlying shade also becomes meshed into the pastel color. The texture typically has a linear quality corresponding to the direction in which the blade travels over the surface, which gives an additional a sense of movement.

You have to manipulate the blade carefully, to avoid shaving the grain of the paper or digging into the surface. Because of the textural interaction of the medium and support in pastel work, it is very difficult to either disguise or accommodate actual surface damage.

Linear texture

▼ Scraping out can be used as a positive element of drawing technique for introducing very fine linear texture in a color composition. In this example, the tip of a blade has been used to draw into heavily applied color, creating the whiskery effect of the seedheads and enhancing the complexity of the varied directional lines in the massed grasses.

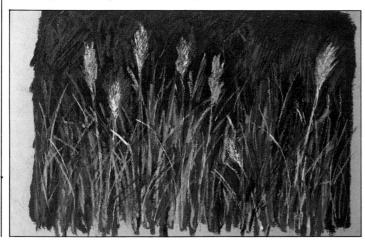

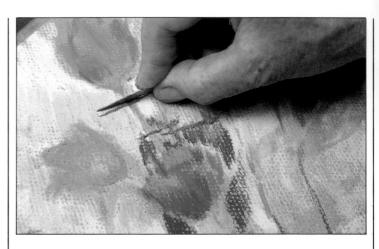

1 In an area of the composition that is to be reworked, the color is scraped back using the flat edge of a lightweight craft-knife blade. To avoid damaging the surface, follow the grain of the pastel marks.

2 In reapplying pastel color over the scraped section, the marks are built up with the same consistency and direction as in the surrounding areas.

You can use oil pastels to make a kind of scratchboard, or scraperboard. The effect this gives is very different from that of conventional scratchboard, and it is also quite unlike the marks and impressions you make by drawing directly with the pastel stick.

You begin by building up a layer of solid black on the

surface of a piece of smoothfinished artboard, using repeated thin applications of waterproof black India ink brushed on evenly. Once the ink layer is dry, you scribble hard with a white or lightcolored oil pastel, so that the surface is covered with a rich, thick, slightly textured layer of color. Oil pastel tends to adhere unevenly to the smooth surface, so you are bound to get some minor variations of shade and texture, but aim to cover the ink as solidly as you can.

With the pastel layer complete, you can begin to draw into the surface, using a pointed or hard-edged tool — a scriber, the tip of a large nail or a scalpel blade, for example, or for less sharp effects, the

3 Use any suitable tipped or pointed tool – a large masonry

5 To remove larger areas of the pastel coating, scrape it back with the edge of a craft-knife blade. Move it flatly across the surface to avoid digging into the board.

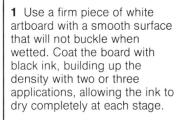

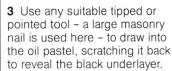

2 Remove the paper wrapping from a stick of white oil pastel, and rub the pastel firmly over the inked surface, gradually covering the board with a thick layer of white.

4 If you make an error at any stage, simply reapply the pastel to cover the scratched marks and restore the surface, then rework the drawing.

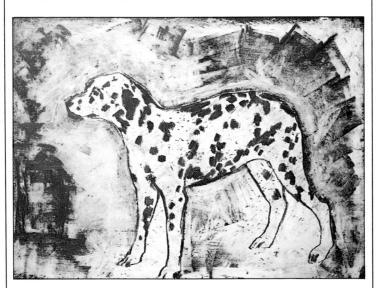

6 As the drawing becomes more detailed, you can adjust the balance of line and shade and develop the textural variation by reapplying pastel and reworking the scratched lines and shapes as desired.

wooden end of a paintbrush. As you scratch into the pastel layer, you reveal the ink, making linear marks that can be true black or grayed, depending on how cleanly you remove the pastel. If you get something wrong, correction is an easy matter — work over the surface again with the pastel and redraw with your scratching tool.

The technique corresponds to ordinary methods of drawing in monochrome, except that you are recovering the black marks from the white surface, rather than laying them on. It is similar to SGRAFFITO, but the important factor here is the resilience of the ink surface and the way its density and slight sheen contribute to the final effect of the image.

▼ This portrait drawing shows a different approach to working on oil pastel scratchboard, where the main part of the image is drawn only with fine lines, scratched with a carpenter's awl. For contrast, part of the background is scraped back with a knife blade. The technique allows variations of style similar to those you can achieve in pencil drawing.

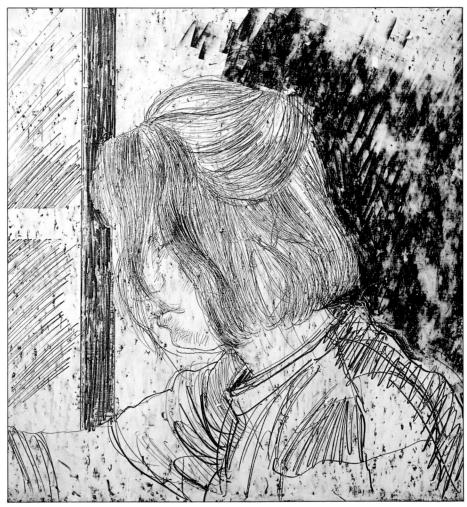

This is an adaptation of a traditional oil painting technique, in which a thin veil of color is applied to modify underlying layers. In painting, you use a light, scrubbing motion of the brush. The comparable effect with pastels is obtained using light, circular strokes loosely rubbed over the paper tooth, to deposit a fine layer of textured pigment without either obliterating or picking up the previously laid color. The side or blunted tip of the pastel can be used.

The hazy effect of scumbling can be exploited working light over dark, to create a slight shimmer and enhance the colors' luminosity, or by laying dark color over a pale or vivid hue, to subtly "knock back" the original color and give depth to the image. If you combine close-toned colors, they will mix optically to give the impression of a "hybrid" color that has a more active surface effect than smooth color BLENDING, but a more delicate texture than typical BROKEN COLOR effects.

The technique is best suited to soft pastels, but with a careful, light touch you can obtain good scumbling effects with oil pastel as well.

Soft pastel

In this example, light-toned color is applied with gentle circular strokes of the pastel tip over an even spread of grainy medium orange.

Soft pastel

This more rhythmic, open texture was achieved by applying a short length of pastel in looping SIDE STROKES over the heavily shaded brown base layer.

Oil pastel

This example shows the effect of two light-toned oil pastels scumbled onto dark red pastel paper. The pink was applied first, then the blue, in both cases using the flattened tip of the pastel stick.

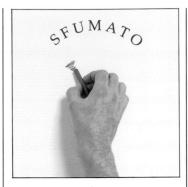

The characteristic of the effect called sfumato (an Italian word meaning smoke-like) is a soft, hazy quality in which tones and colors merge into each other and build an image without reliance on linear structure or emphasis on edges and contours. Like several commonly used pastel painting techniques, it derives from traditions first established in oil painting, sfumato being particularly associated with Leonardo da Vinci (1452-1519).

Sfumato is not a technique in itself, but a visual quality, and you can achieve the effect by using any of the techniques that enable you to apply controlled, subtle color transitions — BLENDING, COLOR GRADATION, SCUMBLING and SHADING. If your image has a varied range of shades and a shadowy or atmospheric mood, you can also use careful ERASURE to lift light out of dark and develop gentle contrasts of light and shade.

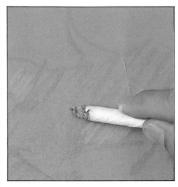

1 The subject is first blocked in with blue and gray soft pastels on buff colored paper, using sketchy outlines and loose hatching to define the areas of light and shadow. The pastel strokes are softened and spread with a torchon (see BLENDING), to make the marks less linear and allow the colors to merge.

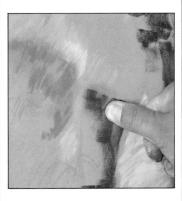

2 The color areas are gradually built up in lightly shaded layers. Dark shades are smudged with thumb and fingers to create patches of soft shadow.

3 The form of the cat's head is developed with dark and light shades. The colors are freely applied using the tip and side of the pastel sticks, and blended using fingers or torchon as appropriate.

4 In the final stages, the features are drawn with feathery pastel strokes, some blended into the previous color and others remaining more clearly defined. Although there are no hard edges or distinct outlines, the dramatic use of light and shade makes a highly descriptive impression of form and contour.

The term derives from the Italian word meaning "scratched," and the technique involves working into layered colors with a sharp tool, scratching into the top layer to reveal another color underneath. To do this successfully, you need a medium with sufficient body to create a clean effect when scratched into - soft pastels or oil pastels that can be thickly laid - and you must be methodical about preparing the color layers to achieve the effect you want.

The basic method involves covering the support with a layer of solid color well rubbed into the paper grain, then applying a second, quite heavy layer of another color on top, but this time without rubbing it in. If you use soft pastel, fix the first color before working over it. You can then scratch into the top layer with a fine scalpel blade or stylus.

Variations include working dark over light or light over dark, using more than one color in either layer; applying a textured rather than flat top layer; and applying pastel over a colored ground of ink or paint, rather than over a previous application of pastel.

Oil pastel over watercolor

1 The base color is painted with a loose wash of yellow-green watercolor. When this is dry, black oil pastel is shaded thickly over the surface and rubbed to produce a smoothly blended texture.

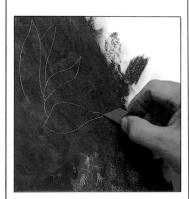

2 The drawing is begun with the tip of a craft-knife blade, taking care just to scratch back the oil pastel color and avoid digging into the paper surface.

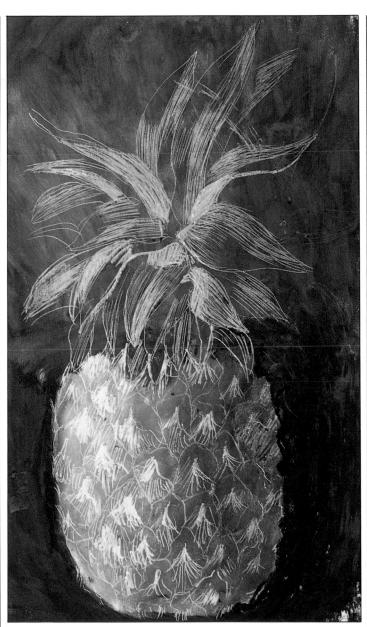

3 This example is worked as a line drawing, using closely hatched lines to produce the impression of variations of color and shading.

Shading is a way of applying continuous tone or color. In monochrome drawing, it is specifically associated with the process of modeling three-dimensional form through the effects of light and shadow; in pastel work, it applies to modulations of color as well as shading.

The technique of shading is a controlled back-and-forth motion of the pastel traveling gradually across the working surface so that the strokes shade into one another. The effect is one of evenly massed color rather than individual marks. Depending on the pressure you apply and the texture of the paper, the color of the paper may modify that of the pastel, but not to the extent that it does in a linear shading method such as hatching (see HATCHING AND CROSSHATCHING).

You can use shading to' create areas of flat or graded color, or as a basis for smooth BLENDING of hues and tones. Conventionally, the effectiveness of shading depends upon working the strokes consistently in the same direction, which provides an even surface finish. However, when you are drawing a particular object, a

change of direction in the shading can be used to indicate a change of direction in the object's surface, suggesting the planes or curves that describe its shape and volume.

▼ Heavy shading in soft pastel can create areas of flat, solid color that give emphatic modeling to solid forms. Shade one color into another to create highlights, shadows and subtle color blends.

▲ Oil pastel is used here, with a simple back and forth movement of the pastel tip. Varying the pressure allows you to develop tonal gradations. The texture of oil pastel generally creates quite an open, coarse texture, but you can build up layers of shaded color to give it weight and intensity.

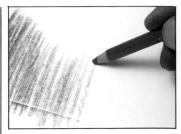

▲ Pastel pencils are more gritty and fine-textured than pastel sticks, and the effect of shading is typically quite hard and linear. To give a clean edge to the shaded area, mask it off and take the pastel over the mask edge on each stroke.

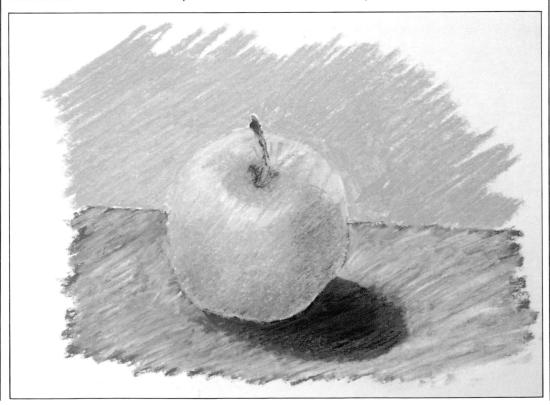

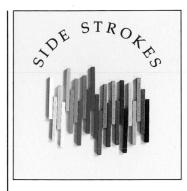

This is an important technique for building up broad color areas with soft pastels, also effective with oil pastels. You simply draw the long side of a square- or round-sectioned pastel across the support to leave a broad band of grainy color. The depth of shading or color depends upon the pressure you apply and the texture of the support. A heavily toothed surface will not completely fill with color even if you apply strong pressure, and the amount of color showing through from the support modifies the effect of the pastel pigment.

You can juxtapose side strokes edge-to-edge to block in large areas of color (see BLOCKING IN). You can overlay them, working in the same direction or opposing directions in successive layers, to develop subtle color blends and mixtures. The grainy texture of a side stroke can be left as it is, or with soft pastel you can use a torchon or your fingers to blend the color more smoothly.

Do not overlay side strokes too heavily or in too many layers, or the colors will become overmixed and degraded.

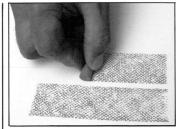

▲ To lay the color evenly, draw the side of the pastel stick firmly across the paper surface. The density of the color depends on the pressure you apply and the quality of the paper grain.

▲ You can obtain graded color effects by lightening the pressure as you extend the stroke.

▲ Side strokes can be overlaid in different directions to produce a very broad, grainy form of crosshatching or to build up color density. Color mixes can be made by overlaying different colors in this way.

As with linear marks made with the tip of the pastel, side strokes will reflect the rapid movement of your hand. Lively, curved, short strokes build up an active texture.

▲ To produce a more varied, broken stroke, angle the pastel very slightly to apply more pressure on one end than on the other.

Sketches serve many purposes and take many forms, from the briefest record of something fleetingly seen to a detailed working drawing that serves as a model for a fullscale composition. Sketching is often particularly associated with outdoor work, and pastels are excellent tools in this case because they combine the attributes of drawing and painting media, easy to handle but providing good color potential. A box of, say, twelve pastels gives you a versatile color range in compact, portable form. An alternative method of carrying fragile soft pastels safely for outdoor work is to put them in a jar half-filled with rice grains. This prevents the sticks from snapping and also keeps them clean.

When you are working on very quick sketches, the variety of Linear Marks that you can make with pastels provides many economical ways of recording shape, form and detail. If you are more interested in broad color impressions and atmospheric effects, you can combine linear techniques with SIDE STROKES and SHADING.

An important aspect of location sketching is that,

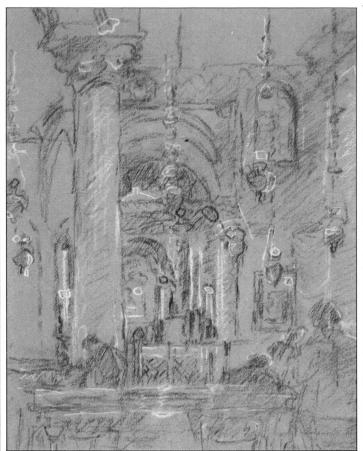

however free the drawing, it relates to something real — a landscape or townscape, figure or animal, activity or event. Your techniques will be selected in response to the visual information provided by the subject, and all artists gradually build their own "shorthand" methods of recording these responses.

DIANA ARMFIELD "Interior of San Marco, Venice" (Study for a painting) Sketching in monochrome is a traditional prelude to working on more complex compositions in full color. By focusing on essential information such as architectural structure and patterns of light and shadow, you can achieve a useful reference sketch quite quickly. Many artists also take written notes on color and detail when sketching in conditions that make it difficult to do a color drawing on the spot.

▼ JOHN ELLIOTT

"Canoeing in Vermont"

The vibrant color choice of pastel is excellent for capturing the mood of a subject with economical techniques. This oil pastel sketch reflects the glowing hues and warm light of early fall in a countryside resort. SIDE STROKES and patches of shaded color are combined with brief linear accents to describe the overall perspective and individual features of the view.

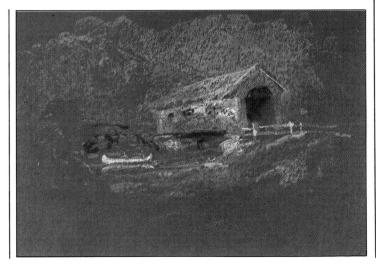

Stippling is the technique of using dot patterns to build an impression of shape and form. It is particularly associated with monochrome drawing, a way of modeling forms through tonal gradations of light and shade. The size and spacing of the dots is varied so that different areas of the dot pattern convey different tonal densities when viewed from a distance. In color work, stippling can be used to enliven areas of massed color, using either individual or closely related hues, or mixed colors. Apply them directly to the support or over a light layer of pastel color already laid in.

If you stipple with soft pastels or oil pastels, you will necessarily achieve quite a coarse, irregular stippling even if you sharpen the end of the pastel to begin with, it immediately wears down in use. With hard pastels or pastel pencils, you can obtain a finer, more controlled effect because these media do not spread so readily. Pencils can be sharpened frequently to maintain a true point, and the corner of a square-sectioned hard pastel will also give you quite a precise, confined mark.

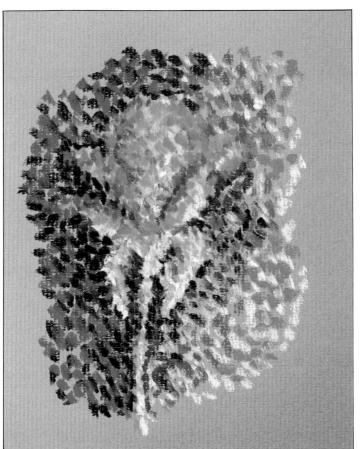

Soft pastel

■ Depending on the pressure you apply to the pastel tip, the effect of stippling in soft pastel can range from fine to very coarse. Integrating dots of different colors enables you to build up an increasingly detailed image, with graded hues and shades modeling individual aspects of the form.

Pastel pencil

▼ The harder, fine tips of pastel pencils provide the means for very fine stippling, but this means that covering a large area of the paper may be very time consuming.

Oil pastel

■ Because of the moist quality of oil pastel, overlaid stippled marks produce actual color blends, as well as the effect of color integration known as "optical mixing" – when seen from a distance the dots appear to merge and form a coherent surface area.

Some degree of texture on the paper is necessary to successful pastel painting — it needs to have a tooth, or distinct grain, which allows the pastel particles to grip the surface. The color is unstable on a very smooth surface, and as you build up the pastel strokes, they will tend to smear, or fail to adhere. A pronounced paper grain also contributes to the color qualities of the rendering,

since the pastel does not immediately fill the recessed areas of the grain texture, thus allowing the color of the paper to show through.

Surfaces suitable for pastel range from cartridge and cover papers through heavy grained watercolor papers to moldmade colored Ingres papers that have an even, visible grain. Fine sandpapers are also sold specifically for pastel work – if you can't obtain them from an art supplier, have a look at the abrasive papers in the DIY store. If you are combining pastel with oil or acrylic paint, you can use artist's canvas or canvas board as a working surface. Quite humble materials can also be sympathetic for pastel work, such as cardboard and rough brown wrapping paper.

▲ Pastel is very responsive to the paper surface. A light application on heavy watercolor paper shows the grain as a very pronounced texture.

▲ A buildup of thick color makes the paper grain gradually less distinct. Variations in the weight of the pastel strokes can be used to create visual contrast between solid and BROKEN COLOR.

■ Unusual textures can be particularly effective if suitably matched to a given subject. For example, the ribbed texture of corrugated cardboard could enhance the effect of a landscape or townscape view.

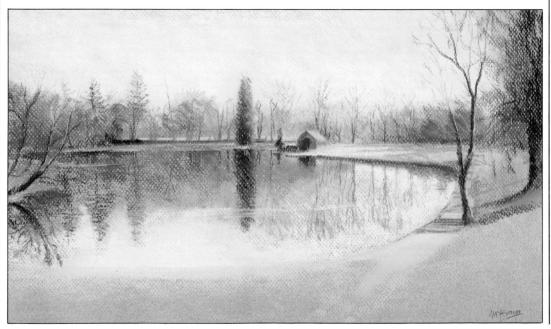

■ MARGARET EVANS
"Laich Loch, Gleneagles"
The heavily grained paper plays
a very positive part in the
impression of this gentle
landscape view. Both its color
and texture have been carefully
integrated with delicate
treatment of the pastel color to
unify the image.

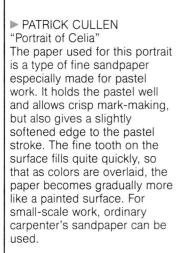

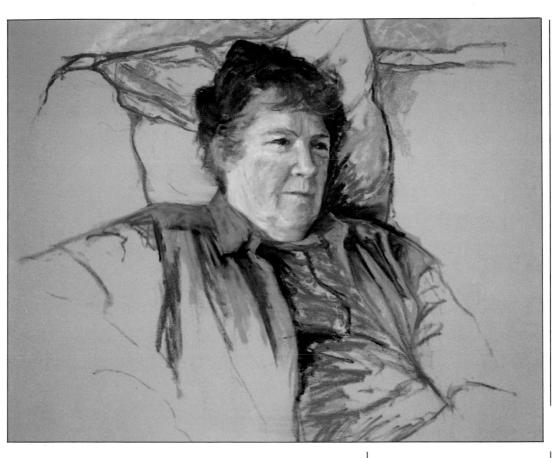

■ This is a detail from a foliage study worked on velour paper, which has a rich velvety nap (in the past, real fabrics such as velvet and silk were sometimes used). It grips the color but softens the pastel marks, allowing complex color blends.

Like HIGHLIGHTING, this is a way of heightening the contrasts of light and shadow in a rendering. If you find that a portrait painting, for example, seems a little flat and lifeless when it is nearing completion, you may need to enhance the paler shades and colors to give a soft sheen or bloom to certain areas of the image. Similarly, it may help in conveying both the form and texture of fabric folds - silk or velvet, for instance. The effect need not be as strong or distinct as a true highlight; the idea is just to "lift" the color values.

You may find that fine linear strokes overlaid on the color area are effective, from a distance giving an optical effect of the desired tone and enlivening the surface from a closer viewpoint. However, you may wish to blend the tint subtly, picking up the color from the previous layer — for this you can use a torchon or your finger to stroke the pastel particles together.

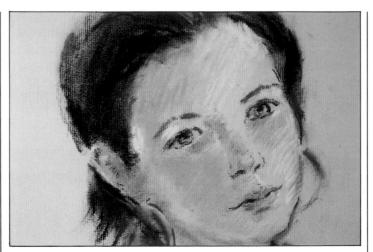

▲ The angle of the light falling on the subject's face is delicately conveyed with loosely hatched strokes of pale flesh tint (see HATCHING AND CROSSHATCHING), rather than with smoothly blended color. The base tone of the skin is formed by the paper color.

VIRENE WISE "Road Diggers" The qualities of light and shadow are enhanced in various interesting ways in this stylized composition. In the vellow door that frames the head of the right-hand figure, the pure hue is loosely blended with a paler tint. On the bodies. LINEAR MARKS are applied over rubbed and blended color. Complementary contrast is introduced in the intense, bright blue shaded over brown on the legs; color variation can be as effective as shade contrasts in giving impact to the modeling of forms.

Water-soluble pastels are formulated to be used either as colored crayons, or as the means for achieving soft washes of color, by dissolving the colored marks on the support using a brush and clean water. In this way, you can achieve hazy, atmospheric effects of graded, mixed and blended colors, or you can fill a particular area of the rendering quite precisely with translucent, flat color. The texture and evenness of the wash can vary with the character of the marks you put down to begin with, the amount of water you add, and the way you manipulate the brush. If you want to produce combined line and wash effects, you can work into the wash with the pastels, either while it is wet or after it has dried.

Oil pastels can be treated similarly using turpentine as the diluting agent. An oil or spirit medium soaks into paper and can ultimately cause it to deteriorate, so it is advisable to prepare the paper with a coating of size or a light primer, and allow it to dry completely before you begin work with the oils.

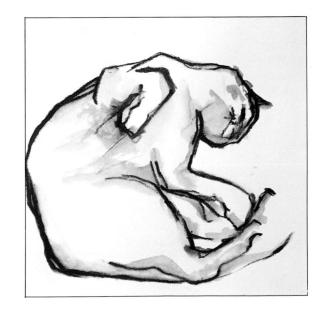

- This free figure drawing has been created entirely with water-soluble pastels. When brushed over with clean water, the color dissolves into an even wash. If you rework linear elements over the damp color areas, the strokes are more dense and solid due to the moistening of the pastel tip, and less grainy than the dry pastel mark.
- ▼ These two details show the variety of texture that can be achieved by this method. This is a technique that lends itself to a very free way of working and a bold approach to color.

Line and wash

The graphic character of line and wash monochrome drawing, traditionally a pen and ink technique, is imitated here using black water-soluble pastel. The line work has the same fluidity and variation as a pen line, but a chunkier texture due to the thickness of the pastel tip. The gray washes are lightly brushed out from the black line.

The translucency and fluidity of watercolor make an interesting complementary contrast to the opacity and density of soft pastel. Both media have brilliant color qualities, but quite different surface characteristics in combination they can form images of depth and subtlety that convey particularly well transient effects of light and shadow. A mixed-media approach is highly suitable for interior subjects and landscapes that include elements of mood and atmosphere.

The simplest way of combining these media successfully is to begin by blocking in the composition with watercolor washes to establish the main color areas and the patterns of light and shadow. Then, when the watercolor has dried, rework the whole image in pastel to develop detail and emphasize color accents and shading contrasts. You can treat this as a layering process, alternating watercolor and pastel work, and working the detail more finely at each stage. However, a wet wash will pick up and spread the pastel particles (see WET BRUSHING), so you need to control your reworkings

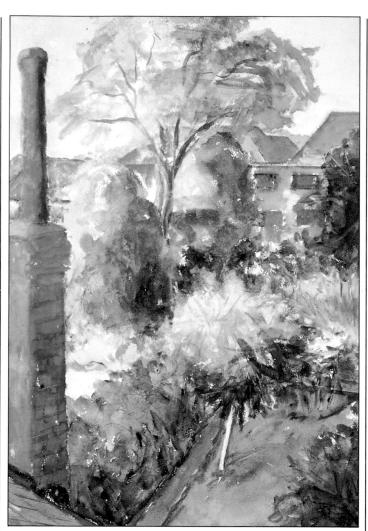

carefully to make sure they enhance the effects rather than muddy the image.

The water-resistant quality of oil pastels is played off against watercolor washes in RESIST TECHNIQUES.

1 In this example, a freely worked but quite detailed watercolor rendering is laid in as the basis for the composition.

2 Loose, grainy pastel strokes are initially applied over the dried watercolor to develop the complexity of the foliage textures.

3 The same treatment is applied to all the foliage areas in the painting, gradually building up the color density with overlaid strokes.

4 In the foreground, where the pastel color is already thickly worked, the artist introduces some oil pastel work to vary the textures, overlaying it on the soft pastel and partially blending the strokes with finger pressure.

5 In the final stage, patches of shaded pastel are laid into the brickwork in the foreground and buildings in the background to develop color contrast, textural detail and HIGHLIGHTING.

▲ JUDY MARTIN
"Orchard in Normandy"
This watercolor and soft pastel painting takes a different approach, with the pastel strokes used as an overall linear texture to build up a free impression of the blossom trees. To begin with, the pastel was drawn over a watercolor base, but the two media were alternated in successive stages to intensify shades and colors and enhance the effect of light.

The principle of wet brushing is similar to working watersoluble pastels into washes, but in this case you brush clean water over marks made with soft pastels, resulting in a grainy wash or loose mixture of line and wash. The granular texture of the pastel particles is retained, but their color tints the water. If you wash over SIDE STROKES, for example, you obtain a dense and fairly even washed effect, in which the pressure of the pastel on the textured support is still faintly visible. If, on the other hand, you lay down open hatched or scribbled marks and brush over them very lightly, you retain the distinct linear pattern registered through a diffused, pale tint of the original color. You can also effectively use this technique to create a subtle suggestion of tonal modeling in a line drawing in pastel - for instance, in figure work, to give a gentle shading to the main contours of the face and body.

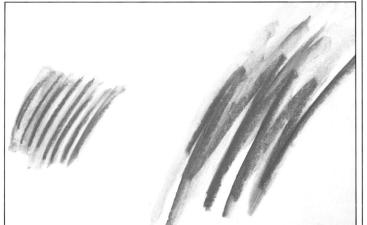

■ Use a soft sable or synthetic hair brush to flood clean water over soft pastel. Light brushing will leave the grain of the pastel texture visible. If you move the brush outward from the pastel color, the tinted water spreads a lighter shade on the paper.

■ Hatched and scribbled lines (see HATCHING AND CROSS-HATCHING) stand out clearly against the paler shade of the wet-brushed color. You can retain the strength of line because the water picks up the color of the pigment, but does not actually dissolve the pastel mark.

▶ When describing an object, be careful to follow the areas of light and shadow that define the form in the initial pastel drawing, as well as applying local color. As you wet the color, brush it outward from the heaviest shades and let it fade toward the highlighted areas.

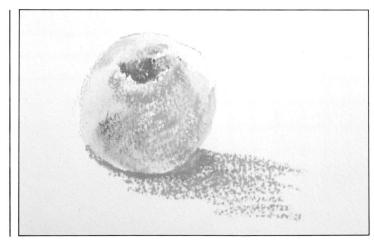

Combining wet and dry color

1 In the first stage, a rapid impression of the subject is built up in soft pastel with loosely scribbled marks and rubbed textures.

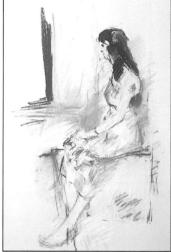

2 Dark shades are added to give definition to the figure, both in describing the contours of the body and in emphasizing the dark mass of the hair.

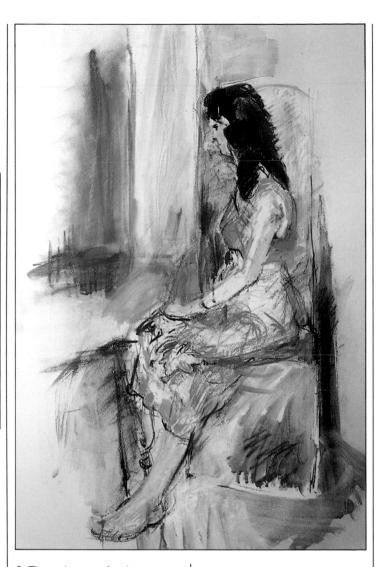

3 The colors are freely moistened with a wet brush, and the "painted" quality of the image is gradually developed. Further pastel color is worked into the damp surface, and finishing touches overlaid when the brushed color has dried.

PART TWO THEMES

Any object, person, event or situation is material for the artist, so neither the themes chosen for this section nor the interpretations illustrated are intended to be definitive of their categories. The images have been selected to show the potential of pastel work, as well as the ways in which the artists have employed the technical range of the medium to match different elements

of a subject and develop a personal style.

All artists, whether beginners or established professionals, can learn something by looking at the work of others. The basic themes in art are by now standard, and it is difficult to arrive at something new and innovative in a general sense. The continuing variety of work in all genres comes from the fusion of observation and technique that is unique to every individual.

This gallery of images is a learning tool that can be used in the same way as the techniques section, to pick out the elements of pastel rendering that you find especially effective and find out something about how they were achieved. Detailed analysis of the pictures enables you to cross-refer easily between the themes and the A-Z of techniques, providing overall a comprehensive guide to the versatility of pastel as a combined painting

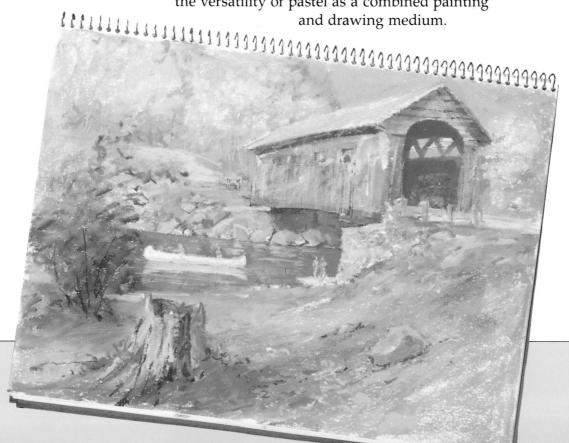

LANDSCAPE

andscape seems to be virtually the ideal subject for pastel work. The range of LINEAR MARKS and massed textures that you can obtain corresponds to the variety of shape and form in nature, while the brilliant colors of pastels and the subtle ways of mixing them are excellent for interpreting natural effects of light and atmosphere. The tradition of working on COLORED GROUNDS is also very helpful in

landscape drawing and painting, giving an overall tone to the image that can represent the broad spread of earth or sky, or the base color of grasses,

foliage or stretches of water.

Subject matter

The landscape theme encompasses a wide range of individual subjects and landscape features — orderly vistas of patchworked agricultural land, the rough spread of open heathland or marshes, the dense BROKEN COLOR effects of wooded hillsides or rocky cliffs, a bleak, stony seashore or glistening sandy beach.

Each of these landscape views also contains a wealth of individual details that might form your main focus within the general theme — for instance a single unusual tree could draw your attention to a particular area of landscape.

Broadly, landscape can be defined as a natural rather than man-made environment, but this does not exclude constructed features such as farm buildings or country houses, roads and bridges, walls and fences. Furthermore, for the town-dweller, the local landscape may be sculptured park, formally planted gardens, or just the small pockets of green space always to be found in urban sites.

Working methods

The specific aspects of landscape that you choose relate to availability and your preferred working methods. Some people are inspired by the fact that they live in beautiful countryside; others have to travel to particular locations if they want to

work outdoors, meaning that the extent of the work is restricted by time and weather conditions. The traditional approach to landscape painting is to

make outdoor sketches and then return to the studio to work up finished paintings — this is a good approach with pastel, as you can use the same medium for your sketches as for the more elaborate work, giving yourself the right kind

of cues on color and texture.

Many contemporary artists mix sketch references with photographic material. You

have the widest options if you take the photographs yourself, as this allows you to select viewpoints and record various details, but you may also find postcards and magazine features useful to remind you of specific locations or the general character of a certain type of landscape.

PATRICK CULLEN "Tuscan Landscape" To create the variety of the dense foliages in the foreground, the artist freely combines areas of BROKEN COLOR with a variety of LINEAR MARKS, building a complex, rich impression of color and texture. The indication of space and distance in the receding landscape is achieved both by simplifying the shapes and textures and by massing subtly cool green, mauve and blue tints in the far-off fields and hills that contrast with the warmer. more vibrant hues of the trees in the foreground. These are linked by the sharper greens and yellows that travel right through the image, enhancing the composition's rhythmic interplay of curving shapes.

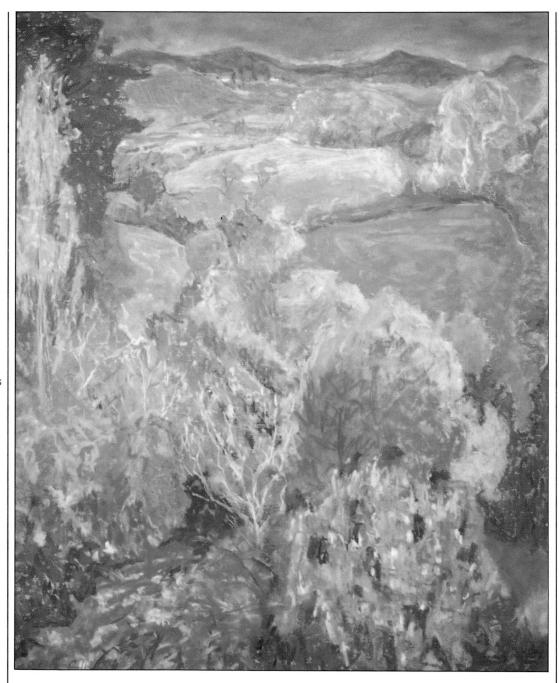

When you are attempting to contain the huge vista of a landscape on a small piece of paper, one of the most important elements is the position of the horizon line. A low horizon gives you less actual space within which to arrange the details of the landscape, but it creates an effect of great distance. A high horizon may give more prominence to the foreground setting, with the sense of recession more compressed toward the horizon itself; or it may indicate that the land is actually rising, so that much of the view is above your eye

Elements that form a linear framework within the image create space by indicating a direction — for example, lines of trees or the patterns of plowed and planted fields converging toward the horizon. With pastel, you can use the line qualities of the medium to emphasize these visual cues. The scale and emphasis of the marks you make also contribute to defining space and distance distinct, bold strokes and large shapes will tend to come forward, forms with indistinct contours seem farther away.

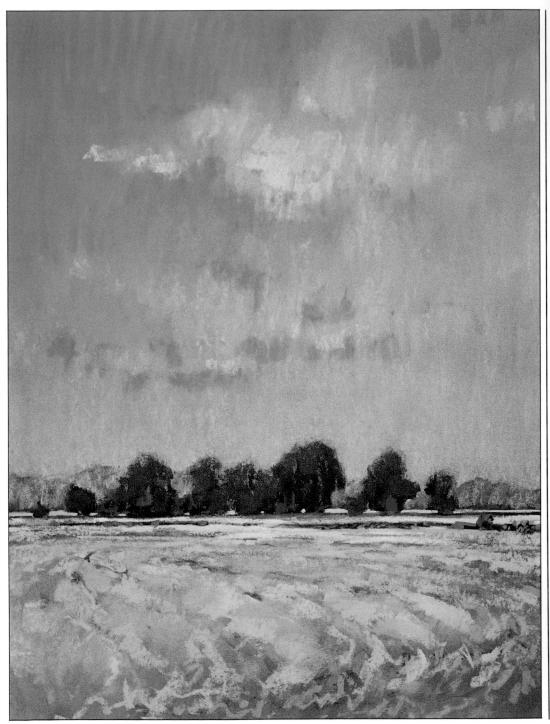

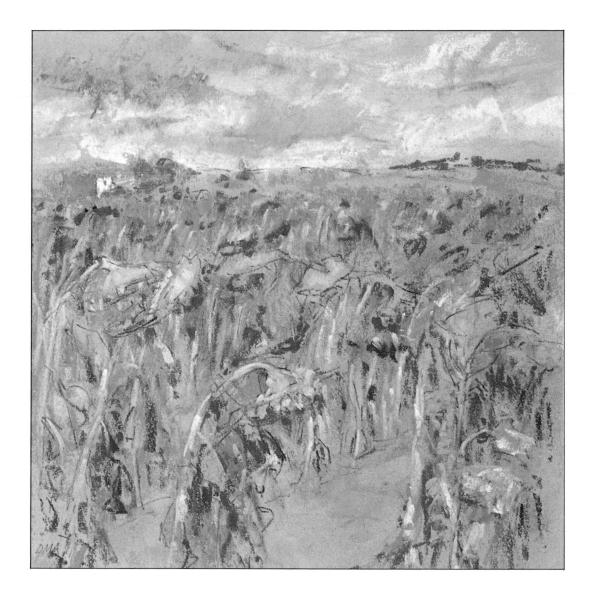

■ GEOFF MARSTERS

"Reach Fen"
Sky and land are described with BROKEN COLOR, with the directions of the pastel strokes emphasizing the spatial division. The sense of distance is enhanced by the shadowy tree line at the low horizon, throwing forward the solid, dark tree shapes.

▲ DIANA ARMFIELD

"Ripe Sunflowers Below Puy"
As the landscape recedes, the definition of the pastel marks is softened, and the color variations are subtly integrated, conveying the gradual loss of detail that occurs with increasing distance.

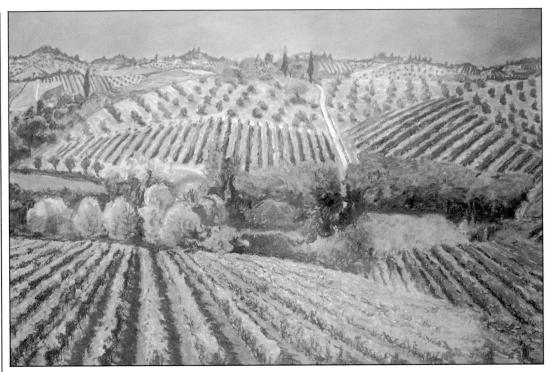

DAVID PRENTICE
"Coloured Counties - Laura's
War"

A high viewpoint creates an unusual configuration of land and sky, freely laid in with bold SIDE STROKES and LINEAR MARKS. The strong impression of light and atmosphere is enhanced by the interplay of warm and cool colors, pure hues and neutral tones, and the technique of GESTURAL DRAWING gives the whole picture surface an active, rhythmic unity, in which the divisions between land and sky are sometimes emphatic, sometimes ambiguous.

▲ PATRICK CULLEN "Vineyards and Olive Groves, Sultry Day"

The patterning of the fields leads the viewer through the spatial arrangement of this composition, with the pattern elements diminishing in size toward the horizon. The pastel is densely worked, with LINEAR MARKS, BLENDING and BROKEN COLOR describing variations of form and texture.

► ROSALIND CUTHBERT "Blue Hills"

The abstract shapes presented by a high mountain range are interpreted as rich masses of color and texture, using a combination of WATERCOLOR AND PASTEL laid over an acrylic and whiting ground. Additional contouring and linear texture are developed with charcoal.

Each season of the year has its own characteristics, but since you cannot compare them at the same time, a clear sense of seasonal atmosphere comes from careful observation of actual qualities of light, color and landscape structure.

Fall is a favored time for color studies: the colors of the trees can be sensational in themselves, and are often enhanced by a rich, warm light. Winter is a less inviting time to work outdoors, either drawing or observing the landscape, but it has its particular visual excitement in the skeletal forms of plants and the strange color variations of lights and shadows on snow. The versatility of pastels makes them equally appropriate for emphasizing the calligraphic qualities of winter landscape or expressing the dense massing of color, light and shade.

Seasonal character can also incorporate a mood, often relating to weather conditions: landscape rarely appears bleak under brilliant summer sunshine, but heavy storm clouds can make gentle pastoral land seem suddenly threatening.

▲ MARGARET GLASS
"Sun and Shadows"
The abrasive tooth of fine sandpaper allows the soft pastel to be applied in heavy IMPASTO strokes. In the foreground, the strokes are loosely worked, the warm brown ground contributing

significantly to the color range of the lights and shadows on the snow. The brilliant light effect is created with an interplay of warm and cool colors – there is no pure white among the pale tints in the snow.

SALLY STRIDE "Oak in Winter"

This is a colorful interpretation of winter landscape, but the seasonal atmosphere is cleverly conveyed by using a palette entirely composed of cool and cold colors. Pale blues and mauves are typically cold, but here even the reds and yellows are selected to inject crisp, clear tints rather than dense. saturated colors. The warmest note is reserved for the strong red-brown woven into the linear structures of the foreground trees, which create the focal point of the composition.

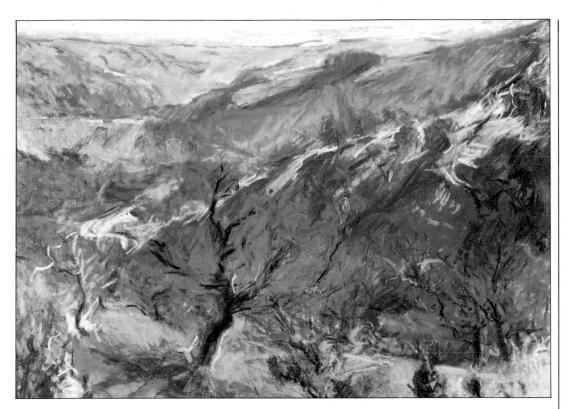

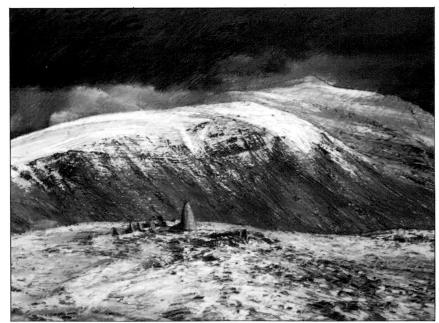

■ KEITH BOWEN

"Moel Siabod" The horizontal emphasis of this restrained composition underlines the bleak character of the open landscape. The color masses yield an immense amount of calligraphic activity, with fine LINEAR MARKS giving harsh texture to the snowcovered hills, and overlaid SHADING and HATCHING building the dense, blackened tones of the sky. The extreme tonal contrast between sky and land makes the reflective snow cap give off a clear, brilliant light.

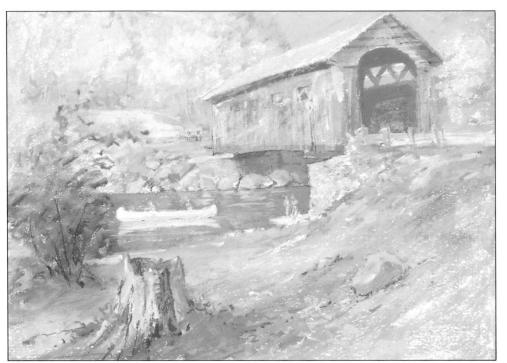

■ JOHN ELLIOT
"Covered Bridge"
The gentle, lyrical colors of this oil pastel painting suggest a delicate spring light rather than the intense sunlight of summer. The variety of cool and warm hues is carefully orchestrated through areas of blended and BROKEN COLOR, subtly leading the viewer to the focal point of the covered bridge, but linking each part of the image to produce a unified composition.

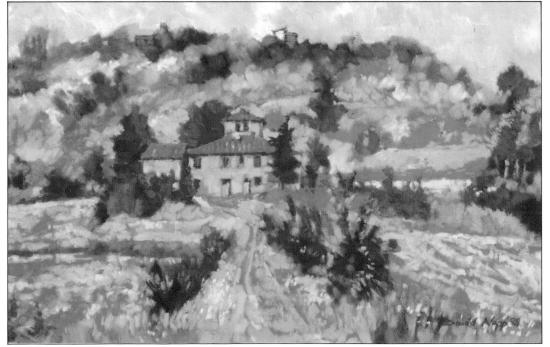

■ DAVID NAPP
"Farm Track in Tuscany"
The technique in this soft pastel painting is very consistent, using short, broad strokes to mix and overlay small patches of color that gradually coalesce into distinctive shapes and forms. The selection of colors evokes gentle warmth in the landscape, but the sky remains cool, again suggesting a spring-like mood.

▶ JOHN ELLIOT "Autumn Near the Artist's Studio" In pastel work, it is often advisable to give full rein to the intensity of color, especially when the technique is free and bold. Oil pastel is used here to develop an active network of LINEAR MARKS, where strong contrasts of color and shading allow the form and texture of the foliage to emerge. A dark, heavily TEXTURED GROUND contributes to the BROKEN COLOR effects, although in places the pronounced grain of the paper is concealed by thick IMPASTO dashes and streaks of color.

Trees can either be viewed as part of the general population of a landscape or as special features for close study. They have a fascinating amount of variation in their natural shapes, textures and colors, according to the characteristics of the individual species and the seasonal changes they undergo.

While botanical identification is not an essential feature of tree studies, it is important to pay attention to specific visual qualities such as typical outline, branch structure, leaf shape and color. The more you analyze the particular qualities, the more you can develop the richness and detail of a tree "portrait" or give definition and contrast to a study of massed trees.

SALLY STRIDE "Autumn Tree"

Using a tree as the focal point of a landscape view gives an immediate sense of scale. The curving branches lead the eye into the space of the landscape. A free, gestural approach is applied to form and texture, with the arrangement of colors helping to define the different elements of the composition.

▲ DIANA ARMFIELD
"Aspens Along the Path in the Rockies"
This image conveys very precisely the detail and

character of the slender aspens, and demonstrates how the buildup of many small pastel strokes constructs the impression of form. The soft

pastel is handled loosely and economically, BLOCKING IN areas of grainy color and developing textural detail with a variety of LINEAR MARKS. The cool hues

dominant in the painting are offset with discreet ACCENTING in clear pink.

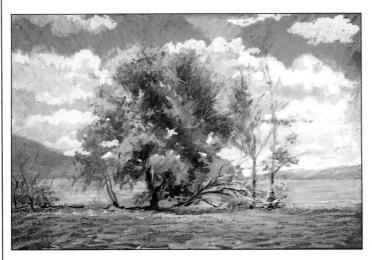

▲ JOHN ELLIOT "Hudson River From Piermont Jetty" The majestic mass of this old

waterside tree is boldly handled with a solid buildup of oil pastel, silhouetted by the pale sky.

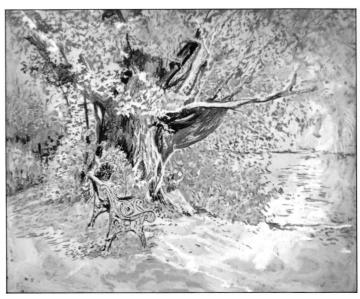

▲ JOHN ELLIOT "At Audubon Lake" The techniques of "etching out" on a pastel-covered

SCRATCHBOARD is particularly effective for a subject with pronounced qualities of pattern and texture.

▲ JANE STROTHER
"Olive Trees, Monteccio"
A cultivated tree planting
creates an interesting alignment
of forms. This free oil pastel
sketch focuses the interaction
of the angled trunks and foliage

masses, eliminating incidental detail. The pastel is rubbed and blended to create basic color areas, overlaid with LINEAR MARKS and loose HATCHING and SHADING.

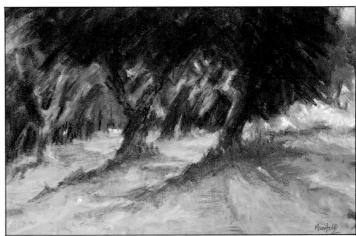

▲ DEBRA MANIFOLD

"The Retreat"

An unusual variation of RESIST TECHNIQUE was used to develop the rugged textures in this dramatic composition. The image was first drawn in oil

pastel, then black soft pastel was vigorously worked over the oily base. As with the fluid media more often used in resists, the dry color adheres irregularly and creates a tough, broken texture.

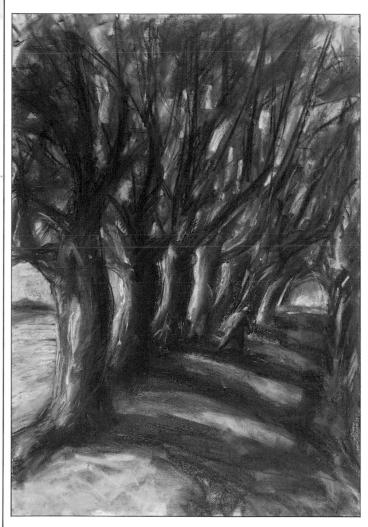

more broadly blocked in, the medium has a harsher grain than that of soft pastel. This suits the threatening mood of the composition, described with strong blacks and a limited color palette.

▲ ROSALIND CUTHBERT
"Cypresses"
The naturally elegant, elongated forms of these trees are stylized into distinctive, solid shapes, using dense SHADING in soft pastel to introduce the

color variations. The verticality of the columnar forms is thus emphasized, and the inclusion of the tiny figure at the center of the composition creates a point of scale that also enhances their grandeur.

The immense amount of detail contained within any landscape view can be focused more closely in individual studies of foliage and flowers. This is an opportunity to experiment technically, and find out how the different kinds of pastel marks convey the extraordinary range of natural leaf and flower forms.

Because the shapes, textures and color nuances in landscape are so complex, it is often tempting to settle for a broadly impressionistic style that creates a striking image, but glosses over the characteristic detail of individual elements. In choosing a particular feature of landscape for more intense study, you can deal with the smaller subtleties of form and color, acquiring information that will feed back into your broader landscape views.

Even when you limit yourself to an individual subject of this kind, there are still many different aspects to it, and your representation need not be comprehensive or "realistic." Look for the essential details and qualities that enable you to produce a convincing account of your own visual impression.

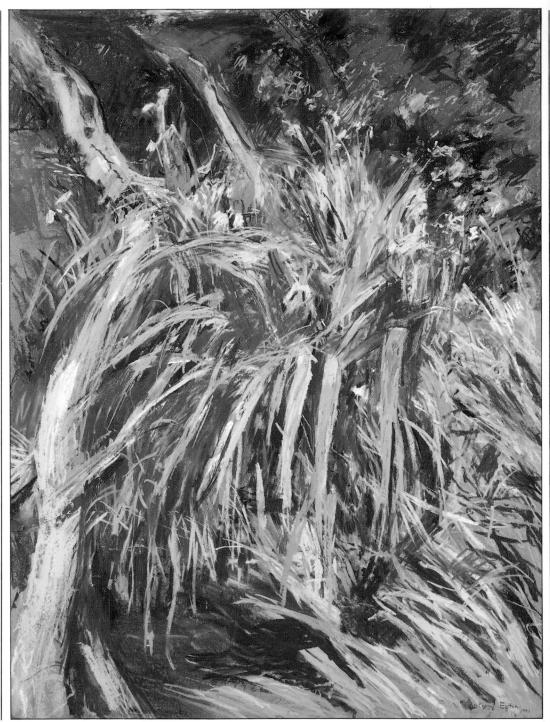

▼ DAVID NAPP
"Poppies in Provence"
Densely massed, warm
coloring beautifully reproduces
the carpeting effect of the
poppy field, played off against
cooler acidic hues in the

background landscape. The marks are differently weighted to bring out detail in the foreground.

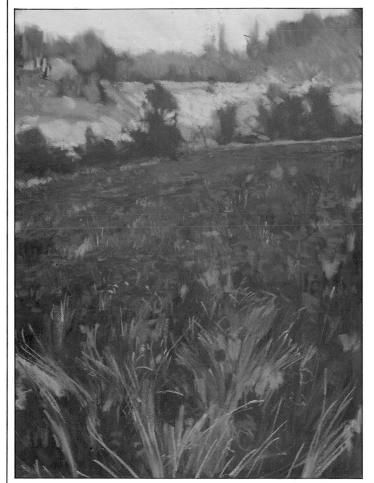

■ ANTHONY EYTON "Irises"

The mass of foliage is freely translated with GESTURAL DRAWING, but confident handling of the complex structure and varied color range produces a striking description.

► ROY SPARKES
"Frindsbury Garden"
Interactions of color and form in
the garden plants were the
starting point for this oil pastel,
interpreted as an active abstract
image concerned with spatial
depth and contrast of shades.

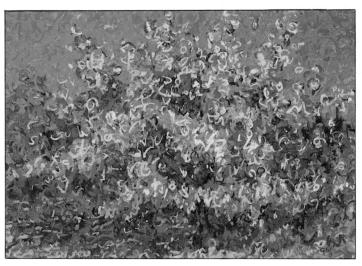

▲ GEOFF MARSTERS

"Cherry Tree in Blossom"

A consistent pattern of small,
hooked LINEAR MARKS describes
variations of texture and local
color, relying on the balance of
color to define form.

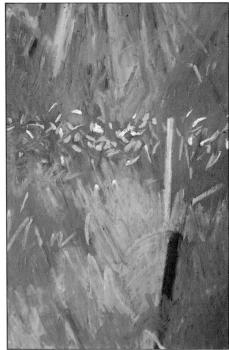

Inevitably, when you work in color and are dealing with the theme of landscape, you must engage with the effects of natural light. In some cases, this will be the very essence of your subject; for instance, the charm of a particular view will stem mainly from such effects as dappled light under trees or the warm colors of afternoon light giving extra intensity to the landscape hues.

It can be hard to capture such transient effects when you are working on the spot, and photographs are not always good references as they may lose the color clarity. Effective interpretation of light qualities comes in large measure from keen observation, but an equally important factor is confidence with your medium. Sometimes it helps to exaggerate contrasts of color and tone and be bold and free in your mark-making - when you step back from the drawing, the individual elements magically cohere into a striking image.

A colored ground (see COLORED GROUNDS) is a useful starting point if you are trying to capture brilliant qualities of light. A base color allows pale tints to stand out fully; when you use white paper, its own

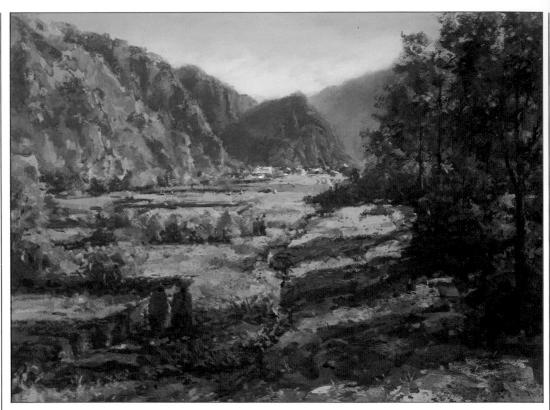

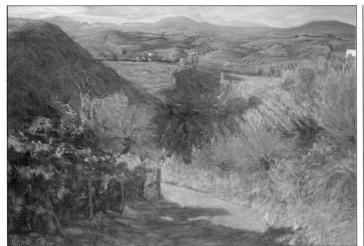

brilliance is constantly competing with the colors that you apply. Medium shades and muted hues are probably most suitable for use by beginners, but you can get excellent results using very dark-toned paper. ▲ ERIC MICHAELS

"Journey to Zunil"

Cast shadows from the trees create the effect of pools and rivulets of light and shade flooding across the ground. This contrast is extreme, and the artist develops the variations in color values at full strength, working in pastel over a watercolor base.

▼PATRICK CULLEN

"Valley in Tuscany, Evening
Light"

The broad spread of light is
offset by a dense massing of
shadow, described both with
tonal variation and the contrast
of bright, warm hues against
cool, muted colors.

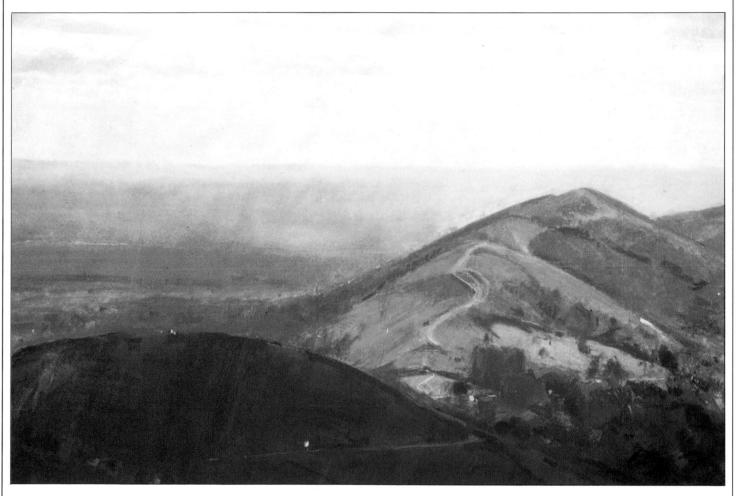

DAVID PRENTICE
"Girl in a Yellow Oilskin"
Unusual effects of light and shade in landscape derive from the lie of the land and transient effects such as cloud shadows. Here, the darkened hillside dramatically foreshadowing its sunlit neighbor is unexpectedly pierced by the figure's brilliant point of light. In keeping with

the ambitious scope of the landscape, this pastel painting is on a relatively large scale, 22×34in (55×85cm). This allows for the full interplay of the broad sweeps of color and accommodates the startling sense of scale.

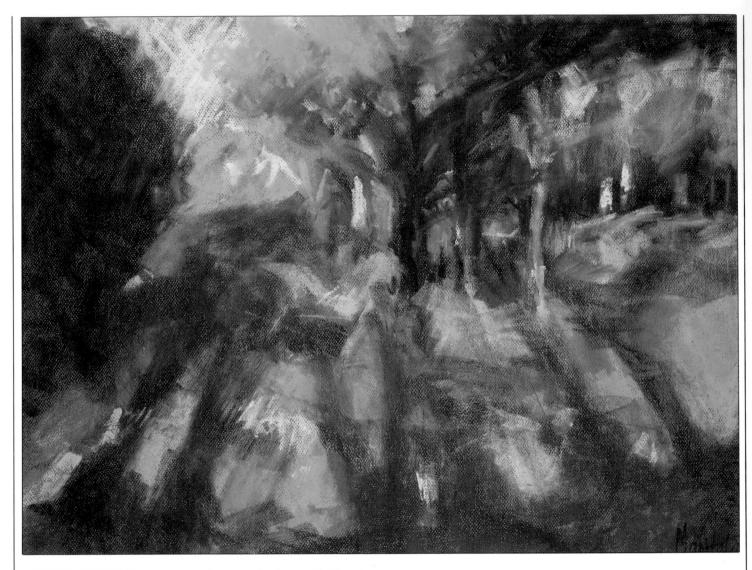

▲ DEBRA MANIFOLD

"Last Light"

Light from a setting sun
provides the stunning contrast
of long shadows and warm,
luminous colors. The artist has
treated the color areas very
loosely and broadly, seeing the
composition as an arrangement
of semiabstract shapes. Grainy
SIDE STROKES applied over a dark
green COLORED GROUND create

the overall pattern of light and shadow, with highlights and accents worked in bold LINEAR MARKS. Glimpses of the ground color showing through both light and dark applied colors soften the brighter tints and harder EDGE QUALITIES.

MARGARET EVANS
"Evening Light, King's Course,
Gleneagles"
The lush green fairways of a
well-kept golf course reflect the
warm evening glow as distinct
bands of golden light. There is
a gentle GRADATION from cool
grays and blues in foreground
and sky toward the rich, warm
yellows and ochers spread
across the center of the
landscape.

"JOHN TOOKEY "Horsey Mill" Masses of pure white on a cool gray ground give the intensely luminous quality of the water and sky in this freely worked soft pastel painting. The colors are kept within a cold range from blue-purple to acid green, and the strong contrast of dark shades at the center of the composition enhances the brilliance of the pale tints.

The most problematic aspect of painting skies is that the sky itself is largely composed of light, which you must translate into the color equivalents provided by a solid, material medium. How vou deal with this in terms of technique partly depends on the overall style of your image. Sky composed of many individual marks building up into a complex feathered texture or mass of BROKEN COLOR can be surprisingly effective, but if the sky becomes much "busier" than the landscape, it will begin to dominate the image and destroy the sense of space.

On the other hand, an evenly colored, open sky may look too flat if treated oversimply. It might be advisable to use two or three closely related tints to give a little depth and variation, BLENDING them if necessary to create a subtly coherent surface effect. Alternatively, you may wish to play up hints of color or atmosphere, even giving the sky an unnatural coloring that expresses the mood of the image and forms an appropriate backdrop to the landscape subject.

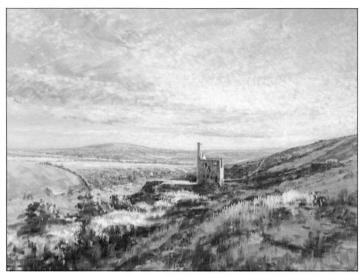

■ LIONEL AGGETT

"Wheal Betsy, Dartmoor"

Pastel is a sympathetic medium for describing cloud formations, its softness contributing to the atmospheric elements and its variety of luminous hues suited to capturing the varied qualities of natural light. The technique of using BROKEN COLOR enables the artist to deal with transient light effects.

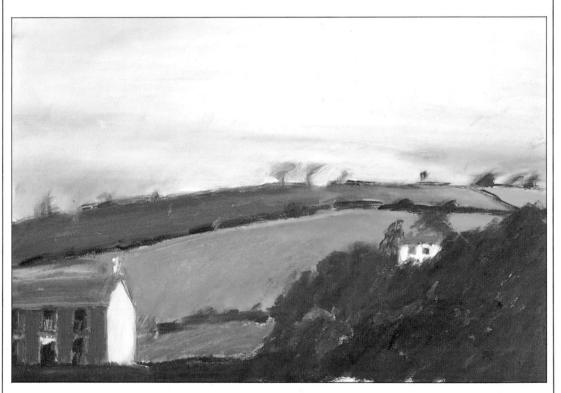

▲ JANE STROTHER "One Welsh Hillside" Oil pastel and oil paint are applied in layers, the pastel

moistened and spread with a rag. The technique provides a veiled shadowing in the cold, gray sky, its bleakness

counterpointed by glimpses of a warm underlayer of red on the horizon and in the foreground.

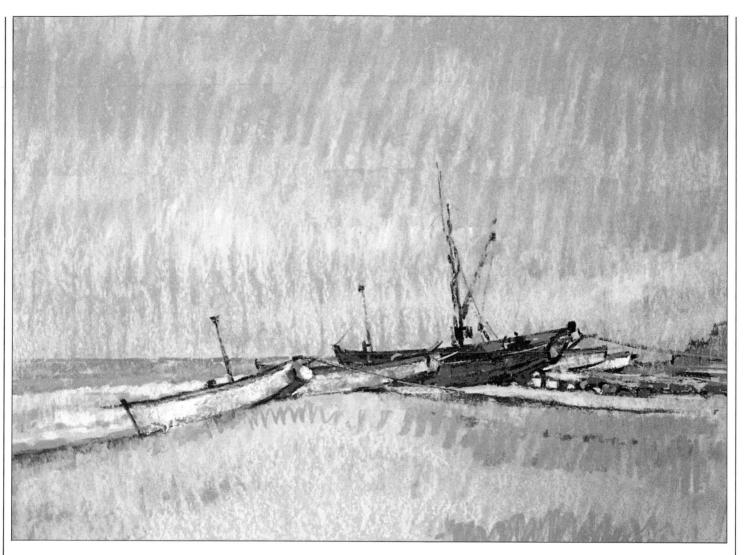

▲ GEOFF MARSTERS
"LT229, IH88, IH265 at
Aldeburgh"
The color nuances of a
subdued, graying sky are
developed with FEATHERING of
broad vertical strokes creating
gentle GRADATIONS of the
delicately varied tints. This
vertical emphasis is repeated
and emboldened in the
treatment of the foreground
plane, the two areas cut

through by the strong horizontal arrangement of the boats. Their shapes are crisply defined with LINEAR MARKS and clear contrasts of color and tint that push back the evenly textured plane of the sky.

Streams, rivers, ponds and lakes are temptingly picturesque, and they also introduce additional elements of color and texture that give pleasant variation to a landscape view. Clear water has no color of its own, but "borrows" those of its surroundings in the form of reflections of sky or landscape features. Moving water has infinitely changing patterns of form, color and texture, while still water can change from a flat, mirror-like surface to a complex mass of tiny ripples with the touch of a breeze.

Like skies, water can be interpreted in many different ways, and you can experiment with a variety of different technical solutions. However, because it has no fixed character, you need to pay careful attention to what you actually see in a given situation. Reflections can appear, for instance, either as a network of colors and abstract shapes or as a startlingly detailed, inverted picture of the landscape surrounding the watery surface.

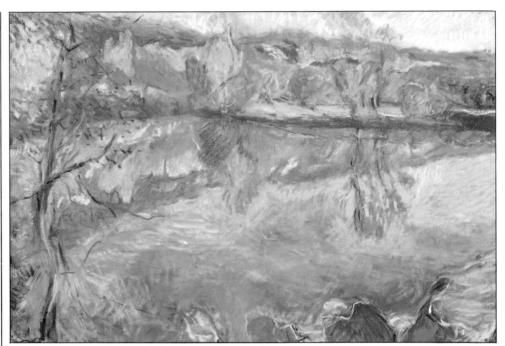

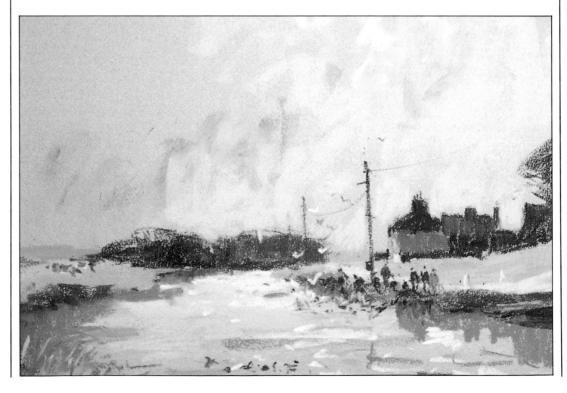

■ SALLY STRIDE

"River Lot, Late Afternoon" In this rendering the water surface is treated with the same active technique as the surrounding landscape, the directions of the pastel strokes helping to differentiate the reflected image from the real.

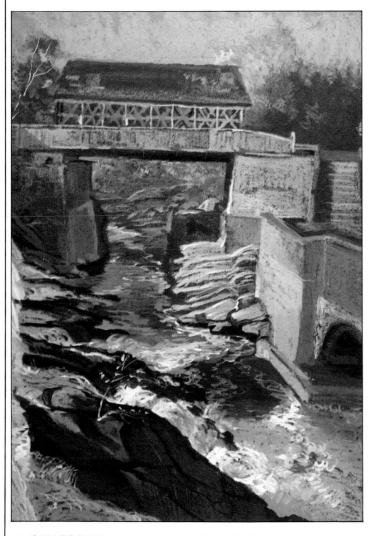

tints to indicate both its luminosity and the faint disturbance caused by its movement.

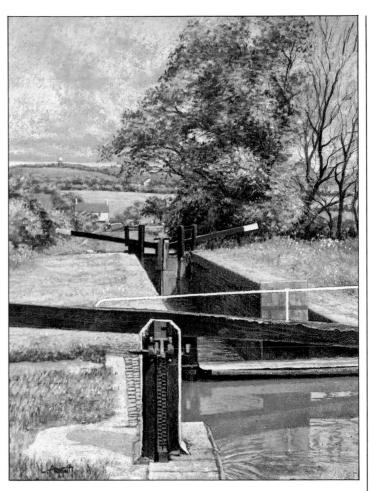

■ JOHN ELLIOT

"Queechy Covered Bridge,
Vermont"

Turbulent water is a difficult
subject that demands careful
observation. In this vigorous oil
pastel painting, its movement is
interpreted as a pattern of

pastel painting, its movement is interpreted as a pattern of LINEAR MARKS laced around solid patches of reflected color.

▲ LIONEL AGGETT
"Down the Flight"
Reflected shapes and colors
often appear as quite hardedged patterns. Here, confident
interpretation of the color
values reproduces that visual
quality, although the individual
pastel strokes applied to the
TEXTURED GROUND appear soft
and grainy in close-up.

Seascape and marine painting are often seen as specialized subjects that individual artists study and develop over a period of many years. The continual motion of the sea is both an inspiration and a difficulty; the latter because it disrupts the continuity of your observations and makes it hard to relate specific shapes, forms, textures and color effects to each other and to the image as a whole. Good photographic reference may be helpful, but photographs do "solidify" the subject — a too hard-edged or static interpretation of the sea's rolling masses is a common fault of a beginner's efforts to get to grips with this awesome theme.

This problem is reduced if you are mainly interested in coastal landscape, when the sea becomes a background to other natural forms, and a certain static quality is not out of place. However, if you wish to incorporate effects such as lapping waves and rising spray, you need to settle for a period of trial and error until you become familiar with your subject's visual qualities and discover the most effective pastel techniques for representing them.

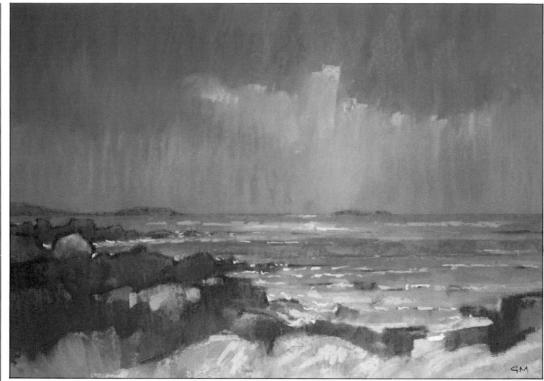

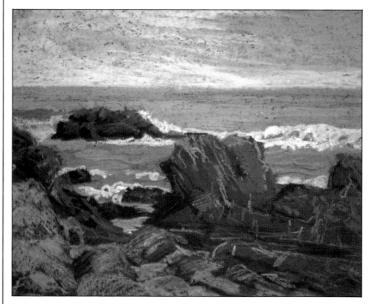

▲ GEOFF MARSTERS

"Breton Coast"

The sky is always an important influence on seascape, and often a dominant area of the composition. Here, the colors of sky and sea are closely linked, and the change from vertical to horizontal stresses in the pastel marks emphasizes the spaciousness of the view.

■ JOHN ELLIOT

"Homer's Rocks"

The surface of the sea is treated quite flatly in oil pastel, with densely shaded, cold grays, except close to the rocks where the foam breaks white and the moving water is shot through with a stronger greenblue.

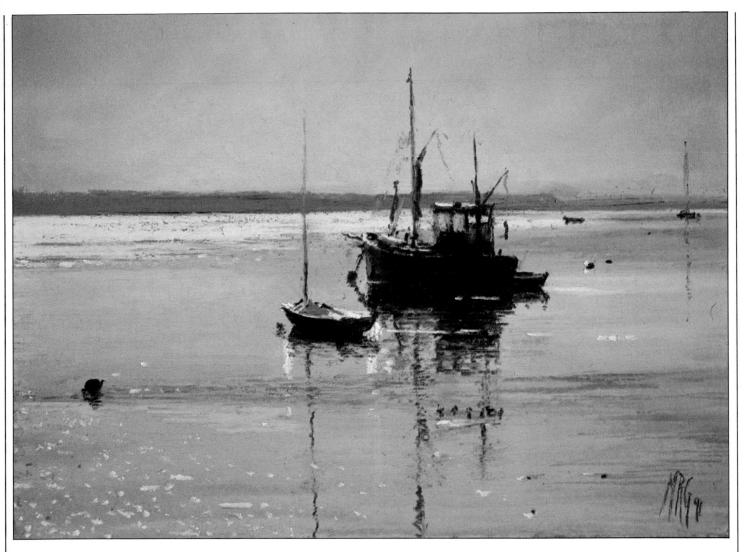

MARGARET GLASS
"Morning Light, Ramsholt"
The simplicity of this
composition focuses attention
on the mood of the subject,
described by careful
orchestration of the color
values. The medium is soft
pastel on sandpaper (see

TEXTURED GROUNDS), a surface which grips the color particles and allows continual layering to build the atmospheric effect. As colors are overlaid, they soften and merge, creating the smooth, glassy quality of the water surface and the subtle lighting in the sky.

DEMONSTRATION HAZEL HARRISON

The relatively simple construction of this composition emphasizes the sense of space. The soft pastel palette is effectively employed to recreate the atmospheric contrast of a dark, heavy sky and reflected light on the sand and stones of the beach.

1 The composition's main features are sketched out in line. The blue paper is chosen to provide a dense background and to create an underlying color contrast that will enhance the warm, sunlit colors of the beach.

2 The lighter shades in the sky are freely shaded with the tip of the pastel, using pale gray-blue and cobalt. The marks are rubbed with a soft cloth to spread the powdery color and form an atmospheric, hazy effect.

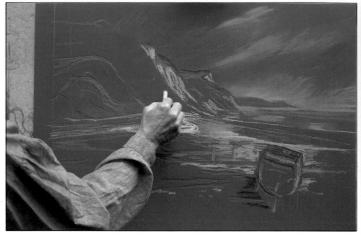

3 The artist continues BLOCKING IN the image with loose, rhythmic strokes, establishing the overall color range more

broadly and defining the structures of the main forms with line and mass.

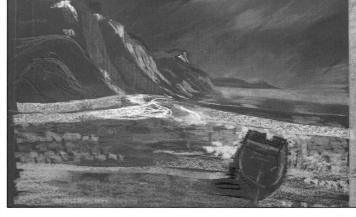

4, 5 Variations of color and texture are developed in more detail with a combination of SIDE STROKES and LINEAR MARKS. The contrast of cool colors in sea and sky and warm hues in the foreground enhances the spaciousness of the view. A light spray of fixative (right) is applied at this stage to seal the surface before reworking.

6 The artist continues OVERLAYING COLORS to build up the landscape features. Corrections are made to the perspective of the boat, with

the shape redrawn with firm outlines to redefine the structure and give it weight and depth.

7 In the final stages, the textures of the beach are elaborated. By introducing paler tints and increasing variation in the hues, the artist illuminates

the foreground of the image and emphasizes it by subtly graying the colors of sea and sky.

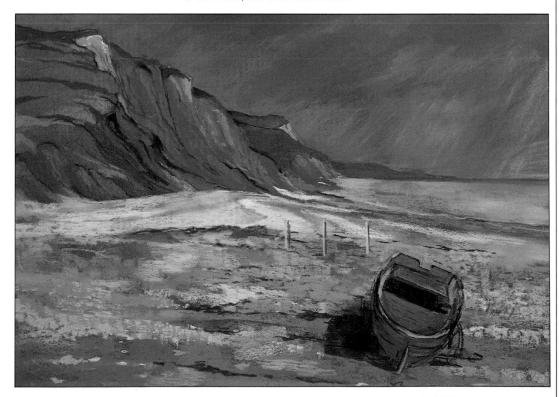

HAZEL HARRISON "Charmouth Beach"

THE ENVIRONMENT

he title of this section reflects the fact that themes in art overlap and defy strict categorization. All the images presented on the following pages relate to man-made aspects of the environment, but they frequently demonstrate a fusion of, for instance, elements of landscape and townscape, and present the ways particular locations form a context for human activity. Some of the artists have chosen to record their own immediate surroundings, while others have expressed their responses to exotic and picturesque locations.

Place and mood

Common to all is a keen sense of place, whether it is the individual character of a house or village, the detailed intimacy of a furnished interior, the bleak but familiar setting of an industrial townscape, or the colorful enticement of a busy outdoor market. Different aspects of the environment are interpreted in a variety of diverse and equally fascinating ways in this selection of paintings, sometimes highly realistic and descriptive, sometimes focusing more on mood and atmosphere.

A response to the mood of the subject is

particularly noticeable here, but is similarly at work in many examples of other themes, particularly landscape compositions and works that feature figures, animals or objects in various settings. Technical factors can be descriptive not only of actual physical elements of your subject, but also of its broader character and the feelings you wish to convey about it. Bold, very active marks convey dynamic relationships of form and texture; softly broken or blended textures and broad spreads of color are more gently atmospheric.

As you become confident of your technique, you can also become more ambitious in terms of composition. The

way you present your subject can give it an emotional as well as material context: variations of style and technique can allow you to interpret a given situation as either welcoming and relaxed or mysterious and threatening. The extent and arrangement of the composition and the treatment of colors and tonal values convey your

personal impression. Whenever you find an image particularly striking — its effect may be pleasant or unsettling — it should be possible to analyze some of the ways in which the artist has used technique and composition to create a mood.

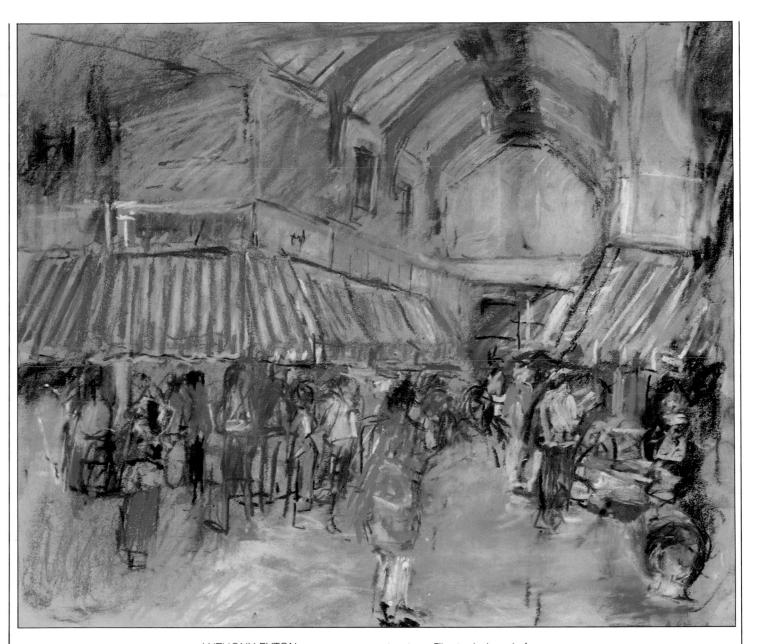

ANTHONY EYTON
"Market Hall"
This is a very vigorous study
that captures the busy
atmosphere of the location, and
also a clear impression of its
distinctive architectural

structure. The technique is free and calligraphic, with much linear activity enlivening the picture surface. The hues are boldly stated, both to describe aspects of local color and to create a vibrant mood.

The spatial organization of individual buildings and architectural groups often provides a ready-made composition, with the colors and textures of the various construction materials adding surface interest. The colors and textures of pastels correspond well to features such as weathered brick, wood, stone and painted plasterwork. The medium's linear qualities also help to give definition to subjects composed of planes and angles.

A building often has a special character that makes it an attractive subject in itself. Its particular appeal can be stressed by the viewpoint that you take — distant or close, face-on or angled, with the building merging into or isolated from its surrounding context. The subject can also be enhanced by imaginative treatment of unusual effects of light and color, as well as basic physical attributes of shape, form and texture.

► KEITH BOWEN "Ty Mawr"

The angled viewpoint allows the artist to incorporate whole the interesting shape of the old Welsh stone cottage. The painting is worked on board, giving a firm base to the buildup of overlaid pastel textures describing the stonework.

▼ MARGARET GLASS
"The Smokehouse, Cley"
The awning in bright sunlight
first drew the artist's interest,
and was centrally placed in the
composition. The warm color of
the sandpaper ground shows
through the BROKEN COLOR
describing stone and cobbles.

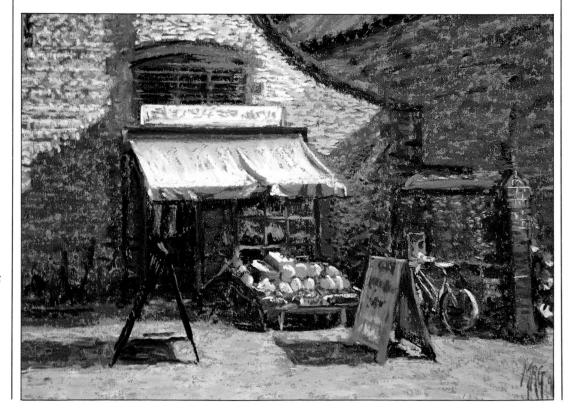

▼ JOHN TOOKEY

"King's Lynn"

The formal structure of the townscape and its cool, grayed tones are conveyed with an interesting combination of ink line, watercolor and soft pastel.

This produces a varied but wellintegrated range of surface qualities incorporating fluid and grainy textures, sharp linear detail, and softer, atmospheric effects.

▲ JOHN ELLIOT "Winter at High Point, New Jersey"

The tonal balances of this image supersede the color interest, aptly translated with a limited palette of earth colors on a warm buff COLORED GROUND. Controlled vertical and horizontal LINEAR MARKS describe the planes of the wooden buildings, contrasted with the loose HATCHING AND CROSSHATCHING in ground and sky.

■ JOHN TOOKEY
"Cley, Norfolk"
The same mixed-media
approach as in the image above
is applied to a subject that
presents clear, solid shapes
and warm lighting. The
treatment of line and mass
creates effective variations in
the EDGE QUALITIES of the
architectural detail.

■ JANE STROTHER "Rome Flats"

Cropping right into the uniform façades of the buildings so that neither the base nor the apex of the houses is seen creates a confrontational image softened by the warm, inviting colors. The artist's technique of combining oil paint and oil pastel to make both the color masses and loosely scrubbed textures perfectly complements the character of the image.

▼ JANE STROTHER "The White House - High Summer" The isolated house, partly masked by a few trees, provides an unusual and intriguing composition. The combination of OIL PAINT AND PASTEL is used here to bring out strong color contrasts and varied textures. The two media

are freely mixed and overlaid.

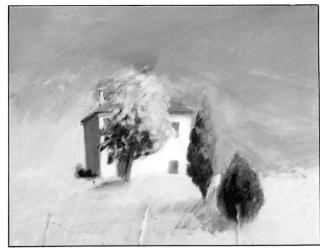

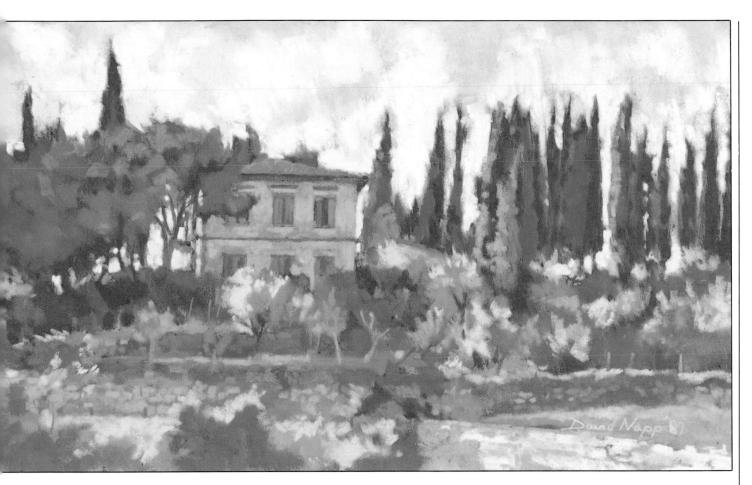

▲ DAVID NAPP

"House and Cypress Trees at

Regello"
The house is given a kind of grandeur by its location, as the arrangement of the composition makes clear. The low-key vibrance of the colors reflects a serene mood.

■ GEOFF MARSTERS "Breton Farm"

In this bold treatment, strong outlines contain schematic color areas and textures, ranging from foreground IMPASTO to light FEATHERING in the sky.

Views of a town or city street are often most interesting as a setting for human activity. There is a fascinating contrast between the solid permanence of an architectural background, and the color and motion of people going about their business. The introduction of the figures enhances the sense of scale; the buildings may form a neutral backdrop to the human interest or may interact with and enclose them, depending on the viewpoint you take and the way you integrate different elements of the composition.

Outdoor markets, colorful and containing a wealth of varied detail, are particularly fascinating subjects for drawing and painting. They exist in all areas of the world, but are characteristically expressive of their own culture and community. They combine aspects of architectural, figure and still life composition and the vital interplay of moving and fixed forms.

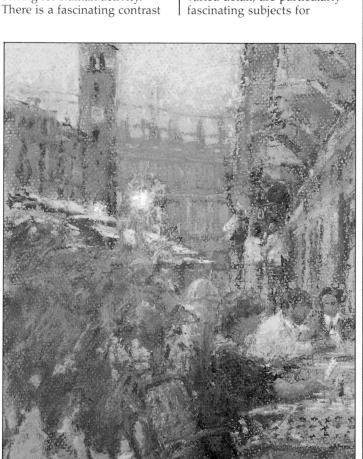

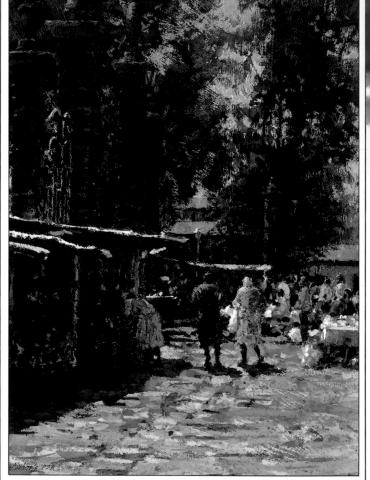

■ DIANA ARMFIELD "At the Restaurant Piazza Erbe, Verona"

The foreground elements have been used to frame the view of the more distant buildings. The heavy grain of the paper contributes to the atmospheric effect of BROKEN COLOR.

▲ ERIC MICHAELS
"Sunday Morning in Patzcuaro"
Here, the artist makes full use
of pastel's pure, intense hues,
overlaying its grainy textures on
the heavily contrasted pools of
light and shadow created by a
watercolor underpainting.

▼ DIANA ARMFIELD

"Market Stall, Piazza
Bartolomeo"

The cast shadow of the righthand building gives this
composition a predominantly
cool cast, against which the
sunlit corner of the far building

stands out dramatically. Both architecture and figures are described with a subtle interplay of free LINEAR MARKS that structure the forms and areas of SHADING and BROKEN COLOR that give weight and solidity.

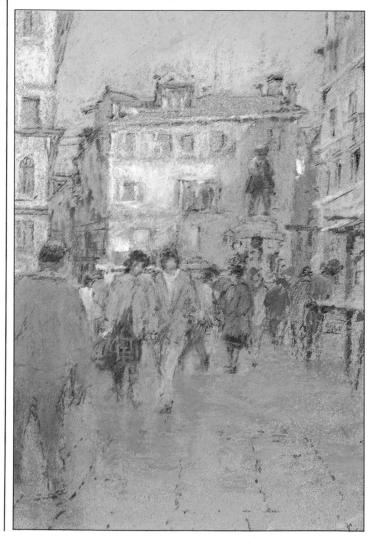

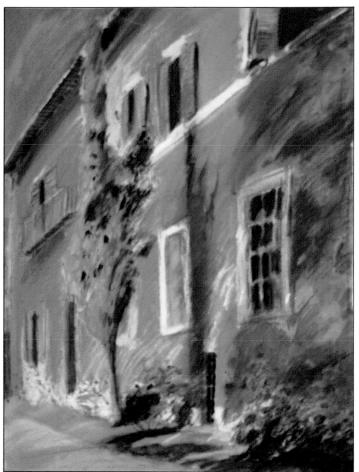

▲ JANE STROTHER

"The Red House"
A streetscape atmosphere emerges from the close, acutely angled viewpoint in this composition, although its subject is a single building, The framing of the perspective suggests an unseen continuity. A combination of OIL PAINT AND PASTEL, vigorously rubbed and scribbled, is used to create the scrubbed textures of the colorwashed walls.

There is typically a kind of harshness to an urban industrial setting or working environment. Such subjects may not immediately present themselves as sympathetic vehicles for pastel work, but as the examples here show, pastel can be a tough, dramatic medium as much as it is a colorful and picturesque one.

Much of the interest of such subjects lies in the unusual configurations of shape and form presented by the various structures that play their part in a particular function, including buildings, machinery and vehicles. Linear frameworks and striking tonal contrasts are good material for a pastel rendering, and a subject that at first seems

lacking in color will gradually yield many subtleties of hue and shading. Some subjects have a stark, abstract quality that can be exploited in a broadly imaginative, interpretive vein.

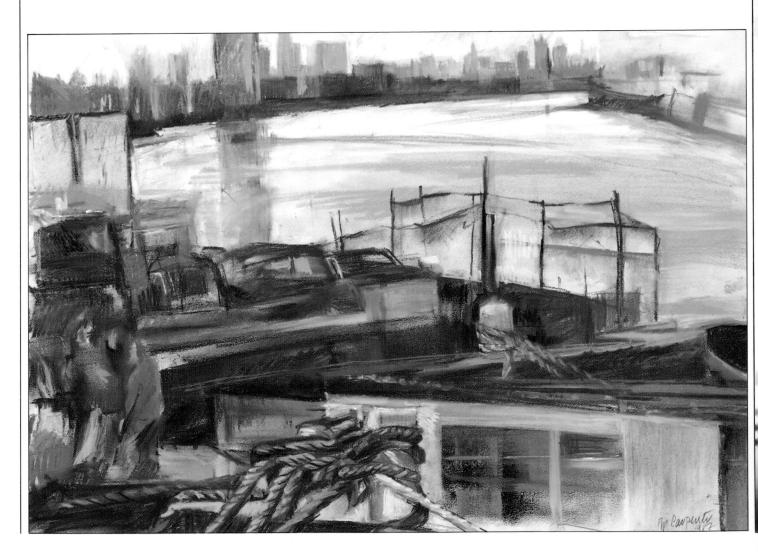

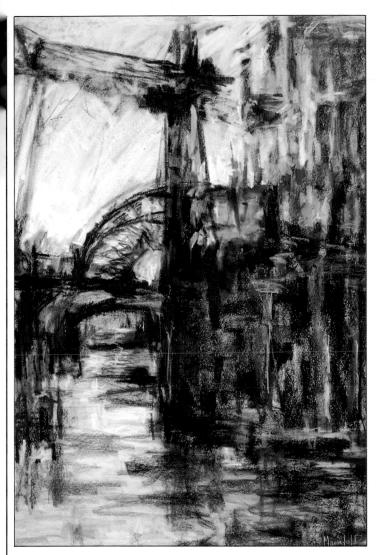

■ DEBRA MANIFOLD "Dockhead"

To emphasize the stark drama of the derelict site, colors are limited to black and white with occasional punctuations of green and red. The drawing is rapid and spontaneous, using a combination of charcoal, oil pastel and soft pastel.

▼ GEOFF MARSTERS

"Interior of Boathouse"

The strong contrast of light and shadow is constructed not only with extreme tint variations, but also with the contrast of complementary colors. The brilliant flashes of orange and blue enhance the spatial organization of shapes and volumes.

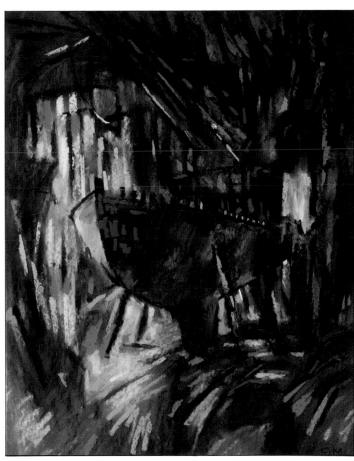

■ PIP CARPENTER

"Wood Wharf Boatyard –
Upstream"
The texture of hard pastel is
well suited to the geometry of
the subject, and the artist finds
plenty of incidental color among
the cold grays of the
riverscape. The glassy surface
of the river is represented with
bold horizontal strokes in pure
white.

The household interior is one of the most accessible subjects, indeed it is sometimes overlooked for this very reason - it is overfamiliar. But the most ordinary room reveals a complex arrangement of forms in space and a wealth of incidental detail in the décor, furnishings and objects. If you use your own home as a subject, you can work very privately and at your own pace. As with still life, this is an opportunity to try out varied approaches and study different aspects of the subject at leisure.

Public settings such as a café or restaurant, or the interior of a museum or place of worship, are of interest, both for their general atmosphere and for the specific details of purposebuilt interior architecture. Perhaps there is elaborate ornamentation and formal

MARGARET GLASS
"The Parlour, Bale"
The pattern elements within the room are freely interpreted with decisive strokes building complex detail.

organization of objects within the space.

Lighting is an important part of the mood and style of an interior. When you work in a homey setting, you may wish to set up artificial lighting in a way that emphasizes space and structure, but it is often worth taking advantage of the accidental qualities of natural light – strongly angled sunlight entering the window can create scintillating color accents and dramatic shadows.

Sometimes you can see beyond the enclosed space of the room, through the window or into an adjoining room or hallway, for instance. This adds depth to the image and may provide interesting contrasts of color, light and texture.

▲ CHARLOTTE ARDIZZONE
"Interior with Sofa"
Vigorous HATCHING AND
CROSSHATCHING, varying the
directions of the pastel strokes,

constructs the planes of the interior and objects within it. The high-key palette of colors gives a vivid quality of illumination.

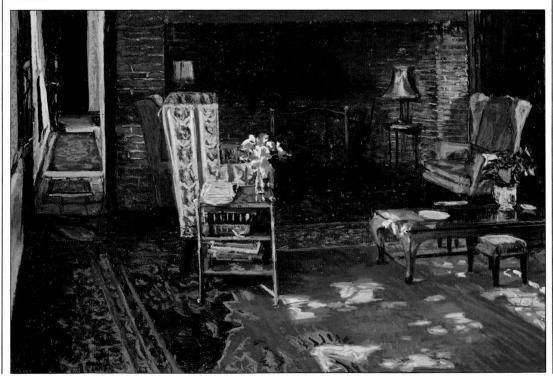

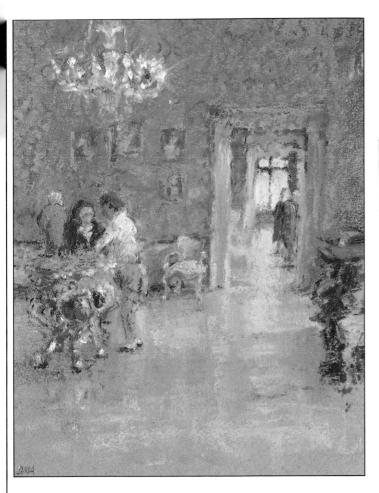

▲ DIANA ARMFIELD

"In the Ca'Rezzonico, Venice"
Like the previous composition,
this image opens out the
interior space by showing the
view through into the rooms
beyond. The pattern detail is
softly worked with loose
scumbling, its warm colors
creating an agreeable contrast
with the cool tints describing
reflected light on the polished
floor.

▲ TOM COATES

"Interior with Seated Figure"
The monochrome scheme and open, sketchy style of this drawing dispense with details of color and texture, but precisely construct the space and scale of the room.

■ ERIC MICHAELS

"Inside the Great Mosque"
An interior with exceptional architecture and an imposing mood is naturally an attractive subject for a painting, but it is a challenge to produce an image that matches its grandeur. This pastel rendering does so by framing the perspective to emphasize the height and depth, utilizing the strong, elegant shapes in dynamic juxtaposition. Many subtle nuances of color are contrived within the solid blocks of light and shade that form the dramatic chiaroscuro effect.

■ DIANA ARMFIELD

"Interior, San Marco"

This comparably impressive location is handled in a very different and equally successful manner, conveying the vast space and complex framework of the interior through a dense network of individual marks that both construct and decorate the cathedral interior. The relatively even distribution of low-key tints describes the dimly lit atmosphere, elaborated with many vivid color accents and brilliant points of light.

A sense of mood derives from a complex interaction of factors, from simple physical characteristics to memories and associations brought to an image by artist or viewer. Some places have an inherent atmosphere relating to their appearance or function; some present a different character according to the weather or time of day. A straightforward record of a particular environment may in itself convey a mood, but you can also take a more deliberate approach and use formal elements of drawing and painting, such as color and composition, to develop your feeling for a subject and communicate more than just an immediate visual impression.

Your viewpoint and the extent and organization of your composition contribute to the mood of the subject. An individual building or a whole town can be made to appear isolated and remote by placing it centrally within a broader landscape. A low-level or flatly frontal view makes the building seem less accessible than an angled, eye-level view that emphasizes ways into and around the structure.

Harsh lighting or

exaggerated colors can create a sense of alienation, while naturalistic color, even with strong lights and shadows, is more reassuring. Colors and their tonal values are often associated with mood, and although personal responses to colors vary, there are some reliable general rules. For example, neutrals and pastel colors are more serene than pure, bright hues, and gentle gradations of shade similarly create less impact than strong contrasts of light and dark.

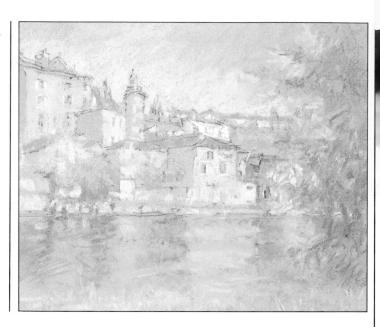

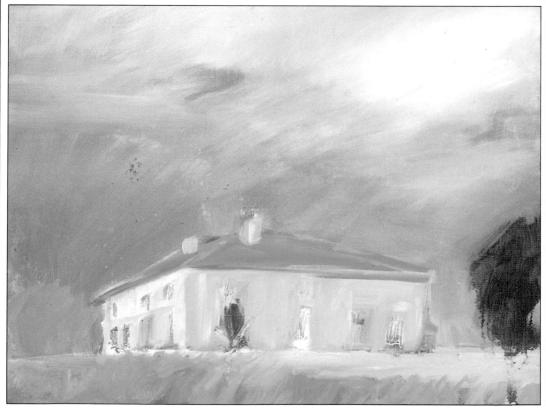

DIANA ARMFIELD

"Puy l'Eveque"
Two main factors account for the serene atmosphere of this view. The first is the palette of closely shaded, gentle colors, and the second the delicate technique, in which the varied marks create a fragmented surface from which the impressions of form, space and texture subtly emerge.

■ JANE STROTHER

"The Yellow House"
A stormy sky creates a threatening mood, with its color and texture giving weight to the image. This atmosphere is underlined by the apparent isolation of the house, centralized within the composition, but the sunlit colors of the house and foreground landscape create an element of contrast.

▶ ERIC MICHAELS
"Indoor Market, Santiago"
The busy atmosphere of the market is encompassed in the long view of the market building, which allows so many elements of activity to be seen. The composition was first blocked in with watercolor, then developed with an intricate buildup of pastel marks.

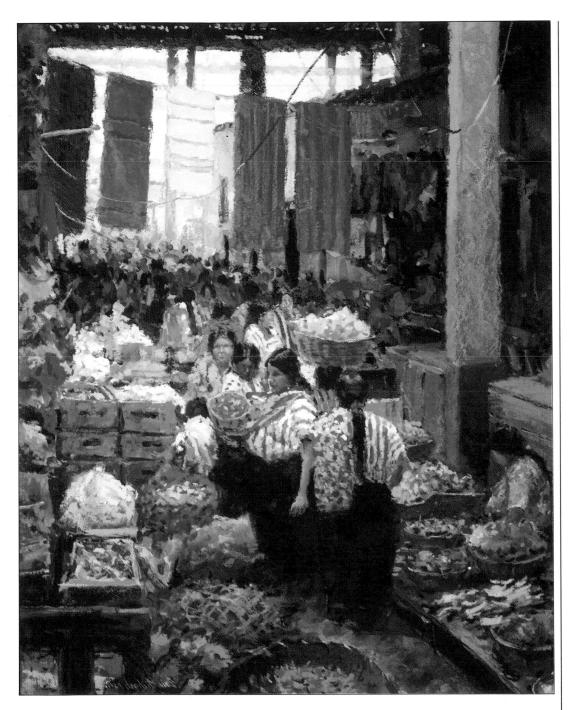

DEMONSTRATION DAVID FERRY

The solid geometric volumes and intricate structures of an industrial construction site are colorfully described in this image, in which the artist employs an inventive mixed-media approach to develop different qualities of form and surface texture.

1 The large-scale construction site incorporates a complex interaction of organized structures and randomly placed elements. The artist needs to deal with the variety of shapes quite selectively to avoid overcomplicating the image with indistinct features.

2 A good-quality printmaking paper is pinned to the drawing board and the image area framed with strips of masking tape. As the techniques to be used will involve wetting the paper, it has to be heavy enough to resist buckling. The basic shapes within the composition are drawn freely with a 2B pencil.

3 Aerosol spray paints, of the type sold for retouching the bodywork of automobiles, are sprayed on the paper to form a loose underlay of background color. This method is chosen as a quick way to give an overall balance to the initial pencil line drawing.

4 The separate planes of the main structures are blocked in with broad HATCHING in oil pastel. Coarsely spattered color is also applied by flicking ink from the bristles of a brush.

5 The artist gradually builds up the planes and volumes with broadly textured areas of oil pastel color. Firm IMPASTO strokes are used to develop linear structures. The colors are freely blended and overlaid, some areas reworked as

SGRAFFITO, using a craft-knife blade to scratch into the surface layers and increase the range of textures. A stencil brush has also been used in places to "mash" colors together and roughen the surface.

7 Colored ink is brushed over the pastel, intensifying the brightness of the hues and introducing a rhythmic brushed texture. The artist can work freely over the edges of the painting, as the masking tape protects the borders of the

paper and will ensure that the final image is cleanly framed.

6 The geometric qualities of individual shapes are more sharply defined, with the edge of the pastel used to draw strong, heavy lines, sometimes guided by a ruler. In this picture, you can also see areas

where the artist has used STIPPLING and SCRAPING OUT to vary the surface qualities of the pastel marks, and where the slight translucency of oil pastel has been exploited in creating depth in the color overlays.

8 The area of sky that forms the background of the image is also reworked with fluid ink washes and spattering applied over the oil pastel marks. This use of RESIST TECHNIQUE creates a very rich texture which the artist

develops with soft, stabbing strokes of the brush. Here again, the masking tape is forming a clean edge to the rendering, over which the brushwork can be freely manipulated.

9 The artist now uses opaque white ink to "clean up" areas of the drawing and block out any loose pastel marks that he does not wish to keep. This heightens the pale tint of the sky behind the crane tower,

throwing its linear framework into sharper relief.

10 When the artist is satisfied with the balance and detail of the rendering, he removes the masking tape that frames the picture area. Despite the vigorous activity of the ink and pastel work within the frame,

the masking has maintained a firm, hard edge, an important element in the overall image.

DAVID FERRY "Construction Site"

Mixed media effects

These details of the finished picture show the immense variety of surface texture obtained by the different techniques, particularly the fluid patterning of ink and oil pastel resist (top left) and the harsh, calligraphic quality of sgraffito (left). The artist has also made

the most of individual color cues, such as the strong red of the oil drum, and has enlivened the image by interpreting the industrial grays with loose color blends of yellow, brown, purple and blue.

THE FIGURE

he human figure is an extensive resource for the artist, providing a theme that encompasses many different formal and expressive elements. You can view a figure simply

as a compact structure composed of related forms and volumes, or you can engage with the individual person, so that your rendering identifies a particular mood or activity or locates the figure in context by details of dress, accessories and environment.

The many different traditions of figure work give artists all kinds of access to the subject. Study of the nude figure has been a classic element of formal art training for centuries, and many artists still feel it is an important aspect of figure work, hence the survival of the traditional life class. For most of us, however, the theme of the human figure comes in terms of ordinary people — people that we know, people that we see in the course of daily life. Among the most accessible models are family and friends, often seen at home and engaged

in everyday activities. To avoid formal posing, you can catch these subjects while they are relaxing — reading, watching television, listening to music, or even asleep.

Beyond these domestic situations, you must begin to accommodate more movement in the figures, as with people you see in the street or park. If you wish to make movement a more prominent element you can go to locations where activity is the main purpose — such as a sports center or dance studio.

The medium

Pastel is a very versatile medium for figure work, for the images you create can vary from quick sketches to highly finished, detailed, full-color compositions. Pastel's linear qualities can express contour, direction and motion, while its painterly ones provide the means to interpret mass and color.

Your approach to figure work and the techniques that you use depend to some extent on your viewpoint and the

figure's prominence in the overall composition. Because of the directness of pastels, you need to have a sense of what most interests you about your subject, so that you can develop your work to the desired stage without too much overworking or correction that might deaden the image. Your technical skills need to be subtly varied if you

are working on close studies, where

nuances of tone and texture make a dramatic contribution to the finished image. On the other hand, if you are drawing a crowd of figures in a busy recreation area you can take a freer approach single pastel stroke may represent a whole head or torso, giving the impression of individual figures.

torso, giving the impression of individual figures emerging from a mass of brief marks and color accents.

SALLY STRAND "Court Break" This artist achieves a remarkably precise sense of realism, yet the images are large and her technique allows a great deal of freedom. She first draws in charcoal on heavy watercolor paper, then rapidly brushes in watercolor washes to define basic shapes and forms. These washes are the opposite colors of what the pastel painting will be - for example, she lays in warm ocher for an area that will ultimately be blue. The pastel overlays are built up with LINEAR MARKS, working from dark to light and counterpointing the hues and tints. In later stages, SIDE STROKES and finger BLENDING add to the weight and solidity of the forms. The quality of light is orchestrated by means of color. There is no white in this painting - the players' clothing is a brilliant combination of pale tints, including green, blue, mauve, pink and yellow.

The standing figure is a dynamic form, the body seen in full proportion and with the tension of imminent movement — since few people stand stock still for long. Every

standing pose has its own specifics of weight and balance; for instance, the torso may be firmly supported on both legs, or have the weight shifted to one side with one leg bent or extended. Other factors that contribute to the balance of the pose are the angle of the head in relation to the body, and the disposition of the arms.

The individual character of the figure in a particular pose is a combination of internal and external detail. The simple outline of a figure can be very telling, but the volumes of which it is composed, and their formal relationships, create the solid sense of realism.

Clothing adds color to your rendering and is also expressive of both form and character. It makes useful surface detail, but look for the ways in which it can also describe aspects of the pose, emphasizing or concealing the contours of the body and adding to the rhythms and tensions of the figure.

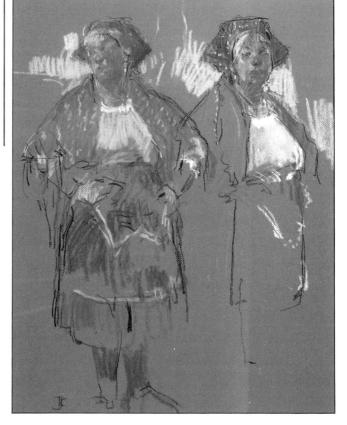

■ IRENE WISE
"Sylvie at the Paris
Rendezvous"
Vigorous GESTURAL DRAWING
creates a bold image capturing
the mood and character of the
subject. The contours of the
figure are simply expressed,
but are finely descriptive of the
body's weight and balance.

TOM COATES
"Peasant Woman"
The solidity of the figure
emerges clearly from a
"nervous" outline sketched in
black and loosely filled with
color. This is a very stable
pose, with the axis of the body
running vertically and balanced
by the angles of the arms.

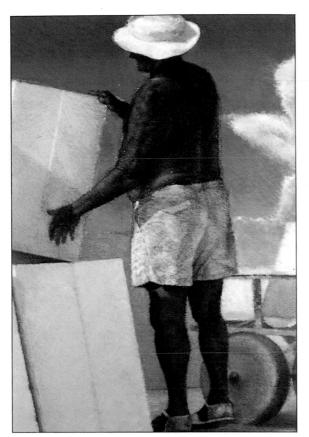

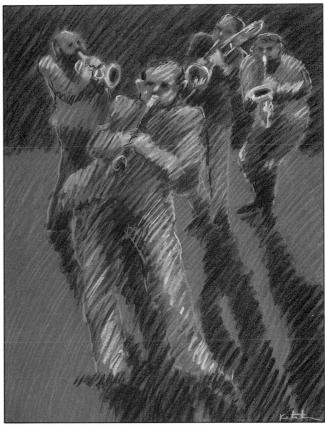

▲ KEITH BOWEN

"Spanish Quarry" (detail)
The stocky shape of the stoneworker is seen as a virtual silhouette against the pale shades of the sky and stone, but each component is subtly modeled with light and shadow. The tilt of the body is seen in the repetitive, parallel stresses through the shoulders, waist and alignment of the feet.

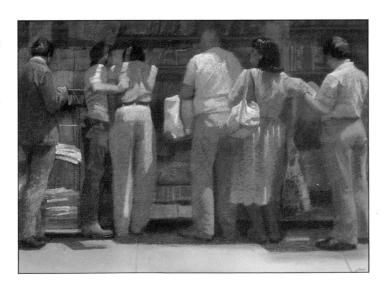

▲ CAROLE KATCHEN
"Peanuts Hucko"
Although the body shapes are
not precisely realistic, they are
wonderfully expressive of the
musicians' energy and tension,
the active qualities of each
pose enhanced by the loose
HATCHING of the pastel strokes.

■ SALLY STRAND
"Corner of 48th"
This group incorporates subtle but dynamic shifts in the poses.
Notice the vertical stance of the man on the right, the slight backward angle of the woman beside him, and the forward-leaning attitude of the man in front of her.

The study of a person performing a specific task may be an opportunity to portray an unusual configuration of body and limbs and to examine visual rhythms and tensions not expressed in formal poses. There are different ways of conveying activity and movement, the two most common being a "freeze-frame" approach that

focuses one aspect of the action, or a more abstract, sketchy approach that is often applied to rapidly moving figures.

Examples of the latter method are illustrated in the following section, while the compositions shown here take the first approach, a "snapshot" of the figure at work or play. In portraying the

figure itself, it is important to notice the exact angle and direction of different parts of the body which contribute to the action, and also the way clothing and props help to explain the nature of the activity. Each of these images is carefully composed to convey the impression of the person's physical and mental concentration.

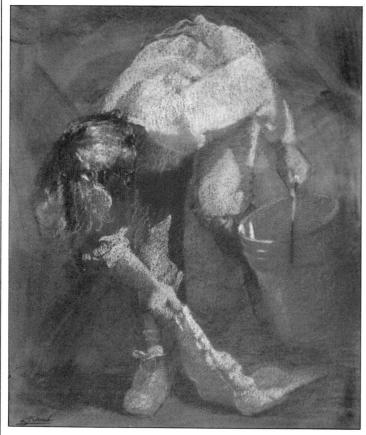

▲ SALLY STRAND
"Nearly Overlooked"
The action is described both by the contour of the body and the pattern of light and shadow within it, the rhythms echoed by directional strokes.

► KEITH BOWEN

"Bricklaying"

The bent and stretched poses of the bodies create an active configuration offset by the geometry of the location.

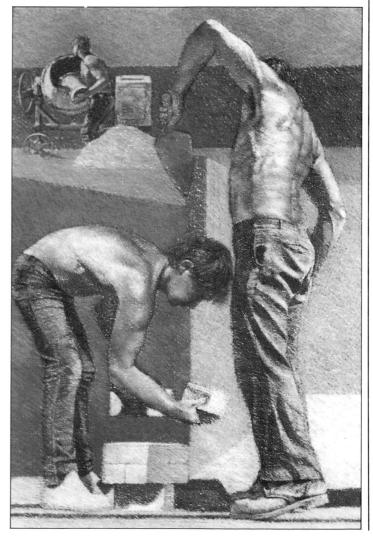

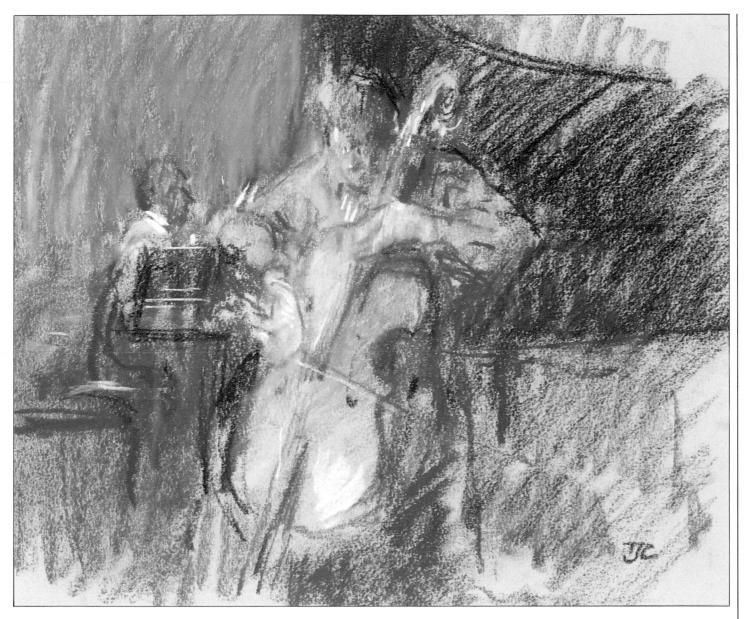

▲ TOM COATES "Cellist"

The free technique of this study makes an image less strictly representational than the two pictures opposite, but all have formal similarities. The figure is the central focus of the

composition, and the directions of the pastel strokes construct the rhythms and tensions of the poses.

Very rapid motion is difficult to convey, although as previous examples have demonstrated, precise rendering of a split-second action can be highly descriptive, seeming to encompass the essential character of the action.

A very different approach is taken here, using the calligraphic qualities of the medium and the free motions of the hand to travel along with the whole movement, building up a dense network of related marks and overlapping contours. This is particularly effective with stylized or repeated movements, such as dancing or exercising, as certain visual cues and points of reference return throughout the cycle.

This needs a vigorous, uninhibited technique — the drawing should emerge quite freely. There is always an element of experiment, and some sketches will be more successful than others; but as you will be working rapidly, you should soon achieve some interesting results.

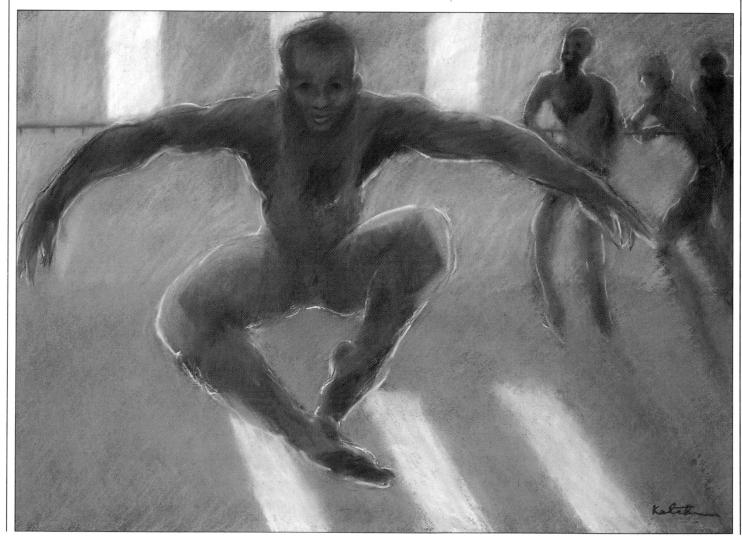

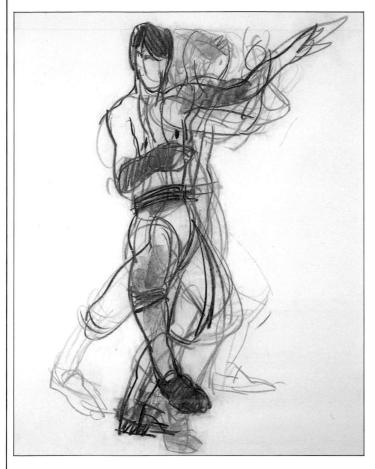

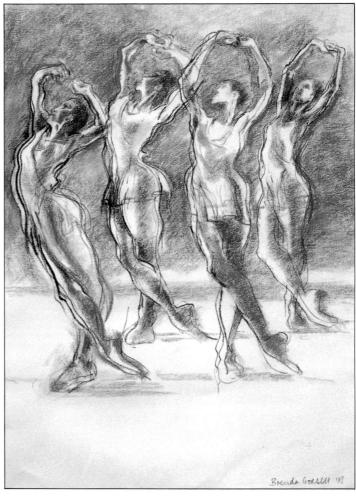

■ CAROLE KATCHEN
"Ronnie in the Air"
LOOSE SHADING and color
BLENDING produce a soft SFUMATO
effect which is highly
atmospheric, but the slight
dissolution of the figures is
pulled back by the brilliantly lit,
broken contour lines. The
painting is quite large,
29½×39in, and the gestural
qualities of the densely meshed
strokes are clearly visible.

GEORGE CAYFORD
"T'ai Chi Exercise"
When describing the continual motion of a figure, it is necessary to guide the pastel freely in direct response to the movements as they are seen. Speed is essential; thus the pastel is used here mainly as a line medium, with varying colors explaining different sequences of the exercise.

▲ BRENDA GODSELL
"Dancers in Gray"
In this CHARCOAL AND PASTEL
study, the tonal balances
construct the figures quite
solidly, but the rapid retracing
of the contour lines contributes
the fluidity and rhythm of
transient poses that will shortly
flow into different
configurations. Because the
colors of pastel are so
appealing, its dramatic potential
as a monochrome drawing
medium is often overlooked.

Figure groups can represent all of the visual points of interest of the single figure, but their interactions are the keynote of the image. The elements of composition are as important as the details of individual form and character — alignment of the figures, the relationships of size and proportion, the space or closeness between them, and the relative distance from the viewer.

The grouping may be random, as with people on the street, or it may be due to a common purpose, of people come together to share an activity or form an audience. The active and passive relationships between the figures can be expressed in the composition, whether or not the group's full context and surroundings are portrayed.

► SALLY STRAND
"Taking the Daily Paper"
The artist enjoys the incidental compositions of daily life. The extraordinary qualities of light and color in her large-scale pastel paintings are built up gradually, playing off dark against light, and warm colors against cool hues.

ERIC MICHAELS
"At the Well Chichicastenango"
The randomness of figure
groups that are "found" rather
than posed creates interesting
compositional elements. This
close focus on forms cut off by
one another and by the framing
of the composition creates an
intriguing sense of narrative, as
well as a vivid orchestration of
color and pattern.

The most common problem in drawing children is identifying the precise characteristics that make them childlike — they are not mini-versions of adult people. The head is larger in proportion to the body than in an adult; the limbs are mobile and flexible, but the chubbiness typical of young children disguises bone and muscle structure.

Another difficulty is getting a child to pose. If you are working from life, you need to choose a style and technique that enable you to work quickly or can accommodate changes in the pose if the child becomes fidgety. If you are working on a more complex composition that needs prolonged attention to detail, you may need to work from photographic reference and, if possible, ask the child to pose briefly to check any elements of form and posture that are not clear from your reference pictures.

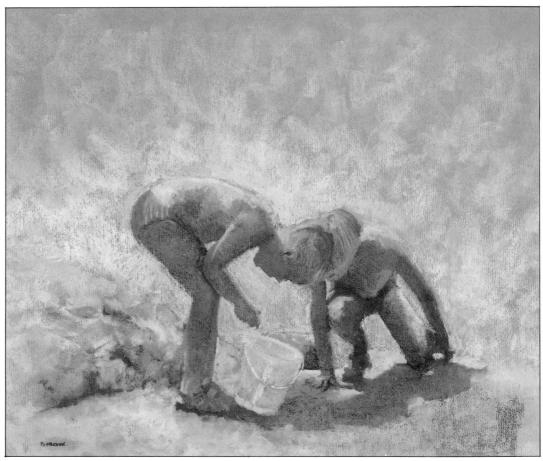

▲ BARRY FREEMAN "Curiosity" Children have an easy suppleness that enables them unconsciously to create graceful poses in the course of ordinary action and play. In this composition, the two bodies are linked in a rhythmic, selfcontained shape at the center

of the composition, the more striking because detail of their surroundings is minimized. The natural color diversity and gentle technique express the simple pleasure of the subject. Broad, grainy pastel strokes, juxtaposed and densely overlaid create defined areas of integrated light and color.

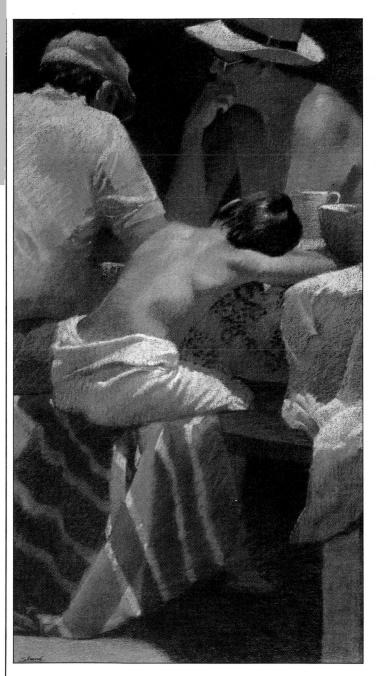

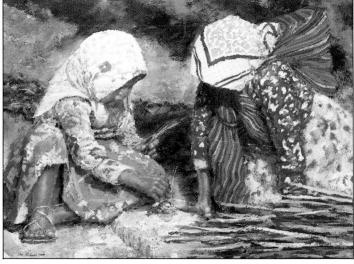

■ SALLY STRAND
"Played Out"
This lyrical painting
demonstrates that there is no
particular trick to portraying
children; it simply requires
highly accurate observation.
Here, the artist has found the
precise contour and texture of
the child's body that are
unmistakably expressive of his
youthfulness.

▲ ERIC MICHAELS
"Simple Treasures"
Like the painting of the two
boys on the beach opposite,
this delightful study captures
the typically childlike poses and
concentration on play. The style
of their bright clothing,
introducing an exuberant color
choices, appears imitative of
the adult version, but the
weight and proportions of the
bodies and the tiny glimpse of
the left-hand figure's face all
display the characteristic
features of the child.

Many of the figure studies illustrated in this section show at least some of the surroundings. In some cases it is no more than a general indication of the kind of space the figure occupies, while in others the setting is treated in enough detail to suggest a kind of narrative background. Describing the setting can help you to explain the character or

action of the figure, but it also expands the variety of compositional elements that need to be considered from a technical point of view.

The more of the surroundings you include, the more you encounter the elements of scale and space. An interior setting introduces a specific perspective; a landscape background has to

convey its space while sensibly relating to the size of the figures. New details of color and surface texture are added to the composition; and as the figure becomes one of a number of visual components, you need to decide how to use your pastel techniques, either to make the figure stand out as a focal point or to integrate it with the other elements.

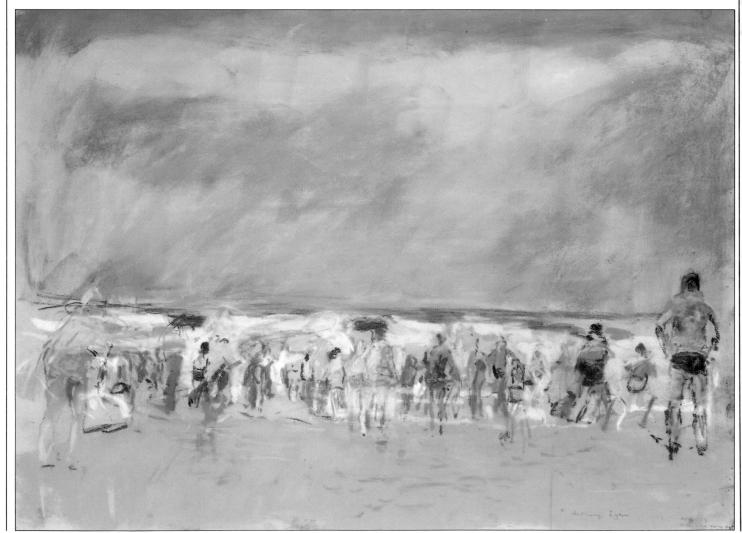

There are various technical factors that you can bring into play here, such as the emphasis and activity of the pastel marks, and how they are used to describe different elements of form and surface detail. Other factors are the color relationships within the image, with strong colors used as points of accent and focus; the patterns of light and shade

that model the spaces and volumes; and the relative distinctness of individual shapes and forms, as when something that is sharply described stands out against a more impressionistic background.

■ ANTHONY EYTON
"Biarritz"
This is a rapidly executed study, with the main color areas of sky, sea and beach freely

shaded and scumbled, and the dense activity of the figures applied gesturally, using LINEAR MARKS and bold dashes of vivid and dark-toned hues.

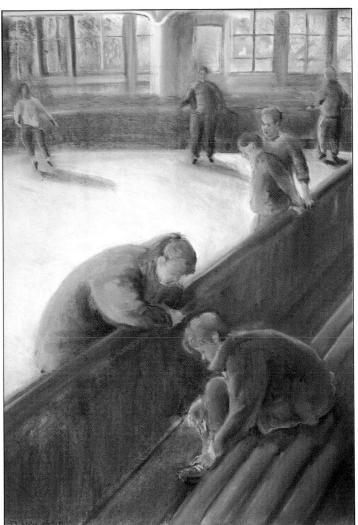

■ SALLY STRIDE

"Two Girls on a Tree Trunk"
The landscape setting dwarfs the figures, but they form the focal point of the composition.
This is achieved by giving solid structure to the forms of the tree trunks and the two girls, while the remainder of the landscape is merely suggested in the rich pattern of LINEAR MARKS creating an abstract color study.

▲ IRENE WISE
"Skaters at Richmond"
The casual, recreational aspect
of the subject almost disguises
the careful thought given to the
composition in the way the
figures occupy the space.

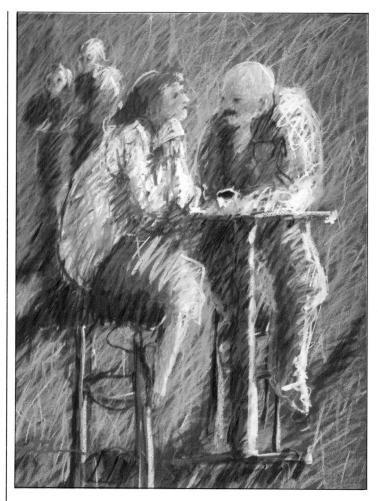

▲ CAROLE KATCHEN
"Conversation at the Rose
Café"
Only the stools and table
identify the setting here, but
this energetic painting
beautifully implies an informal
café atmosphere.

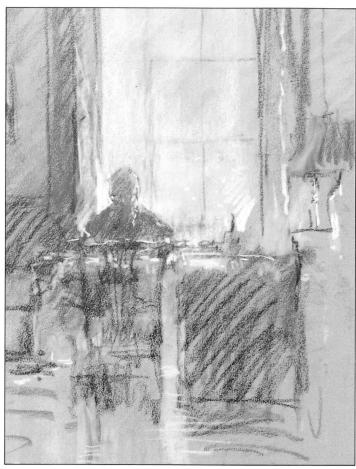

▲ TOM COATES

"Figure Against a Window"
A familiar interior setting can become a powerful study of light and form. In the direct frontal view of the figure seated in front of the window, the composition is a bold

construction of geometric planes and simple masses, economically drawn with monochrome lines and SHADING, and enlivened with warm/cool color accents and strong HIGHLIGHTING.

There are various technical factors that you can bring into play here, such as the emphasis and activity of the pastel marks, and how they are used to describe different elements of form and surface detail. Other factors are the color relationships within the image, with strong colors used as points of accent and focus; the patterns of light and shade

that model the spaces and volumes; and the relative distinctness of individual shapes and forms, as when something that is sharply described stands out against a more impressionistic background.

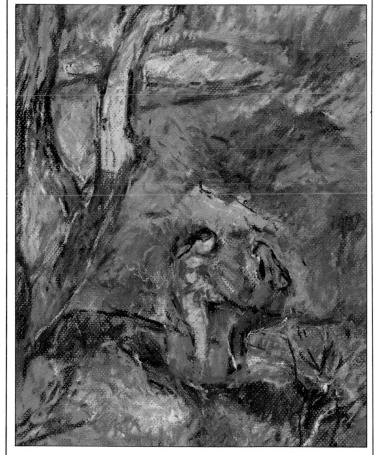

■ ANTHONY EYTON
"Biarritz"
This is a rapidly executed study, with the main color areas of sky, sea and beach freely

shaded and scumbled, and the dense activity of the figures applied gesturally, using LINEAR MARKS and bold dashes of vivid and dark-toned hues.

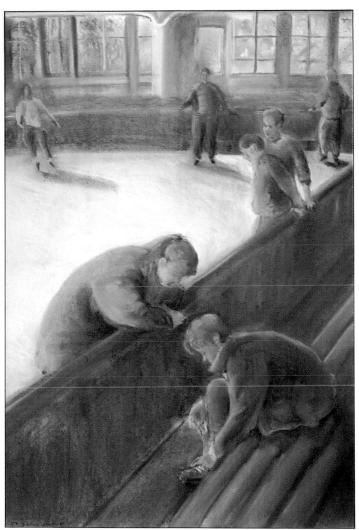

■ SALLY STRIDE

"Two Girls on a Tree Trunk"
The landscape setting dwarfs the figures, but they form the focal point of the composition.
This is achieved by giving solid structure to the forms of the tree trunks and the two girls, while the remainder of the landscape is merely suggested in the rich pattern of LINEAR MARKS creating an abstract color study.

▲ IRENE WISE "Skaters at Richmond" The casual, recreational aspect of the subject almost disguises the careful thought given to the composition in the way the figures occupy the space.

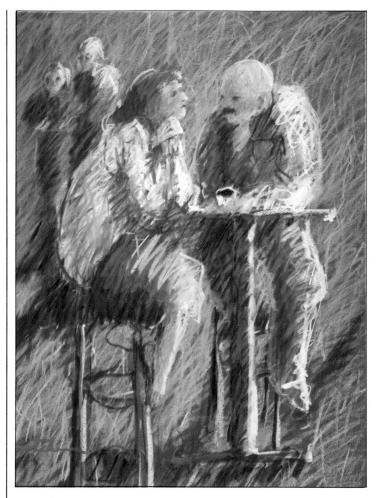

▲ CAROLE KATCHEN
"Conversation at the Rose
Café"
Only the stools and table
identify the setting here, but
this energetic painting
beautifully implies an informal
café atmosphere.

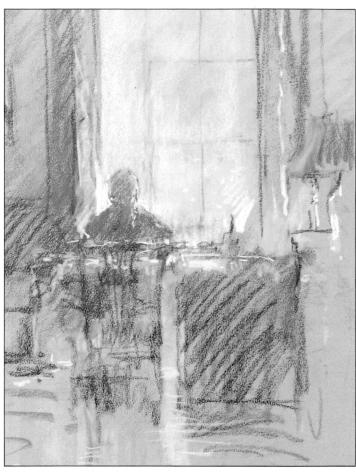

▲ TOM COATES

"Figure Against a Window"
A familiar interior setting can become a powerful study of light and form. In the direct frontal view of the figure seated in front of the window, the composition is a bold

construction of geometric planes and simple masses, economically drawn with monochrome lines and SHADING, and enlivened with warm/cool color accents and strong HIGHLIGHTING.

▲ MARGARET EVANS
"The Beaters"
Varying directions in the hatched pastel strokes convey both the horizontality of the landscape and its recession from foreground to horizon. The consistent technique of

combined SHADING and HATCHING describes the variety of form and texture, so that the figures are visually integrated with the landscape, but also stand out. Pale tints overlaid on the muted, earthy colors suggest cool morning light.

The classical and academic values of the life class persist in that the unclothed human body is still used as a vehicle for studying form and proportion. However, with the enormous variety of technical and conceptual approaches that have emerged in the modern age, the nude study also remains an active inspiration. It can be treated

purely as a drawing exercise, but is often interpreted more expressively; each example illustrated here conveys a different mood and context.

Outside the formal life class, it can be difficult to set up the right situation for this kind of figure study. But if you can find someone willing to pose for you at home, the more intimate atmosphere of a

household setting gives an evocative character to the image. Nowhere is the formality of life drawing better integrated with a personal and social context than in Degas's pastel paintings of women bathing — and his inventiveness with technique and composition makes these images enduring models for pastel work.

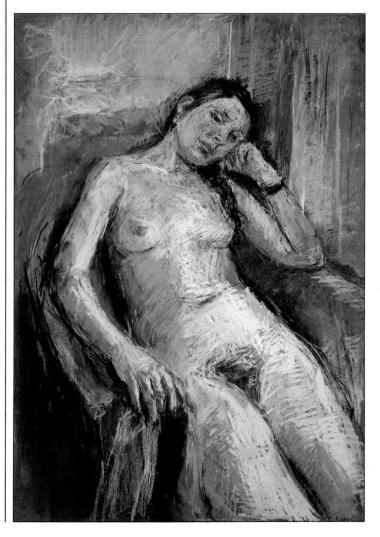

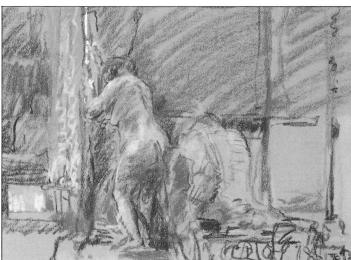

■ ANTHONY EYTON
"Cryss in a Pink Chair"
This is a large painting, just under 4ft high, allowing the pastel strokes to display considerable energy right across the surface. The artist used fixative frequently throughout all stages of the painting, to help get the drawing right and create a ground to work on. It was drawn from life, requiring six or seven sittings to complete the image.

**TOM COATES
"Model in Studio"
The broad setting of the life room is included in the composition, so the figure becomes only one element, not the main focus. Her attitude also suggests an incidental movement rather than a formal pose, which creates the logic of the sketchy technique applied to the drawing. The figure is differentiated by its form rather than by color detail.

べCLIFFORD HATTS
"A Life Study"
The contour of the figure is sharply drawn with hard pastel, the delicate colors "brushed in" with gentle SIDE STROKES in soft pastel. The heavy grain of the TEXTURED GROUND breaks up the density of the pastel, providing a basic medium shade that accentuates the hints of strong color and gives the tints and highlights a special, shimmering vibrance.

DEMONSTRATION VINCENT PARKER

The classical reclining pose is adapted to a distinctively modern setting. The window provides strong directional lighting, and the artist uses both the figure's natural flesh tones and the primary colors of the pillows to illuminate the image with pure hues and brilliant pale tints.

2 A general impression of the light and medium shades is blocked in with side strokes and roughly blended color areas. The color blocks are complemented by active LINEAR

MARKS relating to the contours and angles of individual forms. Notice how the artist has begun to set up links between similar values of hue and tint across the whole image.

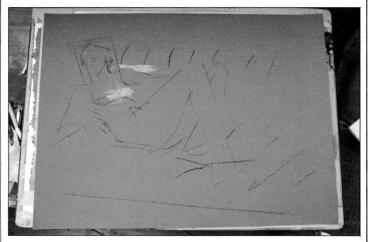

1 The dense gray-blue shade of the paper will give additional vibrance to the pale, warm flesh tints. A simple line sketch in black establishes the main volumes of the figure and the specific angles of the pose. The artist uses bright pastel colors to dash in a few strong lines and grainy SIDE STROKES that form an initial key for the color values.

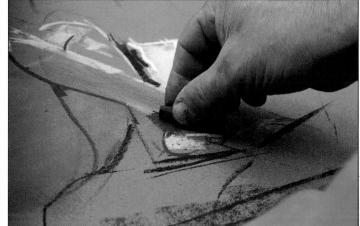

3 Bold line work is used to retrace the contours of the figure, complemented by broad, grainy side strokes to block in shadow tones that emphasize the volumes. The use of black and dark brown

against the high yellows creates a vibrant tonal contrast, enhanced by the complementary color of the blue ground.

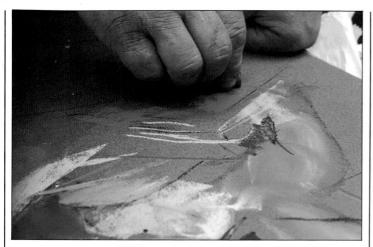

4 Within the limited scale of the drawing, the artist uses a free, gestural approach, forming active marks and a variety of surface qualities. He moves easily between drawing with the tip of the pastel to blocking in

broadly with side strokes, rubbing the colors in places to produce loosely blended masses. To limit the scale of the marks, small broken pieces of pastel are used for the side strokes.

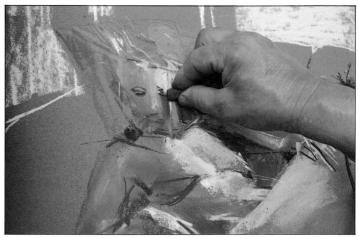

6 Individual features of the body and head are developed in more detail, combining strong, structural line work with solid color masses creating volume. To model the forms, the artist uses not only dark shades, but also cold, pale hues that suggest shadowing by contrast with the warm brown and yellow flesh tints. Frequent ACCENTING with vivid hues helps keep the surface alive.

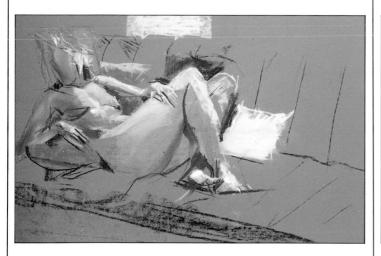

5 By this stage the figure has firmly taken shape. Dark contours are contrasted with intense HIGHLIGHTING in white. The light from the window is suggested by the simple block of white SHADING which relieves

the uniformity of the background tone. By sketching in the sofa, the artist sets the figure fully in context.

7 Although the head is quite a small element of the image, the linear marks are laid in freely and boldly to structure the details of face and hair. The colors and tonal values are also boldly stated, seeking a

distinctive impression of form and texture before more detail work is done to refine the shapes.

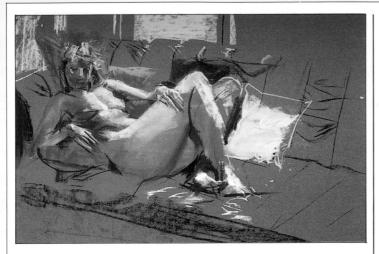

8 Many elements of the image are still very open and sketchy, but the rendering already conveys a clear sense of the interior's spatial arrangement and of how the weight and volume of the figure are solidly supported by the sofa and throw pillows. The many individual pastel marks have a great sense of vitality, but their interactions contribute to an increasingly subtle representation of form.

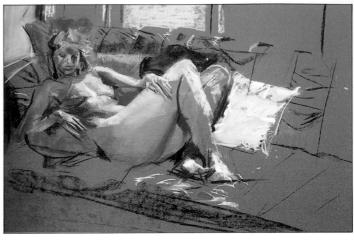

10 The solid volumes of the sofa and pillows are more fully described, enhancing the shading contrasts to create a more vivid sense of illumination. The blacks loosely blocked in with side strokes are

underpinned by heavy line work, and a similar technique is applied to the dramatic bright yellows of the right-hand pillows.

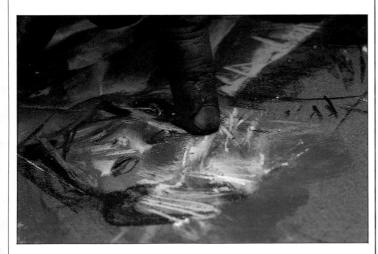

9 The face and hair are reworked with vigorous HATCHING, the linear pastel strokes smudged and dragged with the fingers to build up the density of color. Although there is a random element to this

kind of free technique, the artist is paying careful attention to the resulting qualities of shading and texture.

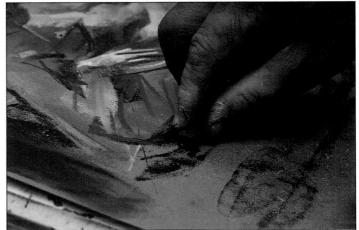

11 This detail gives an interesting impression of the virtually abstract pattern of individual marks and shapes that the artist is building, yet each element has a specific function in developing the

structure of the image. Parts of the surface are still open and grainy, juxtaposed with areas where the colors are richly blended and overlaid.

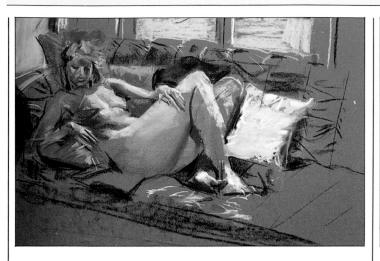

12 With the second windowpane sketched in with loose shading, the tonal balance of the image is adjusted once again. The artist rapidly dashes in brilliant color accents with short, slashing

strokes to heighten the strong hues of the blue and green throw pillow.

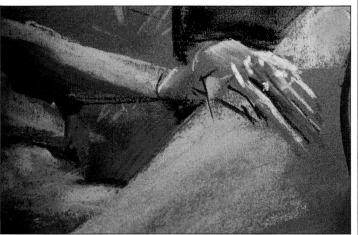

13 In the final stages, the artist concentrates on bringing up the highlights, adding touches of pure white to the hands and face and brightening the pink pillow behind the model's head (see below). Although many

details of the form are not rounded out fully, the finished image is both highly descriptive and vividly expressive.

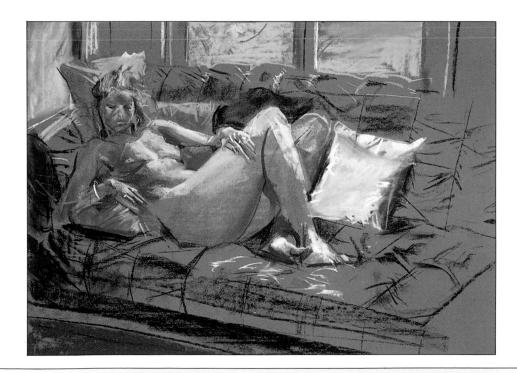

VINCENT PARKER "Reclining Nude"

PORTRAITS

ortraiture is one of the classic themes of pastel painting, very richlyexpressed in the work of 18th-century artists such Rosalba Carriera (1674-1757), Maurice Quentin de la Tour (1704-1788) and Jean-Baptiste Perroneau (1715-83). It was carried through into the modern age by artists as diverse as Henri de Toulouse-Lautrec (1864-1901) and Umberto Boccioni (1882-1916). Whereas the earlier artists took advantage of the smooth blending qualities and subtle tints of soft pastels to produce detailed, complex portrayals of facial features and lavishly styled accessories, their modern counterparts preferred to exploit the medium's expressive qualities of brilliant color and linear vitality.

The likeness

Portraits take many forms and involve different degrees of visual analysis, but their essence lies in creating a likeness. This does not necessarily mean accurate "copying" of a person's features — sometimes the detail of the features is indistinct, or even absent, but the character of that person emerges

vividly from minimal visual cues.

The best portraits contain something about the mood and style of the sitter. It may pay you to risk slight exaggeration of the most dominant features, to

emphasize the person's coloring, to pose them in a way that demonstrates an unusual but characteristic gesture. You can also select clothing, props and background that give the subject a particular context, and provide you with additional formal elements of composition that you can work with inventively.

One of the difficulties of portraiture is persuading someone to pose — being an artist's model is quite boring, and often more of a physical strain than you anticipate. You can work up a successful portrait from a photograph — in fact, an ordinary snapshot can be

the inspiration for a drawn or painted portrait, because candid photographs often capture a transient expression or

mood that represents the person more effectively than a static pose.

When you work from life, it is not necessary to condemn your model to hours of immobility; for one thing, tiny shifts in the pose and changes you incorporate when coming back to work after a break can give vitality to the image.

Because pastel techniques have such immediacy, you should be able to establish a good grounding for the portrait

in a relatively short time. Both the theme and the medium call for an approach that maintains its freshness and spontaneity — a series of quick color sketches is a good buildup to a full-scale rendering. Portraiture is not best served by labored technique.

SALLY STRIDE "Erick"

This is a charming character study, although details of the facial features are deliberately vague. The shapes of head, body and limbs and the overall posture are highly descriptive. The relatively simple color treatment of the figure throws him into relief against the complex masses of pattern and texture in the surrounding interior setting. Clean, sharp HIGHLIGHTING adds to the definition of form. The color range is richly varied, but effectively balanced, giving full impact to the individual hues and shades, but adding up to a cohesive, expressive image.

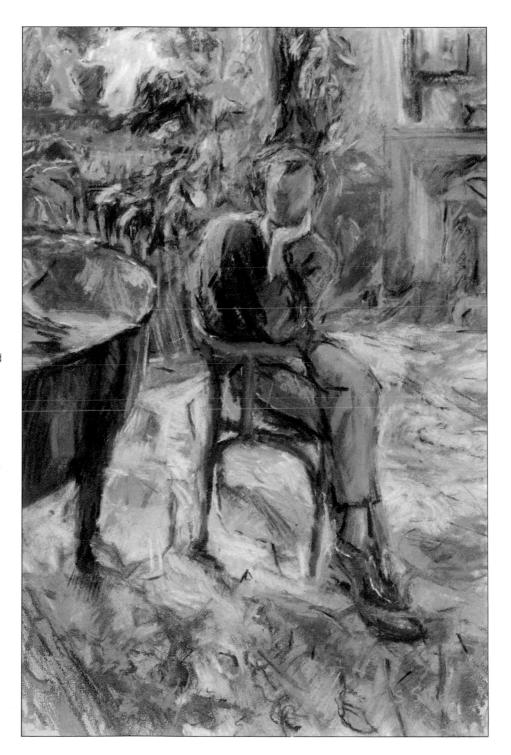

The face is usually the focal area of a portrait, so it is common that pastel portraits concentrate on the head. This single aspect of the person presents many challenges to the artist — the shapes of individual features are crucial, as are the colors of the skin tones and the way the hair frames the face.

The details and nuances are small scale and require very concentrated attention. However, they do not necessarily have to be tightly drawn to achieve the likeness; they can be very successfully represented using vigorous strokes and a bold approach to line and mass.

Facial features — eyes, noses and mouths — are difficult to draw. While some artists have a happy facility to catch the precise shape and form with a few brief marks, others find these details extremely troublesome and fail to marry observation and technique. You need to study carefully the precise shapes and apparent "outlines" of the features, the way they are modeled with subtle shifts of light and shadow, the tiny color changes that give life to eyes and mouths.

Skin tones vary enormously,

both in their natural coloring and with the kind of light thrown on the face. In pastel work, it is common to use BROKEN COLOR effects rather than smooth blends to model the contours of the face, because in this way you can pick up and make the most of every color detail. As demonstrated in the examples here, if you work on colored paper (see COLORED GROUNDS), it can be left bare or lightly covered to represent the base color of the skin or the shadow color. This is a helpful technical aspect of the pastel portrait.

Hair is a part of the portrait you can have fun with when using pastel, the linear quality of the pastel strokes lending itself to the textural detail. This can be contrasted with the techniques used to portray the face, or it can be integrated with the strokes describing flesh tones and shadows.

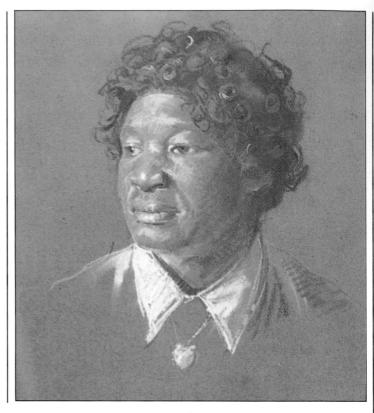

▲ JOHN HOUSER
"Amanda of John's Island"
The color of the ground forms
the basic middle tone of the
skin, with the lights and
shadows colorfully interpreted
by HATCHING AND CROSSHATCHING.

■ JOHN HOUSER "Denise"

The neutral gray of the paper sets off the warm flesh tones, which are also complemented by the cool yellow TINTING where the contours of the face reflect the light. Delicate HATCHING and SHADING are used to develop the softly modeled forms.

▼ JOHN ELLIOT

"Salmagundian"

The rugged, weatherbeaten texture of an older man's skin is represented with rich, dusky pinks and browns, using fine LINEAR MARKS to convey the lining of the face and give

definition to the features. Notice how the shadow areas are typically formed not by overlaying solid, dark tint, but by allowing the grainy texture of the initial BLOCKING IN to emerge through the subsequent reworkings.

▲ JOHN ELLIOT
"Young Professional"
Hints of strong color in the skin tones are developed boldly in oil pastel. The basic color areas are blocked in with SIDE STROKES and overlaid with HATCHING. The

slightly downward-tilted pose emphasizes the strong contours of the brow and nose, reinforced by the dramatic HIGHLIGHTING of one side of the face.

The age of the model is a fascinating aspect of portraiture, because different stages of life are represented by different kinds of visual information. The most obvious is skin texture - young skin is typically smooth with fresh

coloring; aging brings character lines and wrinkles, stronger shadowing of the features, and skin tones that are weathered or faded.

Other important cues are contained in the structure of the face, the shape of the head and the posture of the sitter. In children's faces, the features occupy a relatively small proportion of the whole head, and details are unformed. In adulthood, the underlying structure of bone and muscle shapes the face, and individual features become strongly defined — a heavy jawline or prominent nose, for instance. With age, the patterns shift again, eyes and mouth perhaps becoming sunken,

skin more heavily folded, and the hairline receding, thus altering the proportions of face and head.

The attitude of the head can also be characteristic of age and personality. A direct frontal view suggests confidence and maturity, a

downward or sideways tilt can imply youthful diffidence, the head resting heavily on shoulders and chest can convey tiredness or contentment in old age. Look for these expressive aspects of your sitter's pose as well as the simple physical details.

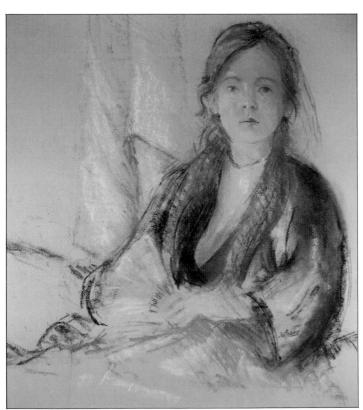

▲ MARGARET EVANS "Malcolm in Dressing Gown" Although a youthful subject, this portrait has strong character. The face and its features are freely described using a variety of warm hues counterpointed by cool blues and grays worked into the shadow areas.

▶ JOHN ELLIOT
"The Artist" (detail)
This portrait has a fascinating ambiguity: the eye is immediately taken by the patriarchal white beard before registering that it is attached to a face not yet aged. In the beard and hair, the basic colors are loosely laid in with a form of SCUMBLING, then developed with a complex pattern of brief, vigorous LINEAR MARKS. In the face, the hatched and shaded colors are more closely integrated, giving the firm profile an imposing, sculptural quality.

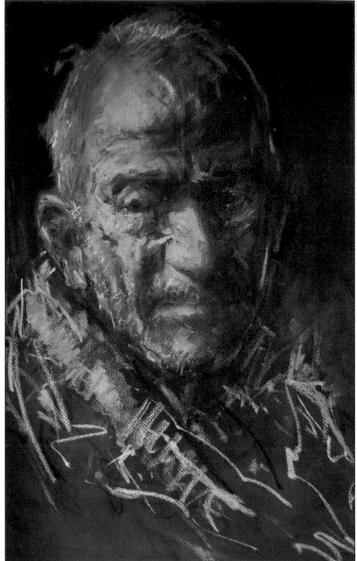

▼ TOM COATES

"Seated Man"

The loose, open technique gives this portrait a sketch-like quality, but the visual cues are thoughtfully selected to create a characterful study. The warm tint of the COLORED GROUND adds weight and depth to the composition.

**KEN PAINE
"The Gypsy"
The active approach to drawing and modeling the forms with pure color creates a dense massing of vigorous marks. The pose in a doorway casts the face half in light, half in shadow, with the hot sunlight represented by the strong reds.

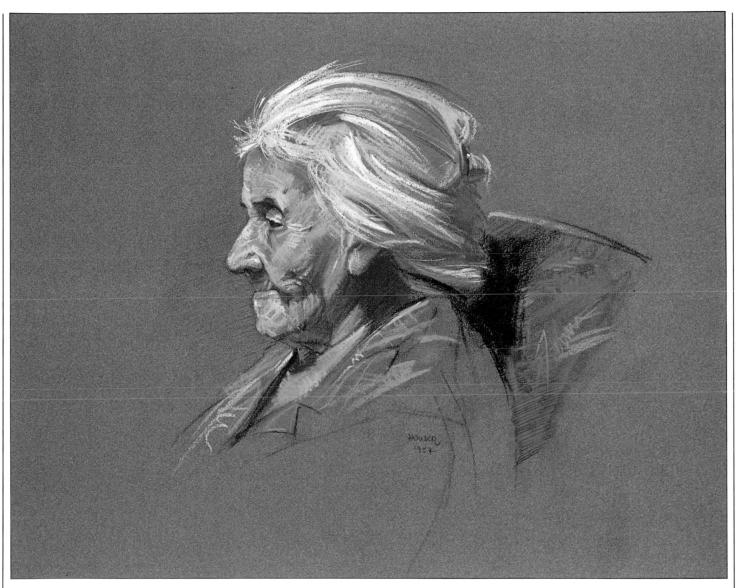

A JOHN HOUSER
"Ramona (Tigua Elder)"
A profile view shows
characteristic features of the
aged face, the sunken eyes and
mouth giving prominence to the
strong lines of nose and chin.
Skin tones and shadows are
built up with a complex network
of LINEAR MARKS and SHADING.

The warm colors and pale tints stand out on the deep blue ground, emphasizing the modeling of the profile.

The more of the model you include in the portrait, the more elements you can bring in to round out the description. The posture of the sitter, for instance, can express something about his or her character, hands convey a lot about age and lifestyle, and clothing and background can suggest occupation and interests. You may, of course, ignore these aspects and concentrate on the formal aspects of figure drawing.

When you set up a full-length portrait, think carefully about the relationship of composition and technique. Consider how prominent the figure should be within the overall image and the scale of the rendering. Decide what it is that really interests you, and relate it to the techniques you wish to employ. A free approach can work on either a small or a large scale, the pastel marks being highly interactive if tightly contained, and more open and gestural on a large scale.

Bear in mind that if you include a lot of props and background detail that you wish to describe with some precision, the actual execution of the work will take some time.

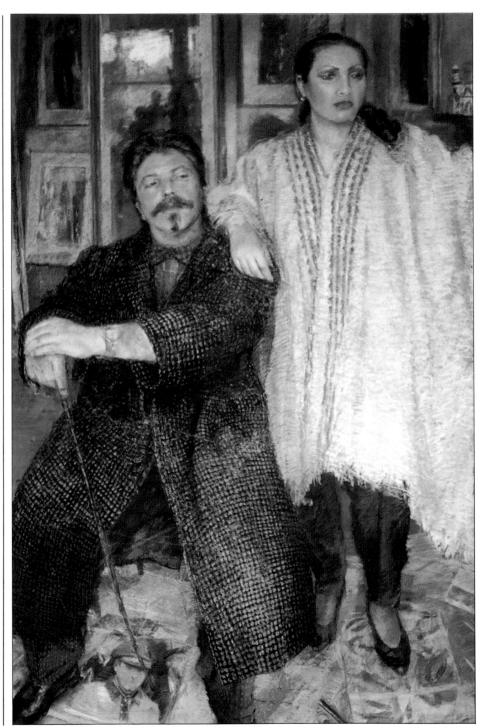

■ BARRY ATHERTON
"Unfinished"
At 5×7ft, this is unusually large for a pastel painting, making the figures approximately lifesized and allowing the artist to include a vast variety of detail, especially in the faces and clothing.

▲ BARRY ATHERTON

"Portrait of a Painter"

The informal pose and studio background give the figure both character and context. The dark clothing creates a solid shape, bringing the subject out clearly from the background, but even the darkest shades are alive with touches of vivid color.

Every mark plays an active role in modeling the forms and creating textural variety.

▲ TOM COATES
"Woman in Pink"
Although the technique used in this study is free and sketchy, using a variety of LINEAR MARKS, HATCHING and SHADING to

structure and round out the forms, it creates a precise and-powerful description of its subject. The limited color choice provides tonal contrast and local color.

Pastel is an excellent medium for rendering dramatic qualities of light in a portrait. The bright colors and scintillating pale tones lend themselves to intense highlights and splashes of strong illumination. For a heavy chiaroscuro effect, the pastel technique of working on a colored ground (see COLORED GROUNDS) is extremely effective. If you use a medium base, you can work up the extremes of shading using your darkest and brightest pastel colors, while maintaining a coherent overall scheme.

An almost monochrome approach creates a strong sense of mood, with any small touches of pure color serving to emphasize the tonal interpretation. However, while you do need some contrast of tonal values to convey dramatic lighting, you can also make use of strong color interactions to model the illuminated form — for instance, complementary contrasts such as red/green or yellow/mauve, and variations between warm and cool colors. or gentle and acid hues.

KEN PAINE

"Self Portrait in Repose" The wonderfully atmospheric SFUMATO effect of this portrait was achieved by working the brown soft pastel on heavy watercolor paper brushed with clean water. A strong sense of rhythm emerges from the combination of the pastel strokes and fluid WET BRUSHING. The white HIGHLIGHTING was added in the final stage.

► KEN PAINE

"The Composer" The basic forms of subject and background were blocked in with black pastel, over which the initial warm and cool color key was "glazed" in with light strokes. Gradually, the forms were more sharply modeled, using heavier pastel strokes and emphasizing the color contrasts. Note the use of brilliant, cold green and blue tints among the dark shadows and strong, hot pinks developing the warmer lights.

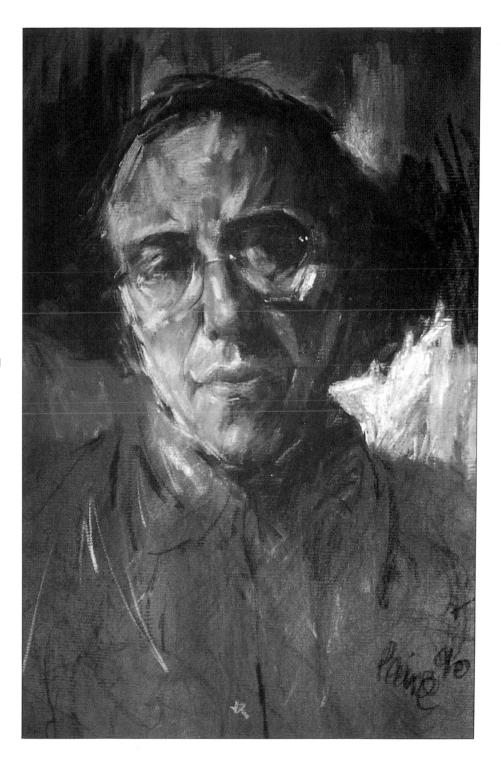

▲ JOHN HOUSER

"Big Wind"

The main light source from the side throws the subject's profile into strong relief, the clear-cut description of the features enhanced by the bold splash of brilliant red forming the background. All of the color cues are strongly realized, allowing each pastel stroke a distinctive contribution to the development of form and texture.

▼ KEN PAINE

"The Philanthropist"

A monochrome study

expresses the drama of the lighting. The technique seems very free and bold, but the

interpretation was carefully thought out. The pastel is built up in thick layers to an IMPASTO finish, identifying the particular structures within the overall shape of the head.

■ ERIC MICHAEL "Tztotzil"

This portrait has the quality of a "found" subject rather than a formally posed study. Such attractive compositions may occur incidentally in any context. The sideways light glances off the figure, causing the strong HIGHLIGHTING on the contours of face and arm, but leaving much of the skin area in shade, where acid green ACCENTING models aspects of the form, picking up subtle hints of reflected light.

DEMONSTRATION KAY GALLWEY

This portrait has an expressive gestural quality that records the artist's confident approach to the medium. While enjoying the freedom of a bold, calligraphic technique, she has achieved a remarkably true likeness of the subject.

Arranging the pose

The artist has chosen to create color interest by swathing the sitter in a patterned shawl and posing her against the backdrop of a decorative curtain. This gives a very rich surround that enhances the dramatic contrast of the pale skin tones and dark hair. The artist's easel is set up at an angle that enables her to see both the sitter and the drawing at the same time, so that her observations are quickly and directly transferred to the paper.

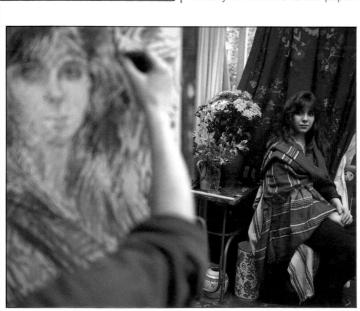

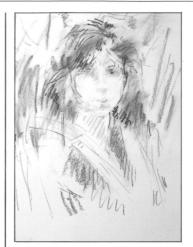

1 The general shapes of head, hair, face and upper body are loosely blocked in with bold LINEAR MARKS and HATCHING. In places, the pastel is spread by the movement of the artist's hand and by deliberate rubbing with the fingers. This initial, sketchy stage creates a general impression of the local colors in each element of the portrait. The darker pastel colors are used to define the basic structure of the head.

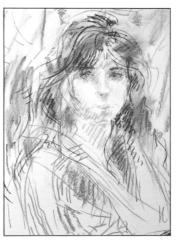

2 The artist relies on the calligraphic quality of the pastel marks to develop the detail of the portrait. From the increasingly dense network of colored lines, the modeling of face and hair emerges more clearly. The eyes are already quite sharply defined, as these are always a focal point in a portrait.

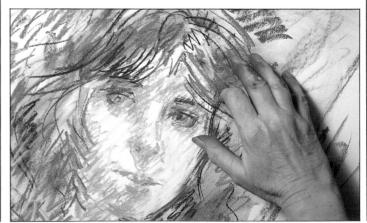

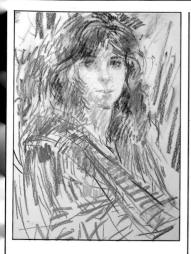

4 The whole surface is kept active at every stage. Although the use of color is now more elaborate, the rendering remains open and workable due to the loose weaving of strokes.

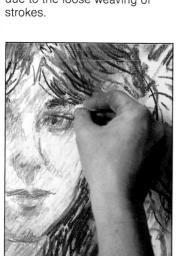

5 The modeling of the face and variation of the flesh tints is developed more intensely. Luminous HIGHLIGHTING is applied to the eyes and the projecting curves of the face.

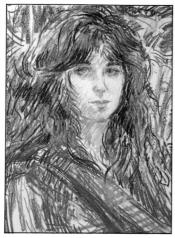

6 Strong directional lines describe the flowing hair; the colors provide greater contrast of shading. A similar treatment is applied to the folds of the patterned shawl.

7 Having added medium grays and mauves to the shadowing around the eye sockets and nose, the artist adds crisp finishing touches that bring back the focus and clarity of the eyes.

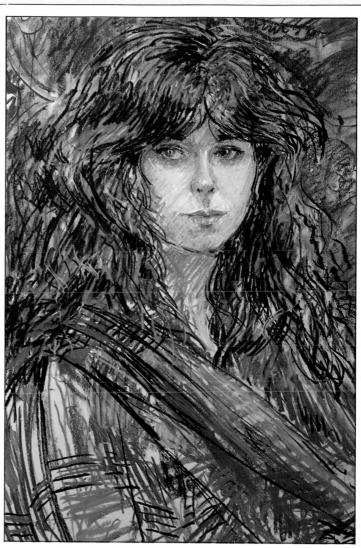

KAY GALLWEY "Portrait of Stefanie"

ANIMALS

he variety of pastel techniques — linear strokes, BROKEN COLOR, FEATHERING, HATCHING and STIPPLING — makes the medium ideal for representing animal textures. It is suited not only to the highly tactile qualities of fur and feathers, but also to the baggy, rough skins of animals such as the elephant and rhinoceros, and the smooth-haired hides of horses and cattle. As a dynamic color medium, pastel readily accommodates bold markings such as spots and stripes, the vivid color schemes of tropical birds, and the jeweled patterning of fish scales or snake skin.

Ways and means

Because animals rarely pose, most artists find it difficult, at least at first, to draw from the living model. The most obvious solution seems to be using photographs, which certainly widens the choice of creatures you can study at close quarters and eliminates the problem of the animal walking away before you can put pastel to paper. However, a static photographic image can be lifeless and lacking in detail. Where it is essential to work from photographs, be sure to allow your technique plenty of life of its own to convey your interest in the subject.

Study and practice

Pets are the easiest live models to start with, or farm or zoo animals, depending on accessibility. When you study the real thing, you may find it helpful at first to spend at least as much time watching the animal as you do drawing it. Give yourself time to get used to the continual movement so that you can start to identify the animal's characteristic details of form and texture.

If you want to put in some practice on describing detail, you can work from stuffed museum exhibits; some artists even use dead animals and birds

found in good condition. This enables you to study pattern and texture closely and unhurriedly, and to observe the ways a creature's markings relate to its physical structure. Anatomical studies are not essential to animal drawing, unless you want to take a scientific interest.

Bear in mind that the most detailed drawing of an animal is not necessarily the most realistic. When you look at a cat, a giraffe or a bullfinch,

you do not take in every hair, every color patch, every barb on a feather. A drawing or painting is always as much about your own perception as it is about the sum total of your subject.

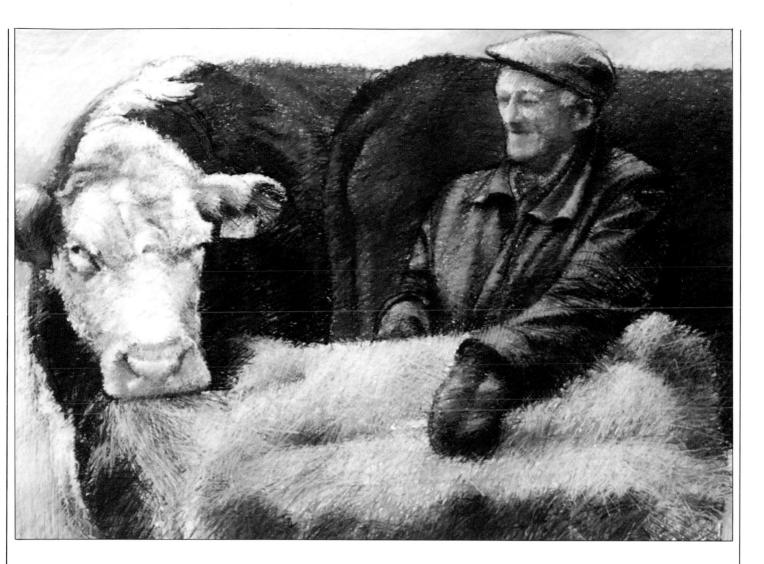

KEITH BOWEN "Winter Feed"

This combination of animal and human subjects conveys very clearly the context of the image and the scale of the massive beasts. The composition is interestingly divided into solid blocks of color by the strong vertical and horizontal stresses, but each color area is carefully modeled tonally and given a distinctive texture built up with

a dense network of individual pastel strokes. At 30×40in, the scale of the pastel rendering allows the artist to manipulate the linear textures very freely. It is worked on heavy white paper, which shows through in tiny glints among the dark shades of the animals' tough hides.

When you are working from live models, quick sketches are an invaluable method of getting to know animal forms. The free motion of a pastel stick enables you to respond very quickly to the movements of the subject, and you do not have the pressure to produce a highly finished image - a single, continuous line sometimes catches the perfect impression of a graceful animal contour. Many sketches are just as satisfying in their own terms as are more lengthy and considered works.

Sketching sidesteps the problem of getting enough time to study the animal effectively, because your representations can be a series of rapid drawings, or you can have several sketches on the go and return to the appropriate one according to what the animal is doing at any given time. Pets and zoo animals develop routine movements and cycles of behavior, so that you can count on an individual pose or movement recurring. With patience, you will begin to recognize the elements that are essential to your representation and develop effective ways of interpreting them in pastel.

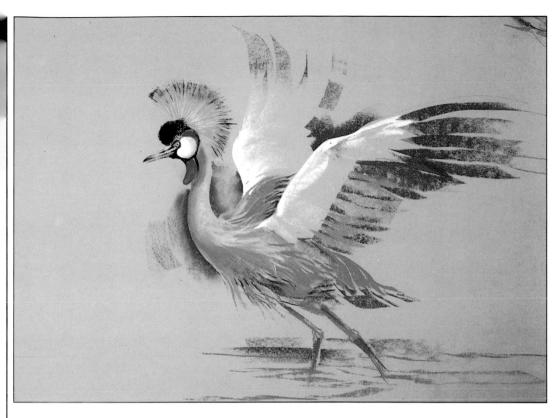

JOHN BARBER

"Crane"

Different types of pastel marks can be matched to the range of textures in an animal or bird. In this soft pastel sketch, the artist has used broad SIDE STROKES to define the sweeping shapes of body and wings (see detail below), fine LINEAR MARKS for the crest and smaller body feathers, and gentle BLENDING to recreate the soft sheen of the downy plumage on the bird's neck and breast.

■ STAN SMITH

"Elephant" and "Cougars"
In these two sketches, the lines are loosely worked in oil pastel (part of the elephant's outline is in pencil), and the washed color is laid in with oil paint thinned with turpentine. The rapid movements of the pastel strokes show how quickly the sketches were drawn, focusing on the contours and skin texture of the animals' bodies, and including only the most essential features.

A study is a much more detailed rendering than a sketch, typically requiring plenty of time for a rigorous visual analysis focusing on the exact form and texture of the animal. It is, in effect, a portrait, or likeness of the particular animal, whereas a sketch may be more freely concerned with the essential characteristics of the species and how these are displayed in typical poses and movements.

Working with pastel, you need to build the image patiently with gradual layering of many individual marks. You need time to do this, which almost certainly means that you will have to refer to

photographs, as the animal will not maintain one pose for long. Ideally, you should combine live observation with photographic reference, so that your memory supplements the pictorial record. It is far preferable to take your own photos of a living creature than to work from pictures in books or magazines, and you can also use sketches as reference, taken from the model, a practice that enables you to relate your observations to the technical solutions that your medium can provide.

▼ STEPHEN PAUL PLANT
"Maine Coon Cat"
The soft gray of the COLORED
GROUND provides a middle
shade from which to key in the
brindled markings. The face
and features are first drawn in
detail; then the fur texture is
developed. A little charcoal is
applied as a base for the strong
blacks and in finishing touches.

► KEITH BOWEN

"Ram Head"
In this GOUACHE AND PASTEL
rendering, fine HATCHING AND
CROSSHATCHING are used to
convey the varying textures of
the ram's smooth head, the
hard, ridged horns, and the
looser hairs on the body.
Complex tint GRADATIONS are
built up using this method, both
directly on the board and over
thin gouache washes.

▼ KEITH BOWEN

"The First Suckle"
The ewe's thick, rumpled wool is elaborated with light FEATHERING Strokes and curling LINEAR MARKS, the massing of the pastel marks gradually building the forms. The body of the lamb is similarly modeled, controlling the weight of the strokes and the color range to obtain the smoother texture and brighter tint of its fleece.

If you are going to represent an animal in the context of its usual environment, you need to consider the degree of detail you wish to achieve, and the way your pastel techniques can construct an integrated image while appropriately describing separate aspects of the animal and its surroundings.

Because pastel is a versatile medium, you will find that the diversity of its marks and textures corresponds well to all kinds of background details — household interiors for studies of pets, landscape

settings or man-made enclosures for farm and wild animals, sky or water for bird studies, and even the unusual underwater environment shown in one of the examples here. But don't overlook the potential of mixed-media techniques — using watercolors, for instance, to flood in large areas of land or sky, or drawing with graphite or colored pencils to develop linear detail.

You can be as descriptive or impressionistic as you wish in representing the environment; a few brief marks can suggest the nature of the creature's habitat, but if you have drawn the animal in detail, you may prefer to apply the same precision to recording its surroundings.

► STEPHEN PAUL PLANT "Doe Rabbit and her Kittens" The technique of building texture with LINEAR MARKS over flat color is consistently applied to both the rabbits and their grassy surroundings.

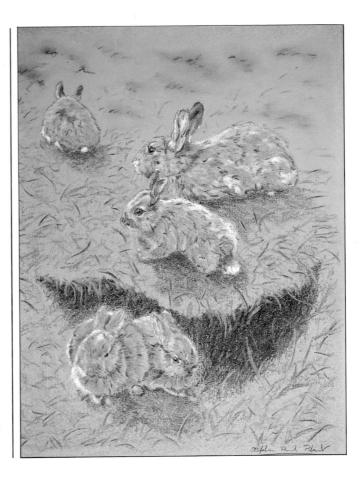

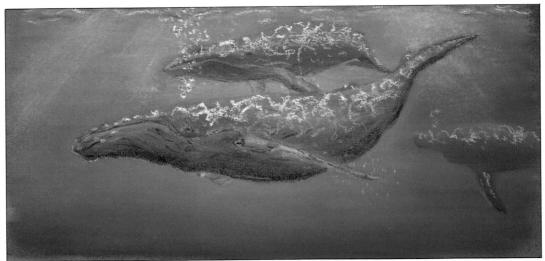

■ STEPHEN PAUL PLANT
"Humpback Whale Cow and
Calf"
When the subject is marine
mammals or fish, the character
of their environment is highly
influential on the form and
coloring of the creatures. Here,
the artist interprets both

elements as a combination of

blended color GRADATIONS and fluid LINEAR MARKS.

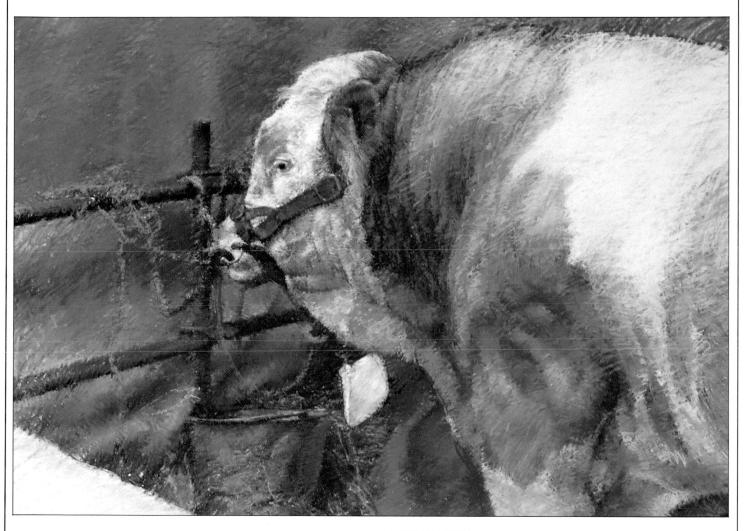

▲ KEITH BOWEN
"Show Bull"
The arrangement of the composition places foremost attention on the massive bulk of the bull, with details of its stall and feed bucket helping to establish a sense of scale. The solid color masses are built up with a dense network of overlaid SHADING and HATCHING.

Birds are a wonderful subject for drawing and painting. They present a huge variety of form, size, texture and color, from the compact bodies and discreet earthy coloring of ordinary backyard species, to the exuberant wings and crests and brilliant colors of tropical birds. There is also a stunning visual difference between a bird on the ground or perched on a branch and the same bird in flight with its wings fully extended.

Some artists specialize in bird studies and spend all their working lives discovering the many variations on the theme. If you want to make this an area of special interest, you can gather reference from a variety of sources. First, and most important, you can observe and sketch birds in the wild. Details of form, color and texture can be gleaned from photographs, and also through museum studies of stuffed specimens. Exotic species can be seen live in enclosed aviaries, and you can again supplement your knowledge of them with photographic reference. There are many books describing the anatomical detail and flight mechanisms of birds, which can all add to your

understanding of the subject.

If you make detailed studies of bird species and want to give your renderings a realistic context, don't forget to pay equal attention to correct information about their habitats.

STEPHEN PAUL PLANT "Barn Owl"

The compact shape and formal detail of the owl in flight is emphasized by the loosely drawn, dark background.

■ STEPHEN PAUL PLANT
"Great Crested Grebes"
There is an interesting contrast
in the rounded shapes of the
birds' bodies and the elongated
forms of the crested heads with
their long, pointed bills. The
paper color creates a unified
tint that helps give the
impression that the birds are
partially camouflaged in their
habitat.

A KAY GALLWEY
"Flamingoes"
The fluid areas of color that establish the general shapes of the birds and the dark ground of the water surface were created by "printing off" a loosely worked oil painting onto

paper. The oil color was allowed to dry before the linear detail of the birds was freely drawn with bold pastel colors. Pastel strokes also describe the shimmering reflections of the flamingoes' colors on the water.

DEMONSTRATION JUDY MARTIN

To draw an image of this kind from life is obviously impossible. The photograph used as reference was a very dynamic shot, and the incomplete pose, with tail and foreleg cropped, was retained as appropriate to the sense of movement conveyed by the image. The artist had previously studied cheetahs in sketches made at the zoo.

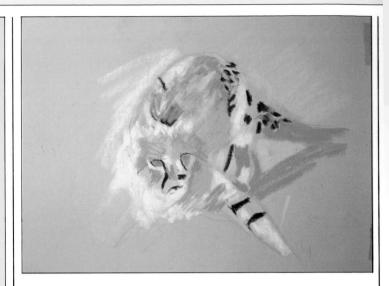

3 The patches of light and shade surrounding the animal are blocked in, and further tints and colors added to the fur, using gestural marks made with

the pastel tip. The hints of color are overstated at this stage, but will become more integrated with gradual overworking.

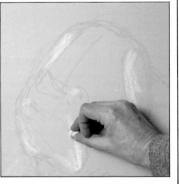

1 The artist is particularly interested in the camouflage patterns of animals. The sandy color of the paper forms the base color both of the cheetah's fur and the dry, earthy background. The contours are freely sketched in yellow ocher and the highlight areas blocked in with a paler yellow tint.

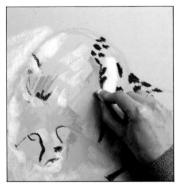

2 Some of the cheetah's markings are drawn in black pastel to key in the darkest tones. Yellow, orange and brown tints in the fur are loosely indicated with rapid SHADING and broad, short SIDE STROKES.

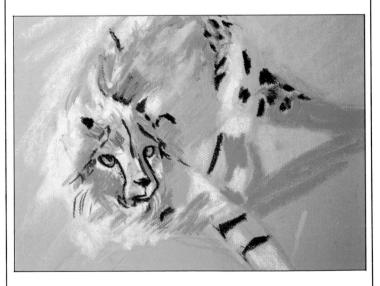

4 The artist begins to define the head, using the natural pattern of black lines around the eyes and nose, and the dark tufts behind the ears. With the

stronger blacks in place, the color detail is reworked more heavily, including the orange and gold eyes.

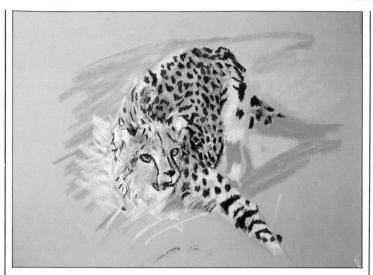

5 The pattern of spots on the cheetah's body and ringed markings on the foreleg are thickly worked with the pastel tip. Around the black spots, the

color detail is developed with shading the LINEAR MARKS, including the white fur highlighting the head and face.

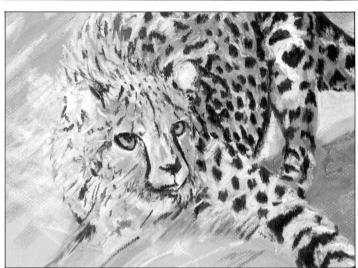

7 The final steps are to put finishing touches on the color detail. Because the yellows now appear a little flat, stronger orange and red ocher patches

are laid into the body and tail, and the spot pattern is reworked in black and sepia. The ruff of fur around the head is more heavily textured.

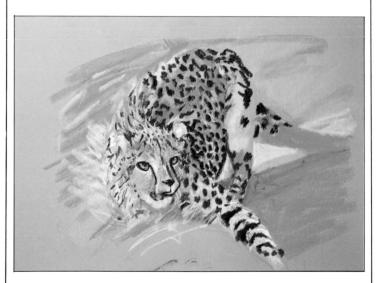

6 The cast shadow under the body and tail is emphasized with a cold gray that contrasts with the warm yellows. The sunlight reflecting on the

ground plane is similarly strengthened with the same pale yellow tint previously applied to the fur.

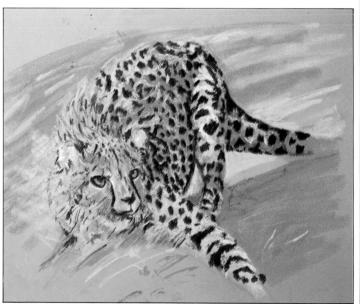

JUDY MARTIN "Cheetah"

STILL LIFE

he great advantage of still life is that you can choose a subject entirely within your control — unlike a person or animal, it doesn't walk away; unlike landscape subjects, it does not bend

with the breeze or change character when the sun goes in. You can use a still life for a period of extended study, resulting in just one pastel rendering or many, so it is an excellent vehicle for learning your craft and sharpening your powers of observation.

Subjects

Natural objects readily present them selves as elements of still life, because they have distinctive forms and varied colors and textures that give you plenty to work on in a relatively small scale - flowers, fruit and vegetables are the most obvious and perhaps most commonly chosen candidates. For the same reasons, household objects with reflective or patterned surfaces, such as bowls, pitchers, pans and bottles made of metal, ceramic or glass are favorite components of still life. Often fabric is introduced, such as a tablecloth or curtain, to give a soft contrast to solid forms.

Less obvious, but equally promising subjects can be found randomly anywhere around the home clothes and shoes, furniture, pillows and rugs, books and ornaments, gardening tools, or brushes and pencils stored in jars in your studio. Any of these objects can be deliberately arranged, or you can treat them as "found groupings" and just study them as they are.

Variations

The scale of such still lifes is sympathetic for pastel work, but you need not be restricted to the home-based context. Different but equally "still" subjects come from the absence of human activity in normally busy

scenes — empty deckchairs in the park or on the seafront, small boats tied to a dock,

machinery on a construction site standing idle outside working hours. There are also natural and manmade features in the landscape that provide outdoor still-life constructions — rocks and stones, for instance, or fences, walls and gateways. Such subjects incorporate many interesting elements of shape,

Whether you are drawing one object or many, and whatever scale you are

form, color and texture.

working to, the active qualities of the marks you make with pastel can contribute a special character to the rendering. Be prepared to experiment with technique and try out alternative solutions — even a simple arrangement of two or three fruits can be interpreted in a variety of ways.

SALLY STRAND
"Bowl of Eggs"
By putting together ordinary
household objects in an
inventive way, the artist finds an
unusual and beautiful image.
The repetitive, simple volumes
of the eggs are subtly disrupted

by the water level in the bowl. There is a fascinating contrast between the opaque, smooth eggshells and the reflective transparency of water and cut glass, fully brought out by the handling of the pastel marks to indicate different qualities of

surface texture and color. But the success of the image is dependent as much on highly developed skills of observation as on expert handling of the medium.

The great variety of fruits gives you a choice of many different qualities of form, color and texture. You can focus on the sculptural elements of volume and contour, modeling the forms with subtle gradations of light and shade, or you can emphasize the colors and textures, working the pastel marks into an almost abstract pattern that incorporates all the variations of surface detail.

Depending on your approach, you may want to isolate the subject and treat it as a self-contained form, or you may prefer to give it a context that includes other objects and a recognizable background. When you are working with simple forms, the quality of light is important – angled light will emphasize the structure of the object, whereas an even spread of light may flatten the forms and reduce the diversity of visual interest.

► FRANCES TREANOR "Wally's Pineapple" The distinctive textures of the fruit are represented as powerfully graphic patterns, exploring every color nuance with a full-strength equivalent. The decorative character of the central image is complemented by the active, vivid background.

◄ PIP CARPENTER

"Bowl of Lemons"
This is an interesting use of water-soluble pastel, with some parts of the image drawn with the dry sticks, others by dipping the pastel into water and drawing with the wet tip.
This is combined with loose WASHES of watercolor that define shadow areas and local color.

■ SALLY STRAND "Lemons" The simple shapes in this composition are a strong vehicle for the artist's exceptional skill as a colorist. Each of the lemons is modeled with a range of subtle hues, from warm yellow and pink to cold blue, green and lilac. The effect of brilliant sunlight derives from bold definition of the highlight areas.

Many still life groupings provide a wealth of pattern elements, both in the juxtaposition of varied shapes and forms, and in the flat patterns often used to decorate household items such as containers, ornaments and upholstery fabrics.

Because you can treat pastel as a medium of line or of mass, it is particularly well suited to pattern-making. Distinct pattern elements can be drawn with the pastel stick, using outlines and linear marks to describe individual shapes and surface details. Color areas can be laid in as solidly shaded, blended or broken color. Use the markmaking capabilities of the pastel to match specific elements of your subject.

Imposed patterns, such as glazed decoration on ceramic ware or printed fabric patterns, are designed to create a colorful surface effect, an element that adds liveliness to your rendering. In a still life, however, they are not seen plainly as flat patterns, but as an additional element of form. You may notice how the imposed pattern can describe something about the underlying structure of the patterned object or material — distortion of the pattern as it wraps around a bowl or pitcher, for instance, or breaks in continuity that signify fabric folds.

■ DAVID NAPP "Fabrics and Fruit" Working with a palette like this, in which dense, highly saturated hues predominate, it would be easy to lose control of form and structure in the composition. Here, the artist moves confidently between flat surface patterns and color characteristics that describe three-dimensional volumes. By accurately identifying specific shapes and the color values they contain, he is able to organize the image effectively without dimming the dramatic impact of its glorious hues.

▲ JANE STROTHER

"Welsh Dresser"

Oil pastel is used freely to draw the image of this hutch, with watercolor to "fill in" color detail. The pastel acts as a resist (see RESIST TECHNIQUES) breaking through the fluid paint. The varied objects and their pattern elements are unified by the strong color theme.

▼ FRANCES TREANOR "Pandora Dreaming" The patterns are deliberately varied to create strong oppositions of color and shape, but the intensity of the pastel color is a cohesive factor in the composition. An interesting device is the contrast of natural with stylized flower forms.

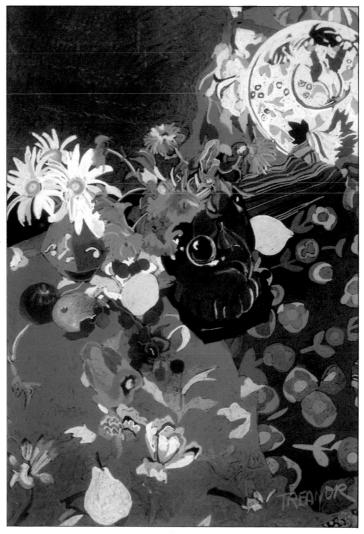

A grouping of objects can either be a deliberate arrangement or a "found" group that needs little or no alteration. Once you start to look around for a subject to draw, you will find many accidental arrangements around your home that provide pleasing material for a pastel rendering, such as plants on a windowsill, plates and glasses on a table, books and ornaments on the shelves. Sometimes you may need to adjust a found subject slightly, to get a better profile on an interesting shape, for instance, or to make sure the light strikes at an illuminating angle.

A basic element of any stilllife group is the relationships of form and space. Whether the objects you select are similar or different in

individual character, their shapes and forms interact and occupy an area within their surroundings. You may choose to indicate the location of the still life very simply — just a couple of lines can suggest the area of space created by a vertical and a horizontal plane, such as a tabletop and background wall. If you give it a more detailed context - seen against the furnishings of a room, for instance, or a view through the window — you have many more visual elements to play with, but make sure a busy background doesn't dominate your intended subject.

▼ BARRY ATHERTON
"Chinese Vases"
A strictly frontal view often
flattens the space within a
composition, and at first sight
the horizontal stresses of this
group are most evident. But the
spatial depth in this image is
quite complex, receding from
the highlighted vases through
the shadowy forms and black
recesses behind them. Pattern
detail is formed with a
combination of pastel marks
and brush strokes.

▲ DANNY CHATTO "Windowsill Still Life" The main color areas of the painting are loosely blocked in with watercolor, over which structure and detail are drawn in soft pastel. Because the still-life group is composed of simple, small-scale objects, the background of the view through the window brings a completely different dimension to the image.

▼ KAY GALLWEY "White Flowers in African Bowl with Wine" This household grouping is an interesting study in texture. Although the active technique enlivens every area of the

composition, the variety of objects and surface qualities clearly emerges. For each component of the still life and background, directional strokes help to explain the construction of form and space.

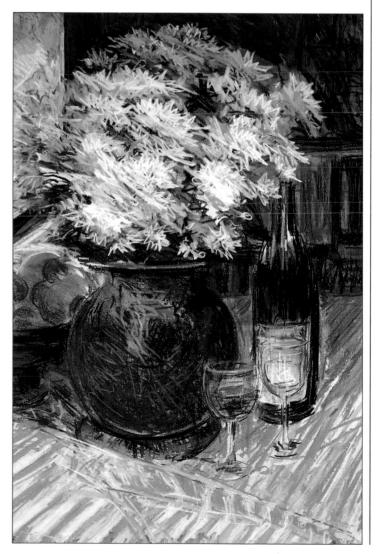

A furnished room is in itself a still life, and any aspect of it may provide your subject. A partial view of a room will include interesting groupings of objects seen in diminishing scale, both in their actual sizes and in the spatial relationships

arising from the perspective of the room.

The focal point of the arrangement could be a vase of flowers on a table, but this will be seen as a relatively small element in comparison with, say, the table on which it stands. You need to consider how the marks you make on paper can represent the varying degrees of detail that you can identify from your chosen viewpoint.

An important aspect of interior still life is the quality of light. You can work in artificial light, but there are practical drawbacks. A central or overhead light is designed to illuminate the whole room, so it may give a too-even, flat

quality that deadens the subject. A lamp focused on the still life can provide a moody, dramatic quality, but leaves you little light to work by. Some compromise between the two may be the answer to this problem.

Many artists prefer to work by natural light from a nearby window. Light directed from a single source helps to model form, and daylight entering a room also provides distinctive color qualities — the gold light of a summer afternoon, for instance, or the cold gray light of a wintry day. When you are viewing a still life in context, these external factors contribute to your interpretation.

▼ CHARLOTTE ARDIZZONE "Table in Window" The simple planes of the

The simple planes of the composition focus interest on the quality of interior light. Each element is described as a color mass, using harmonious hues punctuated with subtle complementary contrasts.

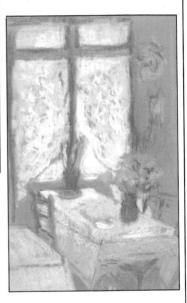

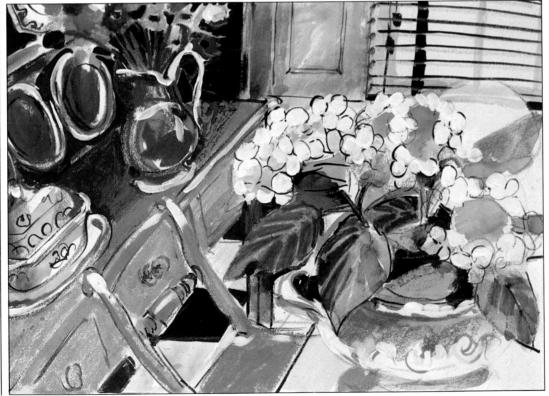

■ JANE STROTHER "Welsh Dresser and Hydrangea"

An unusual perspective pulls the viewer right into the interior setting, creating strong rhythms that lead the eye all around the image. The combination of watercolor paint and oil pastel is used even-handedly, with both used to develop linear structures and color masses.

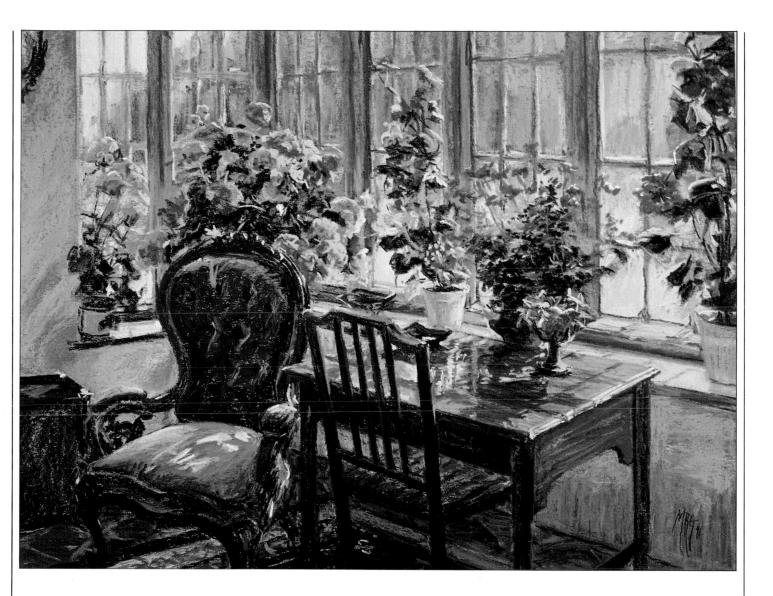

MARGARET GLASS "Morning Light"
In this detailed image, the artist has had to orchestrate various levels of information so that they become completely integrated. There is a high degree of textural variety; and, as the title suggests, the relationships of color and light are a central feature, developed

by playing off warm and cool colors. The palette includes warm blues and greens and cold yellows, pinks and reds, reversing the colors' expected characteristics, and some of the shadow areas contain hues that are bright, but cool and recessive.

The subjects included here stretch the traditional definition of still life groupings, but in the same way as the conventional small-scale still life, they are a vehicle for investigating the formal and technical problems of pastel rendering and also a means of creating expressive images.

Outdoor subjects are most likely to fall into the category of "found" still life (see STILL LIFE: GROUPS), since your opportunity to rearrange the elements will be limited. This is useful discipline, as your subject may contain some aspect that you find difficult to tackle, giving you a problem of observation or interpretation that you might avoid in setting up a still life group yourself. Be prepared to meet such challenges, and if it doesn't work out immediately, perhaps make some quick sketches that you can use as reference to try again on your return home.

There are practical drawbacks to working outdoors. If you haven't got a camera with you, the time you can take to study the subject may be limited, so don't attempt an overambitious approach in terms of scale or

technique. Also, of course, drawing in public does attract attention, which can be disconcerting even to experienced artists, but don't be put off by the idea that passersby may be critical of your work.

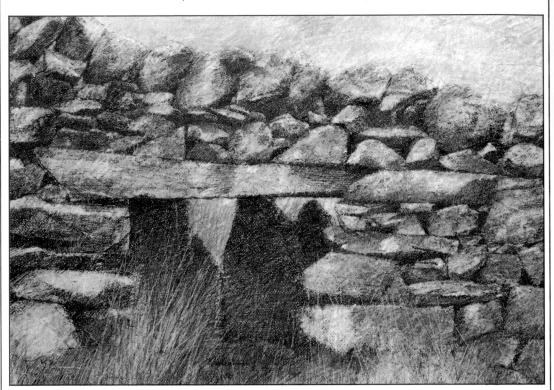

■ JANE STROTHER
"Container Plants"
This attractive image is an illustration for reproduction in print. The more intricate line detail is worked in colored pencil over oil pastel. The pastel is rubbed in places to create massed color, with individual strokes used to delineate flower and leaf forms.

▼LIONEL AGGETT

"Wear the Green Willow"

The repetitive shapes of the deckchairs form an interesting still-life group, sufficiently varied in their different heights and spacings to avoid a regimented effect. The color values and directions of the pastel strokes have been expertly controlled to create the subtle translucence of the deckchair fabrics.

Flowers are just about the perfect subject for pastel painting — there can be few pastellists who have not included flower subjects in their repertoire, and this is the ideal theme for the beginner. The brilliant colors of pastels match the richness of the natural flower color range; the variations of texture that you can rapidly achieve with pastels correspond to the variety of flower forms - soft, smooth, folded, frilled, ragged, spiky.

Cut flowers arranged in a vase can be studied as individual forms or as a group. As in flower arranging, you can select the container to contribute a particular quality to the design — a decorative ceramic container gives a formal pattern quality that can be played off against the

► FRANCES TREANOR
"Harmony, Lily and Iris"
The strong shapes of flowers
and foliage are clearly focused
by hard-edged treatment of the
individual shapes, within which
color qualities vary from solid,
flat color to vibrant GRADATIONS
of hue and tint. Unusually, the
background hues are equal in
intensity.

flower colors, while a glass vase both reflects the light and reveals the incidental detail of the massed flower stems. You can focus all attention on the flower shapes and textures, setting them against a restrained backdrop, or create a vivid clash with a background of active marks and strong colors woven around the flowers.

Outdoor subjects provide dense flower masses and changing nuances of color, light and shadow. An individual plant or a whole flower bed can be the inspiration for a free and enjoyable approach to pastel work.

"Derry's Gift"

The highly decorative border is a hallmark of this artist's pastel paintings, here picking up the color themes of the flowers and recasting them in abstract

shapes. The open hatching (see HATCHING AND CROSSHATCHING) of the white background interacts more fluidly with the flower forms than the dense blue ground of the previous image.

▲ PIP CARPENTER "Irises"

Again in this image, the shapes and forms of the flowers are featured strongly, using an interesting technical sequence. The initial BLOCKING IN was done with a collage of colored paper, washed over with watercolor to establish lights and shadows.

Then water-soluble pastels were applied to intensify colors and create linear definition.

▼ KAY GALLWEY

"Spring Flowers in Blue Jug" Although the linear style of the pastel drawing allows for a very open, active surface, the individual shapes are boldly stated and modeled with strong color and tone, conveying both the spatial arrangement of the group and the individual forms and textures.

▲ GEOFF MARSTERS

"Clematis"

A range of LINEAR MARKS is integrated with patches of SHADING and BROKEN COLOR to construct the dense mass of flowers and foliage. The colors are based in nature, although not wholly representational, and there are many delicate accents and color variations enlivening the loose pattern of flower shapes.

▶ GEOFF MARSTERS

"Poppies"

The shimmering mass of color from which the solid shapes of the poppies emerge is built up with grainy feathered strokes and rich IMPASTO accents. The image creates an impressionistic mood, rather than a descriptive portrait of the flowers. Color contrast is developed with blue against red, rather than the expected green.

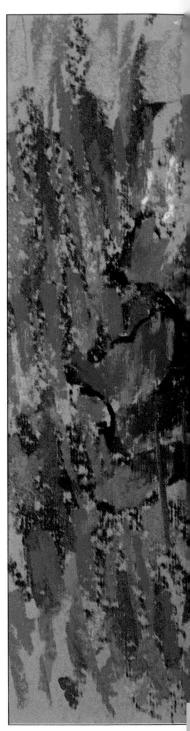

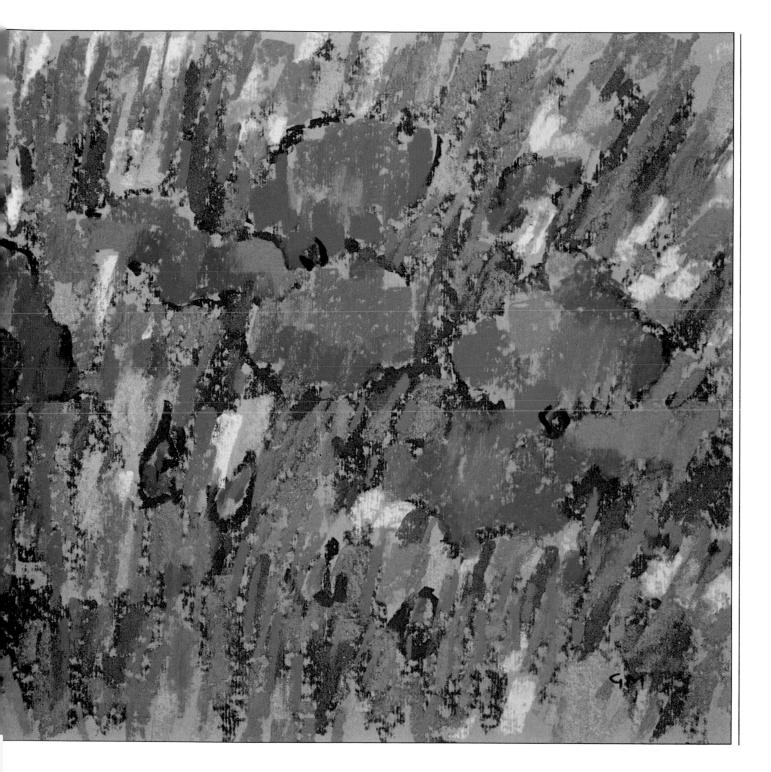

ROSALIND CUTHBERT

The luscious textures of cakes and fruits inspire a free, inventive way of working that combines a range of active techniques.

The artist creates a vivid interplay of hues and shades within a strongly descriptive image.

2 The outline sketch is developed in more detail, using sepia and light mauve to emphasize contours and suggest shadow tones, and pale tints to heighten individual shapes against the medium-colored background. By WET BRUSHING over an application of yellow soft pastel, the artist models the solid volumes.

4 The palette is gradually extended by reference to local colors and the patterns of light and shade that model the

forms. The colors are loosely blended by finger rubbing, maintaining an active surface effect.

1 A TEXTURED GROUND is applied by brushing an adhesive acrylic medium over stretched watercolor paper and rubbing in ground chalk (whiting) and raw umber pigment. The basic shapes of the still life are roughly sketched in white pastel, and the ground is reworked with a brush

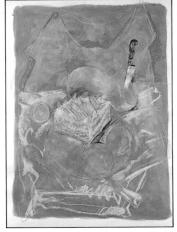

3 Working rapidly with a combination of LINEAR MARKS and wet brushing, the artist blocks in several items of the still life more definitely. At this stage, the range of colors remains limited, and the drawing process is concentrated on developing form and texture.

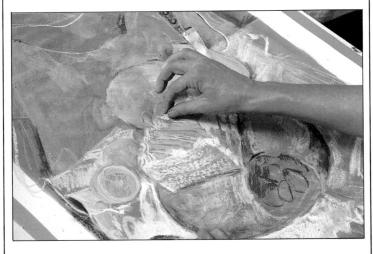

5 Before continuing work on the central section of the image, the artist indicates the surrounding colors, laying in the strong white of the tablecloth more broadly, and indicating the warm red of the strawberry pie. She then returns to details of the fruits and cake.

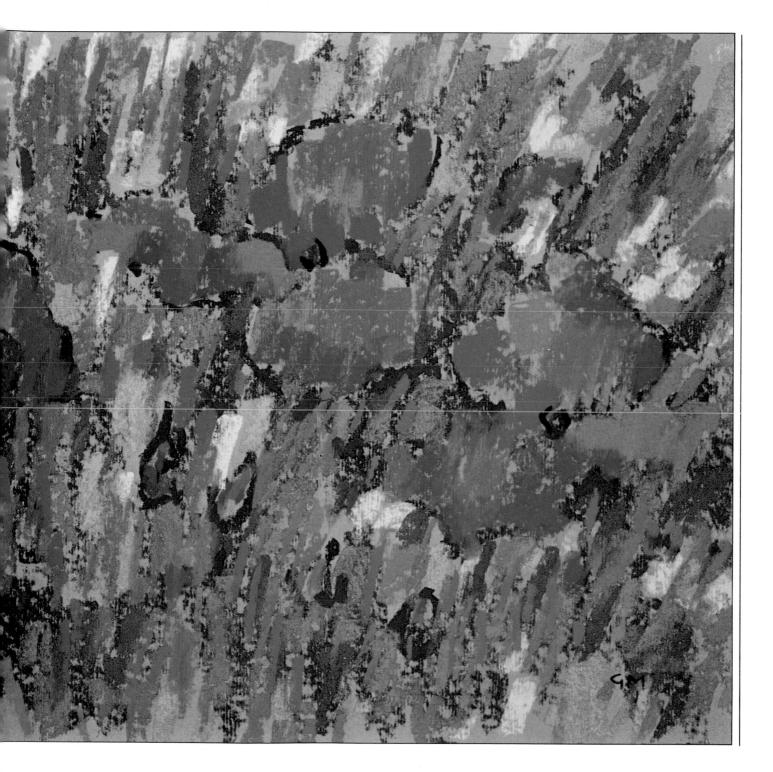

DEMONSTRATION ROSALIND CUTHBERT

The luscious textures of cakes and fruits inspire a free, inventive way of working that combines a range of active techniques.

The artist creates a vivid interplay of hues and shades within a strongly descriptive image.

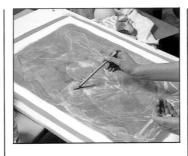

2 The outline sketch is developed in more detail, using sepia and light mauve to emphasize contours and suggest shadow tones, and pale tints to heighten individual shapes against the medium-colored background. By WET BRUSHING over an application of yellow soft pastel, the artist models the solid volumes.

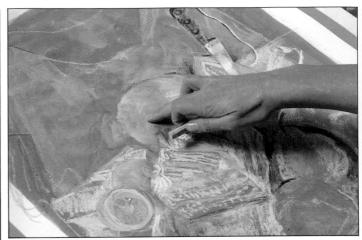

4 The palette is gradually extended by reference to local colors and the patterns of light and shade that model the

forms. The colors are loosely blended by finger rubbing, maintaining an active surface effect.

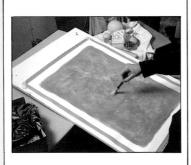

1 A TEXTURED GROUND is applied by brushing an adhesive acrylic medium over stretched watercolor paper and rubbing in ground chalk (whiting) and raw umber pigment. The basic shapes of the still life are roughly sketched in white pastel, and the ground is reworked with a brush

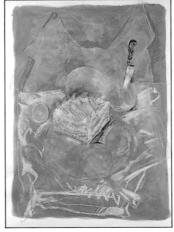

3 Working rapidly with a combination of LINEAR MARKS and wet brushing, the artist blocks in several items of the still life more definitely. At this stage, the range of colors remains limited, and the drawing process is concentrated on developing form and texture.

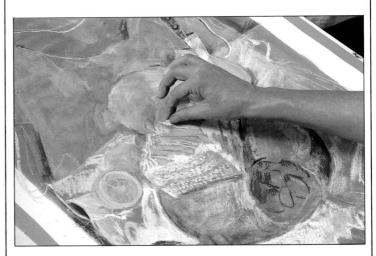

5 Before continuing work on the central section of the image, the artist indicates the surrounding colors, laying in the strong white of the tablecloth more broadly, and indicating the warm red of the strawberry pie. She then returns to details of the fruits and cake.

6 The image is now quite strongly established, but there is a lot of detail work to complete. The full range of shading variations is in place, but the forms and colors need to be built up with greater complexity.

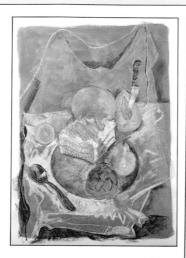

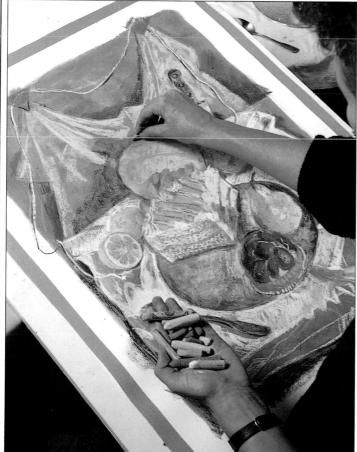

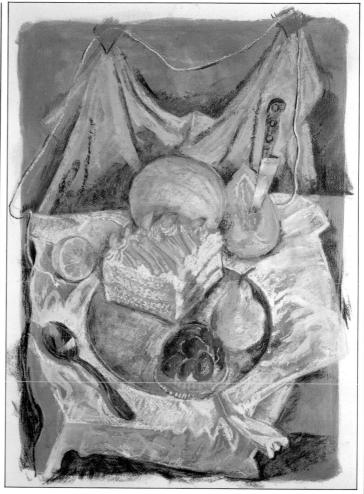

ROSALIND CUTHBERT "The Feast"

7 As each component of the still life takes solid form, the artist works freely all over the image adding highlights and color accents and strengthening the shadow areas. Dry pastel work is again combined with wet brushing to enhance the range of textures in the final image.

Page numbers in *Italic* refer to illustrations and captions

Α

accenting 12, 12, 83, 139, 155 accents 12, 12, 22, 23, 46, 90, 112, 133, 134, 141, 187 impasto 184 acrylic gesso 44 acrylics 76 and pastel 13, 13 in watercolor mode 13 aerosol spray paints 116 age and character (portraits) 146-9, 146 Aggett, Lionel Down the Flight 95 Wear the Green Willow 181 Wheal Betsy, Dartmoor 93 animal textures 158, 162 animals 158-69 domestic 160 sketches 160-1, 160 studies 162-3, 162 in their environments 164-5, 164 Ardizzone, Charlotte Interior with Sofa 110 Table in Window 178 Armfield, Diana Aspens Along the Path in the Rockies 83 At the Restaurant Piazza Erbe, Verona 106 In the Ca'Rezzonico, Venice 111 Interior, San Marco 112 Interior of San Marco, Venice 60

Lunch at Fortnum's 27
Market Stall, Piazza
Bartolomeo 107
Puy l'Eveque 114-15
Ripe Sunflowers below Puy 75
Teatime, Brown's Hotel 17
Atherton, Barry
Chinese Vases 176
Portrait of a Painter 151
Unfinished 150-1
atmospheric contrast 98
atmospheric effects 14, 103, 114-15, 126-7
of broken color 106

В

Barber, John, Crane 161 birds 166-7, 166 blending 14, 14, 19, 21, 26, 27, 36, 36, 55, 56, 59 76, 80, 84, 92, 100, 117, 126-7 by line work 42 and mixing 29 partial 66 see also finger blending; finger rubbing blocking in 15, 15, 23, 34, 47, 56, 83, 98, 153, 168, 183 and building up 18, 18, 20 with dry wash 26 grainy texture 145 hard pastel 20, 85 with hatching 116 and oil pastel 21 with side strokes 21, 59, 138, 139, 145 with watercolor 66, 115, 177 Bowen, Keith Bricklaying 124 The First Suckle 163 Moel Siabod 79 Ram Head 163 Show Bull 165 Spanish Quarry 123 Stone Wall 180 Ty Mawr 102 Winter Feed 195 broken color 14, 16-17, 16, 40, 44, 55, 72, 73, 74-5, 76, 80, 81, 92, 93, 102, 106, 107, 144, 158, 184

brushes 14, 28, 28, 68, 117, 186 and pastels 21 building up 13, 16, 18-21, 18, 22, 83, 162, 164 buildings 102-5, 102

calligraphic qualities 78, 79, 126, 156 calligraphic technique 101 camouflage patterns 168 Carpenter, Pip Bowl of Lemons 172-3 Irises 183 Wood Wharf Boatyard — Upstream 108-9 cast shadows 88, 107, 169 Cayford, George, T'ai Chi Exercise 33, 127 chalk, ground 186 charcoal 49, 76, 109, 121, 162 for monochrome drawing 23 over pastel 22 and pastel 22-3, 22, 127 Chatto, Danny, Windowsill Still Life 177 chiaroscuro effect 113, 152 see also light and shade children 130-1, 130 clean edges 43 clear water 94 clothing 122, 151 cloud formations 93 cloud shadows 89 Coates, Tom Cellist 125 Figure against a Window 134 *Interior with Seated Figure 111* Model in Studio 136 Peasant Woman 122 Seated Man 148 Woman in Pink 151 complementary 109, 138 showing through 21, 24, 46 wet and dry, combining 69 color bias 24 color bleeding 30 color density, and overlaid strokes 66 color gradations 26, 36, 36, 56, 59, 91, 93, 164

color masses 165, 178 color mixing 36 color nuances 113, 173 color relationships 133 color variations 35, 64 and hatching 37 colored grounds 17, 24-5, 24, 26, 72, 90, 98, 103, 138, 144, 144, 148, 162 and light quality 88 colored paper collage 183 colors, lavered 31 construction materials, color and texture of 102, 102 contours fluid 33 and hatching 38 well-defined 27 contrasts 16 color 67, 81, 88, 98, 184-5 complementary 64 shadow/color 90 visual 33 convergence 74, 76 corrections, by overworking 28 crosshatching 8, 32, 32, 34, 36, 38, 38, 42, 46, 58, 110, 144, 163 grainy 59 loose 103 see also hatching Cullen, Patrick Portrait of Celia 63 Purple Fields near Centaldo 16-17 Tuscan Landscape 73 Valley in Tuscany, Evening Light 88 Vineyards and Olive Groves, Sultry Day 76 cut flowers 182 Cuthbert, Rosalind Blue Hills 76 Cypresses 85 The Feast (demonstration) 186-7

D

Degas, Edgar 40, 136 directional marks 33 domestic objects 170, 171 domestic settings 134

dragging, finger 140 dry brush 35 dry wash 24, 26, 26 E edge qualities 27, 27 architectural detail 203 Elliot, John The Artist (detail) 147 At Audubon Lake 84 Autumn Near the Artist's Studio 81 Canoeing in Vermont 60 Covered Bridge 80 Homer's Rocks 96 Hudson River from Piermont letty, New York 84 Monument Mountain 46 Norman Rockwell's Church 27 Queechy Covered Bridge. Vermont 95 Red, White and Blue 41 Salmagundian 145 Winter at High Point, New Jersey 103 Young Professional 145 environment, the 100-19 erasures 28, 28, 56 avoidance of 49 with bread 28, 28 by scraping 28 to create highlights 39 etching out 84 Evans, Margaret The Beaters, 135 Evening Light, King's Course, Gleneagles 91 Laich Loch, Gleneagles 62 Ma Petite Fille 146 Malcolm in Dressing Gown 146 Eyton, Anthony Biarritz 132-3 Cryss in a Pink Chair 136 Irises 86-7 Market Hall 101 fabrics 64, 174, 174 facial features 144 feathering 29, 29, 46, 47, 56, 92, 93, 105, 158, 163, 184-5

Ferry, David, Construction Site (demonstration) 116-19 figure, the 120-41 in action 124-5, 124 groups 128-9, 128 figures 106 in a setting 132-5, 132-3 finger blending 14, 18, 56, 59, finger rubbing 20, 47, 64, 156. fixative, fixing 18, 22, 30, 30, 41, 98, 136 degrading effect of 30 spray on back of work 30, 30 flower subjects, outdoor 182 flowers 182-5, 182 focal points 80, 82, 125, 132, 133, 178 foliage and flowers 86-7, 86, 182, 184 form, color and texture 172 form-space relationships 176 "found" groups 176, 180 framing, with masking tape 116, 117, 118 Freeman, Barry, Curiosity 130 freeze-frame approach 124 frottage 31, 31 fruit, still life 172-3, 172

G

Gallwey, Kay Ballet Dancer 33 Flamingoes 167 Portrait of Stefanie (demonstration) 156-7 Sprint Flowers in Blue Jug 183 White Flowers in African Bowl with Wine 177 gestural drawing 32-3, 32, 76-7, 82, 86-7, 122, 126-7, 126, 132-3, 139 gestural marks 168 Glass, Margaret Morning Light 179 Morning Light, Ramsholt 97 The Parlour, Bale 110 The Smokehouse, Cley 102 Sun and Shadows 78

glasspaper 78

Godsell, Brenda, Dancers in Grey 127
gouache and pastel 34-5, 34, 163
grain of paper 35, 62, 81, 106
graphic patterns 173
grounds
white or light tinted 16
see also colored grounds;
textured grounds
groups 128-9, 128
still life 176-7, 176

Н

hair 13, 144, 147, 157 hands 150 hard edges 27, 43, 43, 90, 95 hard pastels 6, 8, 8, 29, 32, 85, 108-9, 137 and building up 20 and linear marks 42 Harrison, Hazel, Charmouth Beach (demonstration) 98-9 hatching 8, 20, 22, 32, 32, 35, 36, 36, 37, 37, 42, 57, 58, 110, 116, 135, 140, 144, 145, 147, 151, 156, 158, 163 following object contours 38 loose 32, 47, 56, 64, 84, 103, and monochrome drawing 37 open 182-3 overlaid 79, 165 pencil 47 and wet brushing 68, 68 see also crosshatching Hatts, Clifford, A Life Study 137 head, attitude of 146 heads 144-5, 144 highlighting 12, 39, 39, 67, 134, 139, 141, 143, 155 and impasto 40 luminous 157 white 153 highlights 13, 21, 22, 23, 38, 39, 46, 58, 152, 187 Houser, John Amanda of John's Island 144 Big Wind 154 Denise 144 Ramona (Tigua Elder) 149

hues 101 variation in 99 hues and tones 19, 143 of colored grounds 25 gradation of 14, 182 neutral 76-7

1

images, projection of 49, 49 impasto 22, 34, 35, 40-1, 40, 46, 78, 81, 105, 117, 154, 184 industrial settings 108-9, 108 ink line 103 ink washes 117, 119 inks black Indian 53 colored 117 and soft pastel 180 white 118 interior light 178 interiors 110-13, 110, 132, 143 domestic 110, 110, 111, 164 opened out 110, 111 spatial arrangement 140

K

Katchen, Carole
Conversation at the Rose Café
134
Jazz at the Museum 128-9
Peanuts Hucko 123
Ronnie in the Air 126-7
kneaded eraser 23, 28

L

landscape 26, 72-99, 100, 164
coastal 96
color transition 36
and figures 133
layering 31, 66, 162
continual 97
and crosshatching 38
life studies 136-7, 136
light 88-91, 88, 128-9, 172
and change 16
and interior still life 178
morning 135
quality of 121
reflected 111
transient effects 93

light and shade 27, 66, 90, 124,	Martin, Judy	over watercolor, sgraffito 57	pencil 35, 49, 116, 160-1
133	Cheetah (demonstration)	overlaying on soft pastel 66	colored 180
gradations of 172	168-9	painting with 44	and pastel 47, 47
	Golfer 32	pressure and tonal gradation	photographs
lighting 114 directional 138	Movement Studies 32	58	for animal work 158, 162
	Orchard in Normandy 67	and resist techniques 50, 50	for reference 72, 96, 168
and interiors 110	Over the Jump 32	and scumbling 55	Plant, Stephen Paul
and portraits 152-5, 152	Tree Study 35	and side strokes 59	Barn Owl 166
lights and shadows 114, 183	masking techniques 27, 43, 43	and stippling 61	Doe Rabbit and her Kittens 164
contrasts of 109	massed color 8, 10, 32, 87, 180	white 53	Great Crested Grebes 166-7
enhanced by pastel 35	and stippling 61	optical mixing 61	Humpback Whale Cow and Calf
strong 19	massing techniques 34	overlaying 46, 46, 99, 102, 117,	164
line and wash 65	Michaels, Eric	121, 130, 140	Maine Coon Cat 162
line work, pencil 47		to develop color blends and	portrait artists 142
linear definition 183	At the Well – Chichicastenango 129	mixtures 59	portraits 142-57
linear marks 32, 37, 42, 42, 47,		overworking 168	full-length <i>150-1</i> , 150
64, 72, 73, 76-7, 79, 81, 83	Indoor Market, Santiago 115	Overworking 100	poses
84, 90, 93, 95, 107, 121,	Inside the Great Mosque 113	D	arrangement of 156-7
126, 132-3, 138, 139, 145,	Journey to Zunil 88	P	childlike 131
147, 149, 151, 156, 161, 163,	Simple Pleasures 131	Daina Van	stable 122
169, 184	Sunday Morning in Patzcuaro	Paine, Ken	posture 150
fluid 164	106	The Composer 153	pouncing 48, 48
hooked 87	Tztotzil 155	The Gipsy 148	Prentice, David
in sketching 60	mixed-media effects 116-19	The Philanthropist 154	Coloured Counties — Laura's
vertical and horizontal 103	mixed-media techniques 164	Self Portrait 152-3	War 76-7
and wet brushing 186	mood and atmosphere 114-15,	palette 179	Girl in the Yellow Oilskin 89
linear strokes 27, 27, 34, 158	114	cool and cold colors 79	pressure
feathering 29	movement, and the figure 126-	dense, highly-saturated hues	and linear marks 42
and tinting 64	7, 126	174	and pastel strokes 14, 62
linear texture 44, 67	NT	gentle colors 114-15	and shading 58
and hatching 37	N	high-key 110	priming 65
and scraping out 52	Napp, David	limited 103, 146, 186	for oil pastel work 24
luminosity 55, 90, 91, 93, 94-5,	Fabrics and Fruit 174	paper see colored grounds,	printing-off, oil painting onto
157	Farm Track in Tuscany 80	textured grounds	paper 167
	House and Cypress Trees at	paper masks 43	public interiors 110, 112, 113
M	Regello 105	Parker, Vincent, Reclining Nude	PVA, to make textured ground
	Poppies in Provence 87	(demonstration) 138-41	186
Manifold, Debra	nude studies 120, 136	pastel pencils 6, 9, 9, 29, 32, 61	100
Dockhead 109	nade statics 22s, 25s	and linear marks 42	D.
Evening Glow 2	O	and shading 58	R
Last Light 90		pastels	recession 75, 135
The Retreat 84	oil paint 160-1	color range of 8-9	reflections 45, 94-5, 94, 95, 167
Marsters, Geoff	drawing into with oil pastel	and figure work 120	resist image, layering of 51
Barge, the Raybel 17	45	for finer detail 34	resist techniques 13, 50-1, 50,
Breton Coast 96	and pastel 44-5, 44, 104, 107	over charcoal 23	66, 84, 117, 119, 175
Breton Farm 105	as semi-transparent glaze 44	types 6-9	reworking 20, 52, 53, 65, 117,
Cherry Tree in Blossom 87	oil pastels 6, 9, 9, 27, 31, 36, 80,	versatility of 78	145, 168, 169, 186
Clematis 184	81, 84, 95, 109, 116, 117, 145,	water-soluble 6, 9, 9, 65, 172-	to develop detail 66
IH1 at Aldeburgh 29	160-1, 175, 180	3, 183	rubbing 20, 27, 47, 84, 98, 107,
Interior of Boathouse 109	and building up 21	see also hard pastels; oil	
LT229, IH88, IH265 at	as color washes 65	pastels; pastel pencils; soft	of charcoal 23
Aldeburgh 93	and gestural drawing 32	pastels	and frottage 31
Poppies 184-5	and linear marks 42	pattern 34, 176 in still life 174-5, 174	see also finger rubbing
Reach Fen 74-5	and oil paint 92	11 Still life 1/4-3, 1/4	,

	1		
	S	skin texture 146	
		skin tones 144, 144, 145, 149,	
	sandpaper 62, 63, 97, 102	157	
	scale and space 132	Smith, Stan	
	scraping out <i>52,</i> 52 <i>,</i> 117	Cougars 160-1	
	scratchboard 84	Elephant 160-1	
	made with oil pastel 53-4,	smudging <i>56, 140</i>	
	53-4	snow 78	
	scratching out 51	soft edge qualities 27	
	scribbling 32, 35, 37, 42, 107	soft pastels 6, 8, 8, 27, 31, 78,	
	and wet brushing 68, 68	80, 85, 91, 103, 109, 153, 1	
	scriber 53	and acrylic 13, 13	
	scumbling 46, 55, 55, 56, 111,	and building up 18-19	
	132-3, 147	and dry wash 26, 26	
	seascapes 96-7, 96	and gestural drawing 32	
1	sfumato 56, 56, 126-7, 153	and heavy shading 58	
1	sgraffito 54, 57, 57, 117, 119		
	shading 8, 15, 20, 23, 35, 36, 36,	and impasto 40	
١		ineffective as resist media 5	
١	44, 56, 58, 58, 60, 84, 107,	and linear marks 42	
I	132-3, 134, 144, 147, 149,	and overlaying color 46	
İ	151, 168, 184	and scumbling 55	
	combined with hatching 135	and stippling 61	
l	dense 85	space and distance 73, 74-7, 75	
l	of dense color 27	Sparkes, Roy, Frindsbury	
١	linear 10	Garden, Elizabeth H. 46	
l	loose 21, 22, 42, 126-7	spatial depth 176	
	overlaid 79, 165	spattering, ink 116	
l	pencil 47, 47	standing figures 122-3, 122	
l	white 139	stencil brushes 117	
l	shadowing, veiled 92	still life 170-87	
l	shadows 27, 38, 45, 58, 88, 89,	exterior 180-1, 180	
l	107, 149, 169, 179, 186	interior <i>178-9</i> , 178	
	strengthened by accents 12	subjects 170	
l	shape, form and detail, use of	stippling 34, 46, 61, 61, 117, 158	
	linear marks 60	Strand, Sally	
١	side strokes 15, 59, 59, 60, 76-7,	Bowl of Eggs 171	
l	98, 121, 137, 140, 145, 161,	Corner of 48th 123	
	168	Court Break 121	
	for blocking in 18, 21	Lemons 172-3	
l	grainy 46, 90, 138	Nearly Overlooked 124	
	loose 32	Played Out 131	
	open-textured 27, 46	Taking the Daily Paper 128	
	washing over 68	street markets 106	
	sketching 13, 15, 60, 60	streets and markets 101, 106-7,	
birds 166		106	
	layouts in charcoal 22	streetscape 107	
	outline 15, 186	stretching paper 25	
	for portraits 142	Stride, Sally	
	preliminary 8	Autumn Tree 82	
	for reference 72	Erick 143	
	skies 26, 92-3, 92	Oak in Winter 79	
	reworking of 117	River Lot, Late Afternoon 94-5	
	and seascapes 96	Two Girls on a Tree Trunk 133	
		Two Giris on a free frunk 155	

kin texture 146
kin tones <i>144</i> , 144, <i>145</i> , <i>149</i> ,
157
mith, Stan
Cougars 160-1
Elephant 160-1
mudging <i>56, 140</i>
now 78
oft edge qualities 27
oft pastels 6, 8, 8, 27, 31, 78
oft pastels 6, 8, 8, 27, 31, 78, 80, 85, 91, 103, 109, 153, 177
and acrylic 13, 13
and building up 18-19
and dry wash 26, 26
and gestural drawing 32
and heavy shading 58
and impasto 40
ineffective as resist media 50
and linear marks 42
and overlaying color 46
and scumbling 55
and stippling 61
pace and distance 73, 74-7, 75
parkes, Roy, Frindsbury
Garden, Elizabeth H. 46
atial depth 176
attering, ink 116
anding figures 122-3, 122
encil brushes 117
ll life 170-87
exterior <i>180-1,</i> 180 interior <i>178-9,</i> 178
subjects 170
ppling 34, 46, 61, 61, 117, 158 rand, Sally
Bowl of Eggs 171
Corner of 48th 123
Court Break 121
Lemons 172-3
Nearly Overlooked 124
Played Out 131
Taking the Daily Paper 128
eet markets 106
eets and markets 101, 106-7,
106
eetscape 107
etching paper 25
etching paper 25 ide, Sally
Autumn Tree 82
Erick 143
Oak in Winter 79
River Lot, Late Afternoon 94-5

Strother, Jane Container Plants 180 Olive Trees, Monteccio 84 One Welsh Hillside 92 Rome Flats 104 The Red House 107 *The White House — High* Summer 104 The Yellow House 114-15 Welsh Dresser 175 Welsh Dresser and Hydrangea 178

T

textural detail 67 textural effects, and masking 43 textural variation 36 textured grounds 62-3, 62, 63, 81, 95, 97, 102, 137, 186 textures 26, 33, 72, 99 broken 100 complementary 34 contrasted 21 fluid and grainy 103 from different techniques 116-19 and frottage 31, 31 grainy 24 and reworking 65 and scraping out 52 scribbled 32 using oil pastel and oil paint 44 tint charts 25 tinting 26, 64, 64, 144 tints 90, 91, 93, 99, 135, 149, 186 for depth and variation 92 and hues 34, 73 neutral 24 tonal balance 103, 127, 141 tonal contrast 19, 64, 79, 88, 88, 108 tonal gradation 23, 26, 26, 36, 36, 58, 61, 114, 163 tonal modeling 68, 195 tonal values 24, 81, 139 contrast of 152 tonal variation 88, 187 extreme 109 Tookey, John Cley, Norfolk 103 Horsey Mill 91

King's Lynn 103 Salthouse, Norfolk 94-5 torchons 14, 34, 36, 56, 59, 64 townscape 100 tracing 48, 49 translucency 46, 117, 181 Treanor, Frances Derry's Gift 182-3 Harmony, Lily and Iris 182 Pandora Dreaming 175 Wally's Pineapple 173 trees 79, 82-5, 82, 104

U

underpainting, watercolor 106 underwater environments 164

V

velour paper 63 viewpoints 114 angled 102

W

Washes 24, 65, 65 grainy 68 watercolor 121, 183 water 94-5, 94, 171 turbulent 95 watercolor 103, 175 liquid 50, 50 and oil pastel 178 and pastel 13, 66-7, 66, 76 tinting with 25 watercolor paper 121, 186 waves 96 wet brushing 66, 68-9, 68, 153, 186, 187 wet color, and impasto 41 wet and dry color, combining 69 winter landscapes, calligraphic qualities 78, 79 Wise, Irene Road Diggers 64 Skaters at Richmond 133 Sylvie at the Paris Rendezvous 122 Twickenham Riverside 85

\mathbf{Z}

zoo animals 158, 160

Contributing artists

Quarto would like to thank all the artists who kindly submitted work for this book, including the following who carried out demonstrations but are not credited in the captions:

David Carr 69; George Cayford 20, 22, 37, 38, 47, 50, 54, 56-7, 59, 65 top; Patrick Cullen 15, 23, 39, 40, 44, 63 bottom, 66-7; Hazel Harrison 21, 25 right, 26, 28, 48, 52 top and bottom right, 62, 68; Ken Jackson 18-19; Judy Martin 12-13, 29 right, 31, 34-5, 36, 41 bottom, 42-3, 45, 51, 52 bottom left, 53, 55, 58, 61, 65 bottom; Guy Roddon 64 top.

Photographers

All the photographs of the demonstrations were taken by Jon Wyand, with the exception of the following: Chas Wilder 6-9, 186-7